THE CITI EXHIBITION
I OBJECT
IAN HISLOP'S
SEARCH FOR
DISSENT

W9-CEI-877

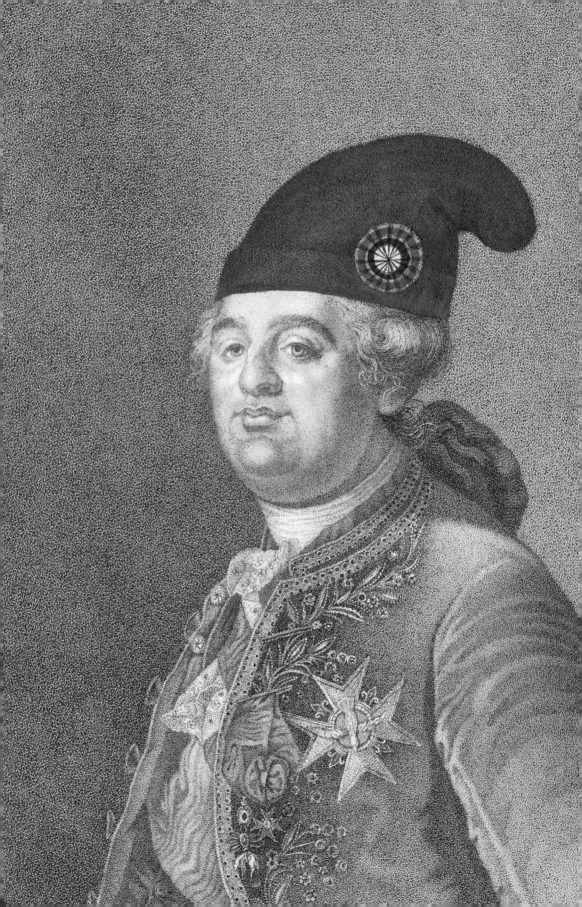

THE CITI EXHIBITION

OBJECT

IAN HISLOP'S SEARCH FOR DISSENT

IAN HISLOP
TOM HOCKENHULL

Thames & Hudson

The British Museum

This publication accompanies the Citi exhibition *I object: Ian Hislop's search for dissent* at the British Museum from 6 September 2018 to 20 January 2019.

This exhibition at the British Museum has been made possible by the provision of insurance through the Government Indemnity Scheme. The British Museum would like to thank the Department for Digital, Culture, Media and Sport and Arts Council England for providing and arranging this indemnity.

Frontispiece: Detail from an altered version of a portrait of Louis XVI, King of France, wearing the *bonnet rouge*. After Joseph Boze, 1792 or later

First published in 2019 in the United States of America by Thames & Hudson Inc., 500 Fifth Avenue, New York, New York 10110, in collaboration with the British Museum

www.thamesandhudsonusa.com

Library of Congress Control Number 2018946042

ISBN 978-0-500-48041-0

Printed and bound in Slovenia by DZS-Grafik D.O.O.

For more information about the Museum and its collection, please visit **britishmuseum.org.**

CONTENTS

We believe that by celebrating the past, we all have the opportunity to define the future. No one brings the past to life like the British Museum, whose permanent collection is one of the finest in existence, spanning two million years of human history. With the Citi exhibition *I object: Ian Hislop's search for dissent*, the Museum and Ian Hislop take the opportunity to use this great collection to demonstrate how personal expression has the power to make change and drive progress. There have been, and continue to be, times and places where freedom of expression is not afforded to all. But throughout history, people have been resourceful in expressing dissent and opposition to authority, whether through mediums such as satire or outright subversion. Their often brave efforts have played a powerful role in shaping society for the better.

As a global bank our mission is to serve as a trusted partner to our clients by responsibly providing financial services that enable growth and economic progress. This mission extends to the 98 countries that we go to work in and the 160 we serve. We are incredibly proud to partner with the British Museum in supporting it in its role as one of the most important global guardians of human history. We value the fact that our support enables the Museum to continue with its ground-breaking exhibitions and renowned education programmes.

We sincerely hope that you were able to attend the exhibition in person. If not, we hope that this book serves as testament to the Museum's mission to make its collections available to a global and increasingly diverse audience.

Jim Cowles
Chief Executive Officer
Europe, Middle East and Africa
Citi

DIRECTOR'S FOREWORD

The British Museum collections, renowned for documenting the great civilizations in history, are an ideal starting point from which to explore what it means to think and act against authority. This exhibition, curated by Ian Hislop and Tom Hockenhull, Curator of Modern Money, and with the support of the Museum's expert scholars, uncovers examples of creative disobedience, some dating back thousands of years.

There are monumental works alongside items of everyday usage. Many were made by unnamed skilled individuals in the service – or disservice – of their ruler, religion, tribe or tradition. From witty insults to revolutionary protests, these objects have all challenged the dominant ideologies of the day. Brought together in one exhibition they prove instructive, amusing, provocative and topical, reinforcing the oft-stated argument that the past can help us make better sense of the present.

We are grateful to the British Library for the loan of two books that complement this complex narrative and were themselves once part of the British Museum's collection, prior to the formal separation of the two institutions. The artist known as Banksy has loaned an object that he once stuck to the gallery walls (without permission), which the Museum welcomes back for the first time as part of this exhibition.

Finally, we would like to thank the sponsor of the exhibition, Citi, for whom this is the first in the five-year Citi Exhibition Series. Without their generous support this exhibition would not have been possible.

Hartwig Fischer
Director, British Museum

PREFACE

This exhibition comes from a very simple idea. The British Museum contains an extraordinary collection of objects from different times and places, but at first sight it all seems to be reinforcement, if not actually a celebration of authority. It's about history's rulers and their statues, pictures, weapons, coins, clothing and jewellery. Or is it? I wanted to find out whether there were objects that challenged the official version of events, defied the established narrative and presented a different view. Was there actually subversive material lurking among the mummies and the monuments? I'm pleased to say that the answer was 'yes'.

In 1972, as a boy aged twelve, I was taken by my parents to see the great Tutankhamun exhibition at the British Museum, and I still have the folder with the boy king's head on the outside. I was hugely impressed with the tragic dynastic glamour of the royal tomb. Now, as an adult, I have chosen to put in this exhibition a rather different Egyptian artefact. It is an ostracon, a stone fragment used to write or draw on, possibly made by a tomb builder (p. 147). The maker has mimicked the formal funerary style used to portray the pharaohs, but has instead depicted a man and a woman doing something more, well, life affirming. When I was younger I was terrified of the huge bearded winged figures in the Assyrian galleries, who had the heads of humans and the bodies of bulls. In this exhibition there is a rather more humble piece of ancient sculpture – it's a brick in fact – from Babylon and inscribed, in accordance with regulation, with the name of the king (pp. 10 & 122). But then the maker has carved his own name on the brick as well, in an act of defiance that is meant, I think, to suggest that it is no less silly for him than for the great ruler to commemorate himself on such an item. The brick was then put in a wall and was probably never meant to be seen again, so we have no idea if 'Zabina' showed his handiwork to his friends and they shared a laugh at his audacity, or whether he did it entirely in secret. Either way, I think the very act of inscription will have been extremely satisfying and, indeed, Zabina may have believed that there was an unseen audience of god, his ancestors or of posterity observing the process and thinking, 'well, that's quite funny'. I like the thought that this brickmaker, nearly two and a half thousand years ago,

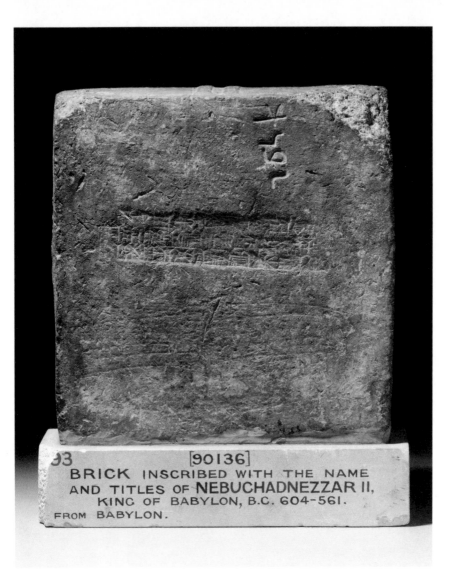

93 [90136]
BRICK INSCRIBED WITH THE NAME
AND TITLES OF NEBUCHADNEZZAR II,
KING OF BABYLON, B.C. 604-561.
FROM BABYLON.

Above
A fired clay brick stamped with
the name of Nebuchadnezzar II
in cuneiform, and bearing graffiti
with the name of a workman,
Zabina, in Aramaic alphabetic
letters, 605–562 BC

quite literally made his mark on the world. It's a fantastic, very ancient, small act of rebellion.

These are the sort of objects that I was hoping to find when Neil MacGregor, the former Director of the British Museum, approached me with an idea for an exhibition about subversion and dissent. I know a little about satirical prints and drawings, but he wanted someone to

look at the Museum's whole collection with an alternative pair of eyes and to see if there was a story of protest to be found. I, of course, have no qualifications for this job except enthusiasm, but fortunately the Museum has brilliant curators and world-class experts who know what they are talking about, and who respond well to the technical, academic question that I put to them: 'Well, what have you got then?' I was initially worried that evidence of dissent would be rare, particularly the further back in history we went. To literally 'make' a protest in the form of an object is quite a committed act and has often, both in the past and present, been one that risked death or imprisonment. Perhaps there would be nothing. But the response from the Museum departments was extraordinary. The material just kept coming, from across periods, cultures and locations, and the range was remarkable: carved doors from Nigeria, a scroll painting from China, shadow puppets from Turkey, a revolutionary print from France, a lacquer box from Burma and banknotes from all over the world.

I was lucky in that Tom Hockenhull from the Coins and Medals department was appointed the co-curator of the exhibition. He made me realize that money has frequently been used for dissent. The very tokens of authority that all regimes consider the evidence of their rule have been hijacked. Not only is this conceptually pleasing, but also what better way is there to get your message into circulation than to use the most widely circulated objects of all? There are coins and notes galore in the collection, defaced, tampered with and imitated, which are pocket-sized statements of subversion designed to be passed from person to person.

When seeing what all the departments had produced I was struck immediately by the variety in tone of the objects. There are some items that you can appreciate immediately, and then there are others that are so subtle it is almost impossible to understand them without explanation. A British satirical print from the eighteenth century showing John Bull, the embodiment of Britain, farting at a portrait of George III is not too difficult to decipher (pp. 14 & 67). Yet a beautiful picture of two innocent-looking owls from China (p. 188) reveals a story of 'animosity toward the proletarian cultural revolution' and an exchange between painter and critic that ended in a suicide. An Indian print that shows the goddess Kali wearing severed heads that look suspiciously European is obviously an anti-colonial statement (p. 101). But what is the significance

of the leopard on a raffia cloth from the Democratic Republic of Congo (p. 169), or the number '45' on an eighteenth-century British teapot (p. 131)? These objects need a little more explanation and context to reveal what their creators were up to, and why they were being more discreet.

There are also items that were not originally meant to be subversive but which were adapted or used to become a means of protest. There are shawls from Madagascar (p. 91), tunics from Sudan (p. 92) and sketches of umbrellas from Hong Kong (pp. 107–8). One of my favourite objects is an example of dissent more or less hiding in plain sight. I have passed it in the galleries and thought it was beautiful, but had no idea that there might be any hidden meaning within it. It is the Stonyhurst Salt (p. 120), an elaborate piece of tableware made from recycled reliquaries. The object was made in England in the 1570s, at a time when Catholic worship had been banned. It is passing itself off as a salt-cellar, but on closer examination this is clearly unconvincing. How many salt-cellars were made from silver gilt decorated with rock crystal, the symbol of Christ's purity, and rubies that look exactly like drops of blood and symbolized Christ's blood, which is represented by the wine Catholics drank at the now-forbidden mass? It is obviously a piece of outlawed Catholic ornamentation pretending to be something else. Presumably it gave its owners a huge amount of satisfaction at the dinner table.

Dissent clearly varies in terms of seriousness. There are some items that have posed a genuine threat to authority and other ones that are much sillier. But they all merit a second look because they show people questioning the status quo and refusing to accept what they are being told. They may have been hoping to overthrow the state, been letting off steam because they could not keep silent any more, or simply been trying to amuse each other. I have spent a career operating in the realms of the written word and in my satirical field you risk no more than the odd libel writ, a fine, or, if very unlucky, a prosecution for contempt. I'm always impressed by people in other societies and in past eras who have risked more – their lives, livelihoods, homes and families – in order just to say 'No'.

Dissent is also quite chaotic. It doesn't create a perfect narrative and it often doesn't present very coherent answers. I think if we challenged many of the people who created or adapted these objects to come up

with a clearly defined solution to the system they oppose, they would say that isn't the point. What we have gathered together in this exhibition is a group of objects from the Museum that firstly define what dissent, subversion and satire mean in material terms and then investigate the ways in which they are circulated, the extent to which they are tolerated or controlled, how subtle or blatant the execution is and the way they subvert official art or representation.

What is tantalizing about this exhibition is that we're glimpsing just the tip of a very large iceberg. The veiled nature of a lot of dissent means that so many stories will have been lost, and we can't identify veiled symbolism without having at least a little bit of historic context. Even today most political cartoons in newspapers need footnotes the week after they're published because everyone's already forgotten what happened. It only gets harder the further back in time that we go. But I think, obviously, that it can be very rewarding. I hope that after reading this book or visiting the exhibition people will be intrigued by the evidence of different narratives operating in what might look like a monolithic collection, and heartened by the presence and historical persistence of the dissenting voice. It is also exciting to think that we know everything about a particular object and then to find out (with a bit of expert research, obviously) that there are still discoveries to be made.

For me, though, the greatest pleasure is in seeing the evidence of that questioning spirit surviving, even if the humans responsible are long gone. The question you might leave the exhibition with, is why on earth do people do this? I suppose it is a release, a way of having some control over the world, an act of defiance. In the end, I think they do it because they can. And that seems to be the important thing. There is a delightful sense of fellow-feeling in seeing a garter from three hundred years ago saying 'Down with Rump' (pp. 88–89) and then a badge that says 'Dump Trump' (below). Perhaps one day that will be a museum piece also in need of an explanation.

Ian Hislop, 2018

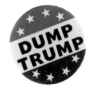

Right
A 'Dump Trump' badge from the
2016 US presidential election

INTRODUCTION

The objects in this book and associated exhibition, which have been selected by Ian Hislop, span a period of roughly three millennia and explore the 'alternative' side of history, offering fresh material insight into the ways in which humans subvert concepts of authority. Objects, both everyday items and finely crafted works of art, become subversive in different ways. They might have been created with deliberate intent or repurposed – adapted to incorporate a message or some other symbol of protest. Others have been turned into emblems of subversion by the context in which they were used. Sometimes the messages they convey are obvious and intended to be seen by the largest possible audience; on other occasions they have been concealed and the creator's motives left deliberately ambiguous. This presumably provided those responsible for making them with the defence, if it were required, that their work

Below
Detail of *Treason!!!*, Richard
Newton, 19 March 1798

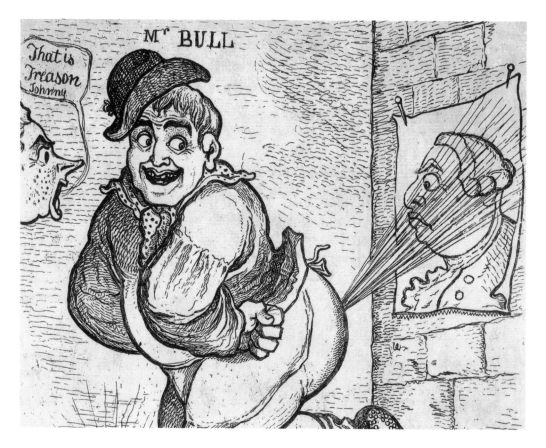

had been misinterpreted. Our aim from the outset was not necessarily to find world-changing acts of resistance, although we came across these as well, but rather, small acts of disobedience by ordinary people.

Some objects are subversive because of the imagery they carry, while in others the subversion is integral to its construction. They may incorporate secret symbolism, serving as beacons of hope in an otherwise hopeless situation, or convey gallows humour, an ability to laugh at some of life's injustices. Together they illustrate the plurality of the human condition, showing that someone, somewhere, will always try to puncture the serious voice of authority, or – to interpret an eighteenth-century satirical print literally – to fart in its face.

Many of the items in this catalogue are products of isolated acts of rebellion, independent of any organized network of resistance. The objectives underpinning some of these acts appear to have been absurdly trivial, others were intended to stay hidden; one can only guess at the motives of the individuals who created or adapted these things. Sometimes, objects, alongside performance, music and the visual arts, have been key markers of social and political change.[1] More often, perhaps, they reflect people trying to reassert or reclaim control, even in an infinitesimal way, of some aspect of their lives, or maybe they were simply amusing themselves by coming up with a witty pun directed at the ruler of the day. However, there is always the danger that the ideas they convey might become 'the explosive material for bursting the limits of the existing order'.[2]

There was a question in embarking on this project about whether we might read too much into the meaning of certain objects, and thus impose on them a false evaluation that people must have always, and without exception, ridiculed their masters. One such question arose over the interpretation of a medieval lead badge, an openwork design showing a man kneeling in front of a woman (p. 16). Below is possibly inscribed the word 'Mother', which, if correctly read, may be interpreted as a mocking reference to the power exercised over the boy-king Edward III by his mother, Queen Isabella, around the time of his coronation in 1327. This would add an intriguing political dimension to our understanding of medieval humour, and contemporary perceptions of kingship. Alternatively, it could say 'Mot. Here', or 'A meeting here'.

In which case, the image may be interpreted simply as that of a knight kneeling in front of his lover.[3] With the meaning of the badge being difficult to pin down, we decided against including it in the exhibition. There is potential ambiguity in several objects featured in this book, and we have tried to indicate other instances where we believe there may be more than one interpretation of an object's meaning, or where there remains uncertainty about the creator's intentions.

This book, mirroring the exhibition it accompanies, is divided into three sections. We begin by looking at overt challenges to authority, from performance to visual satire. They help us to define dissent and its boundaries. In the second section, we explore how objects – including

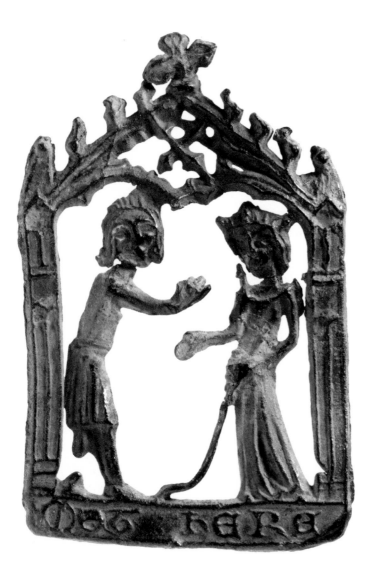

Left
Medieval badge purportedly showing a young Edward III kneeling in front of his mother, Queen Isabella, 14th century

Opposite
Detail of a door panel by Ar'owogun of Osí, Yoruba people, Nigeria, early 20th century

clothing and jewellery – have been used to convey symbolic meaning 'hidden in plain sight', often undecipherable except by those in the know. Building on the concealed aspects of dissent, the third and final section explores the role of the artist as activist, with a look at how imagery and iconography, through allegory and metaphor, can become a vehicle for political or social commentary. How, for example, does an image of a man on a motorbike, on a carved door from Nigeria, convey anti-colonial sentiment (below & p. 162)? To sum up, what follows is an exploration, and celebration, of the wit and ingenuity of those who have questioned the status quo, as told through the objects that they have left behind.

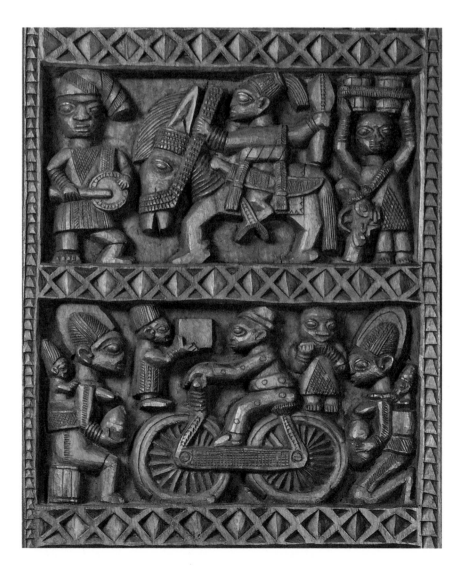

CHAPTER 1
GETTING AWAY WITH IT

Through the centuries, there have been numerous overt acts of subversion, either because those in power have tolerated them, or because an object has been made and circulated in such a way that suppression is all but impossible. These items offer insight into the ways in which rulers have either ignored, allowed, censored, or sometimes even encouraged, acts of disobedience. For example, permitting dissent, or at least the illusion of political criticism, can be a useful means of channelling and controlling the public mood, serving as a metaphorical safety valve on societal pressures. Allowing the politically disenfranchised to upset established hierarchies for a limited period or within strict boundaries can help to deflect attention from social realities.

Many overt acts of subversion can be quite witty. Humour has been put to great effect, becoming a stick with which to beat the powerful, with far more vigour and venom than would ever be permitted through sober critical commentary. Writing on the role of caricature from prison in 1833, the French satirical journalist, publisher and printmaker Charles Philipon (1800–1861) said that it 'takes all forms and characters; it plays all roles; it laughs, is harsh, mournful, or crazy; but it always has a wise reason to act thus. We use it in turn to make a mirror for the ridiculous, a whistle for the stupid, a whip for the wicked.'[1] As he noted, it acts as a mirror, reflecting back and thus exposing the flaws of leaders through wit and exaggeration. Or as Jonathan Swift (1667–1745) observed on satire, it functions 'to cure the vices of mankind'.[2]

Mocking or challenging authority has its risks. As Philipon and countless others have discovered, the boundaries of permissible behaviour can suddenly shift when there is an increase in the external pressures bearing down upon a political system. Uncontrolled and, therefore, potentially dangerous criticism of the political order is an ever-present possibility.[3] Material culture can inform our understanding of the invisible boundary that distinguishes a joke from slander or treason, acting as a barometer of political repression and censorship.

Louis XVI wears the *bonnet rouge*

This is very simple and very effective. The maker has merely taken a well-known picture of the King and shoved a revolutionary hat on it. The crown has been replaced by the symbol of the people. The effect is comical as the great Louis XVI is made to look as if he is a supporter of the revolution. Not so funny for him though – he was executed not long afterwards. **IH**

The saying 'ridicule kills' was popular in post-Revolutionary France.[4] Certainly, the crucial event of the late eighteenth century was the French Revolution of 1789 and eventual execution of Louis XVI on 21 January 1793, which served to raise the stakes of political criticism. The destruction of the Bourbon monarchy began through a campaign of public mockery. Such acts undermined the traditional authority enjoyed by the monarchy and reduced the status of the French king to that of an ordinary man.[5] This is an altered version of a conventional portrait by Joseph Boze (1745–1826), engraved in about 1785–89. A Phrygian cap, traditionally given to freed slaves and therefore associated with liberty, has been added, alluding to one of the defining events of the French Revolution when, on 20 June 1792, the Tuileries Palace was invaded by the revolutionary armed guard. After overpowering the Swiss Guard, the insurgents forced Louis XVI to don the *bonnet rouge*, or red cap, and appear before a crowd to toast the health of the nation. Seven months later, the King was dead.

Right
An altered version of a portrait of Louis XVI, King of France, wearing the *bonnet rouge*. After Joseph Boze, 1792 or later

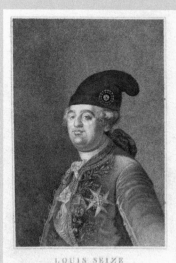

LOUIS SEIZE
ROI DE FRANCAIS

How do you circulate a subversive slogan without social media or a campaign fund to pay for the cost of distribution? It isn't easy to disseminate a message beyond a sympathetic group of friends and allies to the broadest possible audience, and it becomes even harder if all criticism of authority happens to be banned. Addressing the challenges of printing and distribution, for example, between 1933 and 1945, exiled political groups tried to keep the spirit of resistance alive in Germany by producing and smuggling in anti-Nazi booklets and periodicals. Known as *Tarnschriften*, 'camouflaged writing', the front and back pages of these pamphlets were disguised with fake covers indicating cookery books, health and safety manuals and English textbooks, which made it harder to detect them. The campaign was deemed a success, not least because it was a cause of immense irritation to the authorities.

Left
A fake cover in the guise of
a health and safety manual for
the anti-Nazi pamphlet 'Freiheit',
January 1938

Below left
The playful use of bright colours on the back of a 1967 British penny brings an element of levity to an otherwise serious message of criticism of the BBC

Below right
The back of a re-engraved 1797 penny shows a figure representing the Pope hanging from the gallows

The *Tarnschriften* campaign was highly sophisticated, utilizing a large network of writers, printers and distributors inside and beyond Germany. Most subversive campaigns have been far simpler, with activists exploiting the materials and means of circulation that are most readily available. For example, defacing a coin or note has often been the most effective way of anonymously transmitting a message, akin to portable graffiti. As with all anonymous protests, the uncertainty of not knowing who or what is behind a message, whether a lone crank or an organized movement, may increase its potential danger from the perspective of the authorities.[6] Currency embodies many complex notions of state and nationhood, and the manipulation of its design can symbolize a physical attack on the political authority that issues it. The messages of a political or semi-political nature that these items convey are not usually ambiguous, but the seriousness of their intent and the motives that inspire such activism can be less easy to ascertain.

'[Hang] The Pope'

British pennies minted at the Soho Mint in Birmingham in 1797 and nicknamed 'cartwheels', owing to their large diameter, were a popular target for protest messages. The crude design engraved into this coin (below right) was either a general expression of anti-Catholic sentiment or a pro-revolutionary statement by British radicals. Both Pope Pius VI and his successor Pius VII opposed Napoleon Bonaparte. Pius VI was captured and taken to France in 1798, where he died in 1799, and Pius VII was arrested and exiled to Savona in northern Italy between 1809 and 1813. The message on this coin may, therefore, have been a call for an end to the lenient treatment of either of these captive popes.

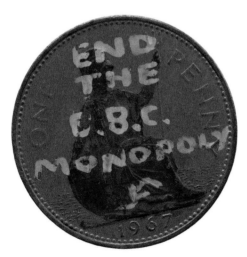

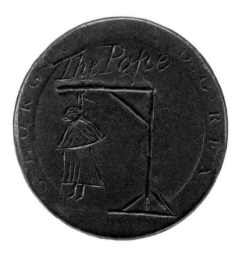

'No landlords, you fools/Spence's Plan forever'

For whom do we toil and feed with our spoil?
Is now through the nations the cry,
Infuriate men sing, till heaven's concave ring,
O, give me death or liberty!
My brave boys.
O give me death or liberty!

From 'The Downfall of Feudal Tyranny' by Thomas Spence, published in *Pigs' Meat*, 1795

A champion of the common man, woman and child, the name of the Newcastle-born radical Thomas Spence (1750–1814) 'was synonymous with ultra-radical opinion' in the early nineteenth century.[7] Spence's Plan advocated equal distribution of wealth and revenues from land rent, a profoundly provocative suggestion in an era already troubled by political instability. It also ran counter to prevailing economic thought, which argued that redistribution of wealth would not alleviate the problem of poverty, serving merely to increase the number of poor.[8]

Left
The head of George III is over-stamped with a protest message on the front of this 1797 penny

Below left and right
A Spence token from 1796 showing a corpse hanging from the gallows is a barely concealed attack on Prime Minister William Pitt the Younger. The inscription on the back reads 'Such is the reward of tyrants'

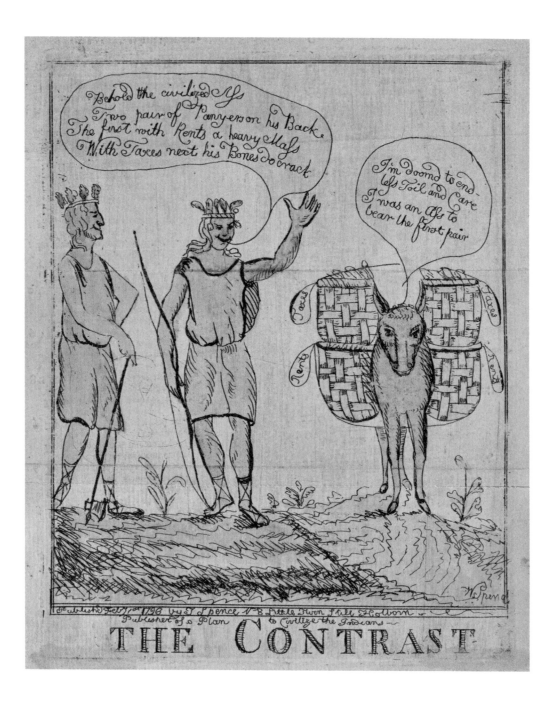

Above

The Contrast, a satirical print
from the frontispiece of Thomas
Spence's *Pigs' Meat*, 1795

Shown here is a large 1797 'cartwheel' penny defaced with one of Spence's slogans, 'No landlords you fools', and the line 'Spence's Plan forever', as well as one of Spence's tokens. In Britain in the late eighteenth century a chronic shortage of small change led many private companies and enterprising individuals to produce their own coinage. Spence issued tokens engraved with political messages, imagery and slogans.[9] Counting among the most confrontational is a farthing-sized piece from 1796 showing a corpse hanging from a gallows with torture instruments on the ground below. The accompanying inscription and pictogram, 'End of P [a human eye] T', is a barely concealed attack on British Prime Minister William Pitt the Younger (1759–1806).[10]

Coinage was just one of Spence's methods of circulating his ideas. Realizing the value in using as many different media as possible, he published a weekly journal, *Pigs' Meat* (1793–95), and sold the works of others, at first from his Chancery Lane bookstall until he was evicted, and then from a shop on Holborn. He chalked graffiti and encouraged others to do the same, and the slogan 'Spence's Plan' could reportedly be found daubed on walls across London. He also wrote popular ballads. Spence was a member and co-organizer of several radical societies, the most well known being the London Corresponding Society, founded in 1792. Its broad platform crystallized around a plan, originally put forward by the Duke of Richmond, for parliamentary reform based on annual parliaments and universal suffrage (for men). A key means of achieving their ends, the society's founder wrote, was publicity: 'the more public the better'.[11] The society's activities were heavily curtailed by the Seditious Meetings Act of 1795, and banned altogether in 1799.

Spence was arrested and imprisoned many times, including on charges of High Treason and Seditious Libel. These spells in prison took their toll and in later years, although he remained politically active, he was plagued by ill health. He died in poverty in London in 1814. During his lifetime, he had attracted many adherents to his political ideology and a great deal of suspicion from the government. Three years after his death an Act of Parliament was passed prohibiting any club or society that called itself 'Spencean'.[12] Despite being banned, his ideology would remain influential, and he later became a hero to a new generation of reformers, radicals and revolutionaries including Robert Owen, founder of the cooperative movement, the Chartists, Karl Marx and Friedrich Engels.

'Votes for Women'

> The coin of the realm is a potent symbol of authority, which makes it the perfect target for an act of defiance. 'Votes for Women' stamped on the male monarch's head makes a suitably direct statement. Whenever I see this object I think of the phrase 'A penny for your thoughts'. No one at the time seemed to care what women were thinking, so someone helped, by putting their main demand on a coin. **IH**

The First World War is commonly perceived as marking the end of an era, when the sun finally set on the Victorian golden age: 'never such innocence, never before or since', to use the oft-quoted words from Larkin's poem 'MCMXIV' [1914]. Yet this is a romanticized and superficial view of the British pre-war political landscape that avoids the reality, which was of a country beset by domestic crises and civil disorder. It included anarchist violence, the beginnings of the Troubles in Ireland and, chief among them, the campaign for women's suffrage.

This coin is an ordinary 1903 British penny, defaced with the suffragette slogan 'Votes for Women'. The coin had been in circulation for about ten years before it was defaced using a hammer and letter punches, of the sort one would use in a workshop to create identity tags, to mark ownership of one's tools, for example. This was just before the outbreak of the First World War, and it was thought at the time

Right
This 1903 penny is thought to have been defaced with the suffragette slogan 'Votes for Women' in 1913–14

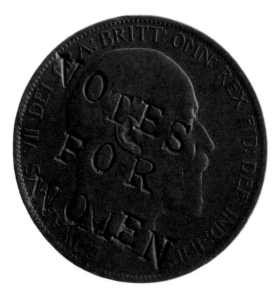

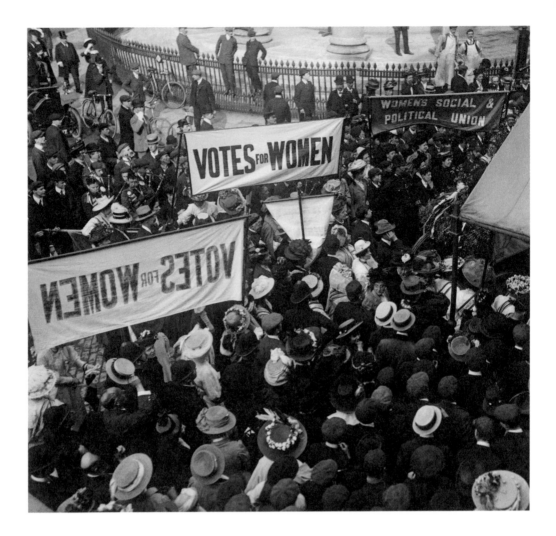

that the suffragettes had copied the practice from anarchists, who were also defacing coins, as attested by a contemporary newspaper report:

> An unusual method of defacing the coinage has just come to light. Anarchists throughout England have lately adopted a novel propaganda; coins passing through their hands are stamped with the words 'Vive l'Anarchie' before being placed in circulation again. It is said that militant suffragists have expressed themselves in favour of adopting a similar scheme. Presumably they are aware that defacing coins of the realm is an offence.[13]

Most 'Votes for Women' defaced coins were put back into circulation, while others were pierced and turned into jewellery, worn either as necklaces or attached to watch chains. Precisely how many coins were defaced is unknown, but it is not likely to have been many. This was,

after all, an unsophisticated process, probably carried out by a single person using just one set of individual letter punches. It would have been repetitive and time-consuming, requiring hours of patient work. The perpetrator has never been traced, and no direct connection has ever been established between the coins and the Women's Social and Political Union (WSPU), or other suffrage societies.

The deliberate targeting of the King, as both constitutional monarch and head of the Church of England, could be likened to iconoclasm, and seen as part of a direct assault on the male authority figures that were perceived to be upholding the laws of the country. Britain's constitutional monarchy was certainly no stranger to suffragette activism in the period 1913–14. In July 1913, suffragettes planted bombs to 'welcome' the King and Queen during their visit to Lancashire. On 21 May 1914, an attempt to present King George V with a petition ended in a pitched battle between suffragettes and the police outside Buckingham Palace. Suffragette militarism or 'direct action', as it was known, was also characterized by the destruction of cultural property. In March 1914, Diego Velázquez's 'Rokeby Venus' was slashed at the National Gallery, and in May the British Museum was also targeted when glass display cases in the Oriental galleries were smashed by a suffragette wielding a meat cleaver.[14] The simple act of defacing a coin might appear trivial in comparison with these more serious acts of sedition, but it nevertheless conveyed the same symbolic message of protest against a government that refused women the vote.

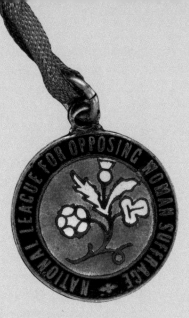

Badge for the National League for Opposing Woman Suffrage

This is a sort of companion object for the suffragette penny. History turned the dissenters into the mainstream and the mainstream into obscurity. Or so we think in the confidence of the present, but it's worth remembering that women only got to vote in municipal elections in Saudi Arabia in 2015. IH

The organizations that opposed women's suffrage in Britain are often overlooked, relics from the wrong side of history, arguing for a cause that would come to be regarded as 'hopelessly indefensible'.[15] Nevertheless, there was considerable public opposition to women's suffrage prior to the Representation of the People Act of 1918, which gave the vote to about 8.5 million women aged over 30. By 1914 the National League for Opposing Woman Suffrage, whose badge is illustrated here, had a membership far greater than the Women's Social and Political Union (WSPU). Moreover, most of its members were female.

Women opposed universal suffrage for numerous reasons, mainly emanating from a fear of upsetting the status quo. Many members of anti-suffrage societies were the wives of members of the elite, but female opposition to women's suffrage was not altogether restricted to the upper classes. Some blamed declining birth rates on the rise of feminism, and feared that a woman's central role within the family

Above
An enamelled badge and ribbon, with a depiction of an English rose, Scottish thistle and Irish shamrock growing from the same plant, issued by the National League for Opposing Woman Suffrage, c. 1910–18. The official flowers of three of the constituent nations of the United Kingdom also appeared in pro-suffrage WSPU designs

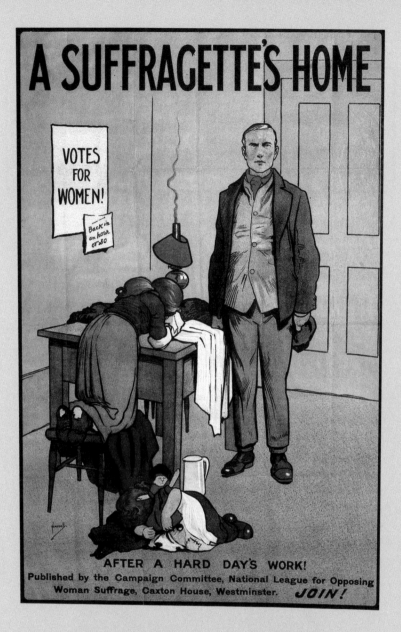

Above

A Suffragette's Home, John Hassall, published by the National League for Opposing Woman Suffrage in 1912

was under threat. Some believed that it would compromise the other gains that women had made, the 'special privileges' being pushed for by unions that included a reduction in women's working hours.[16] For others, opposition was rooted in the behaviour of women (and men) involved in pro-suffrage organizations. Women were frightened by those who advocated militancy, agreeing with their male counterparts that it proved that the female vote would be dangerous and unpredictable if they were ever to gain it.

After the 1918 Act, realizing that their cause was lost, leaders of the National League for Opposing Woman Suffrage disbanded the organization. Women gained equal voting rights in Britain in 1928.

'Nazi'

We are so used to seeing swastikas as graffiti daubed on buildings by the modern far right that it comes as a bit of a surprise to see the symbol used not as an affirmation, but as criticism. In 1934, the *Daily Mail* carried the headline 'Hoorah for the Blackshirts'. This is a more modest statement of the opposing view. **IH**

In Britain, legislation against defacement was originally enacted to halt the commercial stamping of coins by advertisers, rather than political messages, and there have been no recorded prosecutions for at least a century.[17] Defacing coins seems, therefore, to be the perfect way to put a message into circulation and to ensure that it is seen by the broadest possible demographic. The main risk appears to be financial – that coins thus defaced won't be accepted as tender.

The message on this 1937 UK florin errs on the side of commentary, rather than a call for change. The swastika was crudely executed using a single letter 'L' punch. This and its accompanying inscription, 'Nazi', may refer to the German heritage of the royal family or, possibly, the alleged pro-fascist sympathies of King George VI's elder brother, who had recently abdicated the throne. No coins bearing the portrait of King Edward VIII were ever issued in the UK (his reign was too short), which might explain why his successor's effigy bore the brunt of the attack instead.

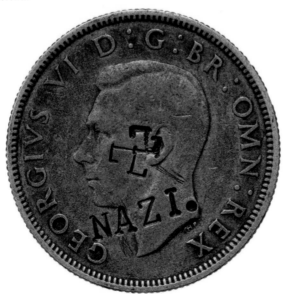

Left
1937 UK florin defaced with a swastika and the word 'Nazi'

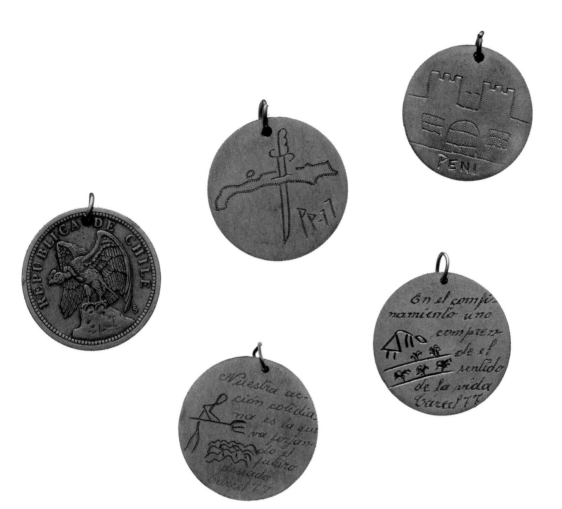

Re-engraved Chilean pesos,
pierced and with loops attached
for suspension. The unaltered
front shows a condor perched
on a rock, while the back of
these four coins alludes to the
incarceration of their engraver,
'Garcel', in 1977

'In confinement, one understands the meaning of life'

Sometimes defacing a coin is not just the best, but the only means of
circulating a subversive message. The messages and motifs on these
pesos suggest that their engraver was incarcerated in Chile at the time.
They have been abraded smooth and the style of the engraving –
chased in a distinctive stipple technique – is commonly found on coins
re-engraved by prisoners. It was likely achieved using a pebble and nail,
rather than hard-to-obtain engraving tools. The coins, some of which
are signed and dated, 'Garcel [19]77', have at least eight distinct designs,
mostly referring to political oppression and confinement. They include
the image of a dagger through a map of Chile and, on another, an
engraving of a prison, 'peni[tenciario]'. The inscription on one coin
reads 'En el confinamiento uno comprende el sentido de la vida', 'In
confinement one understands the meaning of life'. A further example
somewhat ambiguously refers to war shaping the 'desired future'.[18] The
motives, identity and fate of the enigmatic 'Garcel' may never be known.

Defaced banknotes

States operate different rules about defacing current tender. In many countries including the UK, all Eurozone nations and China, whose notes are shown here, it is against the law to deface a current coin or banknote, although the chances of being caught are usually minimal. However, currency thus tampered with is removed from circulation by banks and destroyed, which means that a defaced note is unlikely to be in use for long.

> The advantages of coins in terms of their status and dissemination are shared by banknotes – with the added bonus that it is even easier to adapt them to the purpose of dissent. You don't need a sharp object, just a pen. **IH**

The Chinese note, dated 1999, has an over-stamped message criticizing the ruling Communist Party. [19] The Bank of England £20 note was defaced leading up to the EU referendum in June 2016. The €5 notes illustrated on p. 36 were defaced in 2014 by a designer known publicly only by his first name, Stefanos. Protesting the ongoing Greek government debt crisis, he drew tiny ink silhouettes on the notes, subtle enough that he could slip them back into circulation almost

Below
A Chinese 1 yuan note from 1999, over-stamped in green with a message critical of the ruling Communist Party

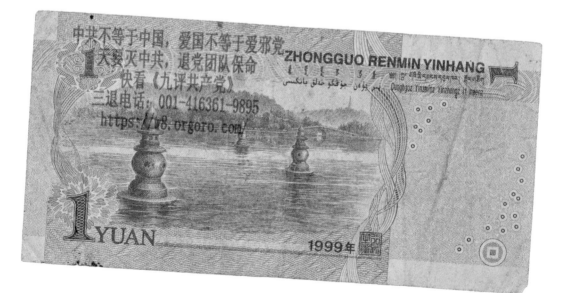

unnoticed. They show an ominous figure of Death and, on another, people being sucked into a vortex. Stefanos has described his project as 'hacking' and explained that he wanted his message to be heard beyond Greece, throughout the European Union. Pointing out that the euro is effectively an official European document that is in cross-border circulation, he has stated that the medium 'allows me to spread my imagery from the comfort of my home'.[20]

In the USA defacing currency is not illegal, and if a note is still legible it can circulate indefinitely bearing a message or slogan. The dollar bills illustrated on p. 37, each bearing multiple messages, had both circulated for a long time. The messages they carry, mostly written in biro, include 'Obamacare – this lie can't fly', criticizing the Affordable Care Act (2010) – an anti-abortion message and, the conspiracy theorists' favourite, 'the C.I.A. murdered Kennedy'.

Acts of iconoclasm have been perpetrated against many fallen leaders in history. Imperial Rome, for example, practised *damnatio memoriae*, condemning the memory of 'bad' emperors by pulling down their statues and erasing their names from monuments. Similarly, after the fall of Muammar al-Gaddafi's regime and his summary execution in Libya in 2011, statues of the dead leader were torn down in the capital, Tripoli. It was also customary to deface banknotes bearing his portrait, such as the note shown on p. 37, in which the face of Gaddafi has been torn out completely.[21] Whoever did it was careful to preserve the rest of the note so that it could still be used as money.

Below
Detail of a Bank of England £20 note, defaced ahead of the EU referendum held on 23 June 2016 with the words 'Stay in the EU'

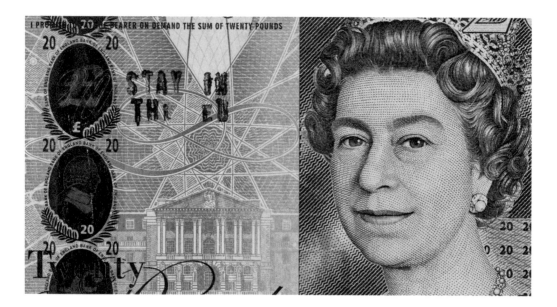

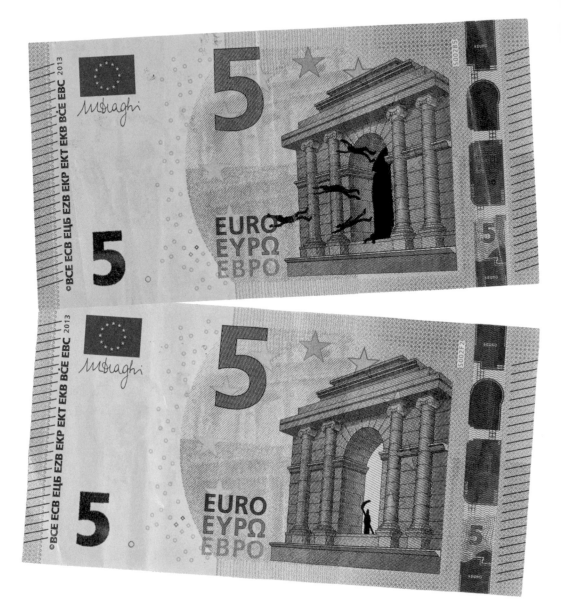

Above
Two €5 banknotes defaced with
tiny ink silhouettes in 2014 by
a designer known as Stefanos
protest the ongoing Greek
government debt crisis

Opposite above
US $1 and $10 bills, each
bearing multiple messages,
mostly written in biro

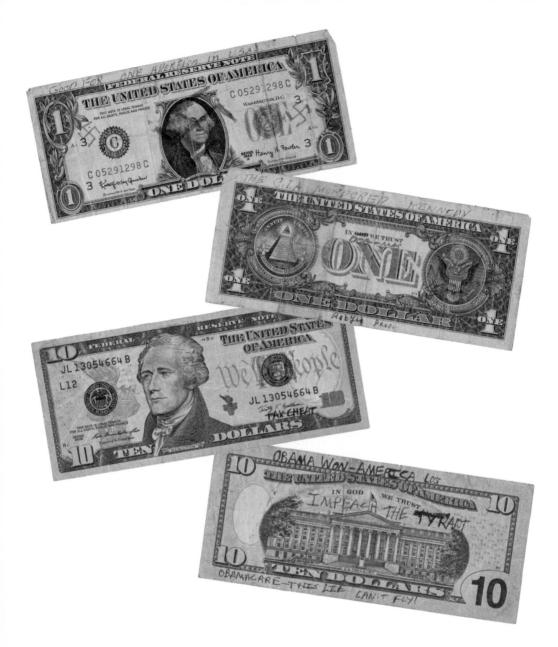

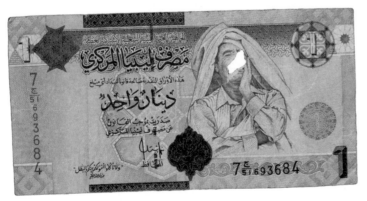

Left
1 dinar Libyan banknote, from which the face of Muammar al-Gaddafi has been torn

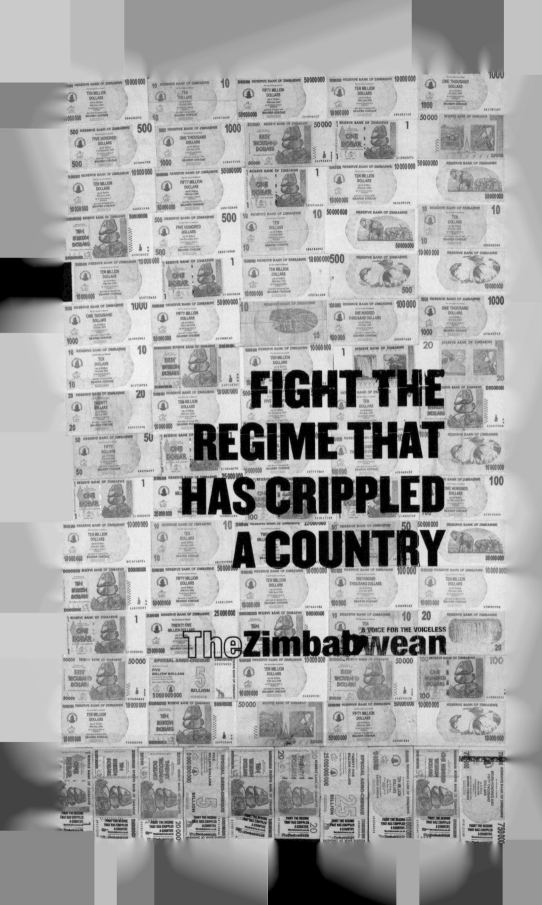

FIGHT THE
REGIME THAT
HAS CRIPPLED
A COUNTRY

A VOICE FOR THE VOICELESS
TheZimbabwean

Opposite

A poster made from Zimbabwean
banknotes for *The Zimbabwean*,
a newspaper established in
South Africa, highlighted the
plight of Zimbabwe's population
in the face of staggering levels
of inflation in 2009

'Fight the regime that has crippled a country'

Sometimes the only way a protest message can circulate is in exile.
From a distance, the first thing one notices on this poster is the bold
inscription, 'Fight the regime that has crippled a country'. As one
moves closer it becomes clear that the poster is composed from dozens
of real banknotes. The currency is Zimbabwean dollars, and the
amounts on the bills are astounding. There are notes for 200,000
dollars, fifty million dollars, and five, twenty and even fifty billion
dollars. Out-of-control inflation struck Zimbabwe in 2007–8, after
the government's controversial step to seize private land from white
landowners. As inflation rose, simply paying for a bus fare could require
handing over bundles of fifty billion dollar notes. At the height of
the crisis the government started printing 100 trillion dollar notes.

The poster was created in 2009 for the independent newspaper
The Zimbabwean, established in South Africa by exiled journalist Wilf
Mbanga. This was at the height of strict anti-press laws in Zimbabwe
when, as one journalist observed, printing presses were being blown

Right
Cover of *Private Eye*, 27 June
2008, referring to the Zimbabwe
presidential run-off. Robert
Mugabe's opponent, Morgan
Tsvangirai withdrew, claiming
widespread intimidation of his
supporters

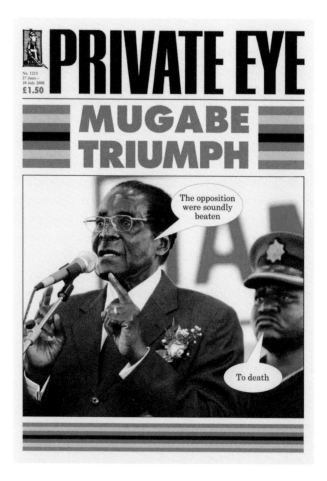

up and newspapers outlawed and closed down. Journalists, editors, reporters, photographers and videographers were being arbitrarily imprisoned, beaten, tortured and even murdered, all part of an attempt by Zimbabwean President Robert Mugabe's regime to censor the free flow of information.[22]

Mbanga had realized that, despite there being strict anti-press laws in Zimbabwe, there were no restrictions on the importation of newspapers printed outside the country.[23] Having exploited this loophole to have his paper brought in from South Africa – although not without encountering significant resistance from the Zimbabwean police – it became a widely circulated voice of dissent against Mugabe's regime. In South Africa the newspaper tried to raise awareness of the economic situation in Zimbabwe through daring publicity campaigns, of which this poster is an example. Other stunts included plastering entire billboards in hyperinflation dollars, and handing out the notes in rush-hour traffic.

Below
Two badges relating to the 2016 US presidential election. 'Make America Gay Again' is a spoof of Donald Trump's campaign slogan, 'Make America Great Again'

Badges

Reducing expenditure in time and materials has long been a major challenge to overcome for groups or individuals as they seek to circulate a message. In the nineteenth century advances in manufacturing enabled the mass-production of cheaply struck base-metal medals bearing political slogans. The endless push for lower costs led in turn to the invention of the modern button badge in the 1890s. The US firm that invented them, Whitehead & Hoag, emphasized that their badges could be 'quickly put together at a minimum expense to the manufacturer and with a great saving of time and labor'.[24] The basic construction of the vast majority of badges, consisting of a piece of printed paper sandwiched between a layer of plastic and an alloy backing, has remained unchanged for more than a century. Badges are ostensibly worn to circulate a message or slogan, although their other purpose is as a form of self-expression, to both demonstrate and reinforce the opinions of the wearer.[25]

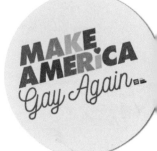

The badges illustrated here were created in the period since 2007. There is a simplicity to their design and an emphasis on the bold use of colours. Flags are popular, because they condense many complex notions of nationhood and belonging into simple blocks of colour. The Palestine flag and slogan, 'Free Palestine', has appeared on numerous badges over several decades. Sometimes, as with the 2014 referendum on Scottish independence, the badges of both sides of a campaign appropriate the same flag. The manufacturer – whose main motivation is often profit – may produce badges for both factions, as here. Slogans also get to the point quickly, even utilizing the same combination of words, such as those that incorporate the phrase 'lives

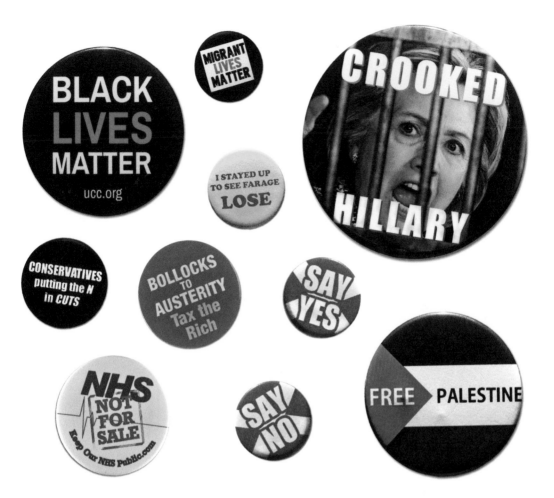

Badges from the UK and US relating to subjects as varied as the Scottish independence referendum of September 2014, the UK government austerity programme post-2010, privatization in the National Health Service and the Black Lives Matter movement

matter'. The repetition of the words serves to increase the impact of the message, giving a sense of solidarity to disparate groups who, nevertheless, have shared experiences of persecution.

In America the campaign badge has been a mainstay of presidential elections since the nineteenth century, although negative campaigning has witnessed growth mainly since the latter part of the twentieth century, beginning during the Watergate scandal in the early 1970s. The badges here are from the 2016 presidential election, widely regarded as one of the more vitriolic campaigns in US political history. From that election, an LGBTQ badge subverts presidential candidate Donald Trump's slogan of 'Make America Great Again', which itself was derived from a Ronald Reagan campaign slogan from 1980.

Despite their ability to convey a message, it would seem that not all badges are intended to attract attention. The ruder messages shown here, such as 'Conservatives, putting the "n" in cuts', are printed on badges with text so small as to be barely visible. Perhaps, therefore, they are marketed at people who want to amuse their friends, rather than make a very public statement that might offend strangers.

'Prepare for rebellion'
'Civil disobedience and peaceful resistance'

Grassroots movements are often unable to utilize common methods of advertisement such as poster and media campaigns because they lack funds and the necessary channels of distribution. From the 2000s onwards, the advent of social media has made it easier for protest groups to circulate prohibited ideas and messages, and to organize demonstrations. Protesting against the government of Bashar al-Assad, an art collective called 'The Syrian People Know Their Way' harnessed the power of social media in 2011 and 2012 to circulate posters. Digital files were sent via Facebook, so that they could then be downloaded, printed at home and turned into placards for marches.

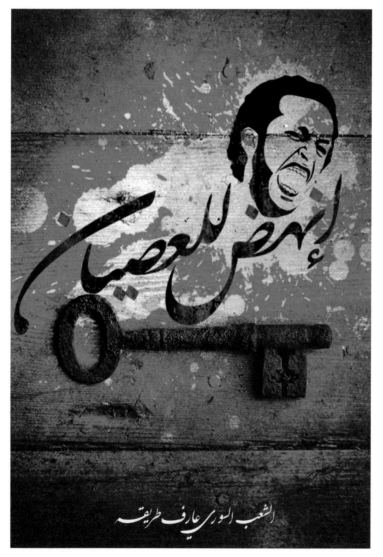

Left
A poster showing a stencil of a shouting face and an image of a key, produced by the art collective 'The Syrian People Know Their Way' in 2012. The slogan in white reads: 'Prepare for rebellion'

As with all channels of circulation, social media has its limitations. In the same year as the Syrian protests, the Egyptian government responded to negative reports in the international media about its bloody crackdown on protests in Cairo by temporarily cutting the country's Internet connection. Even with access to modern communication tools, protest movements and disaffected individuals have continued to engage with more traditional modes of disobedience, defacing public buildings with graffiti and currency with messages, symbols and slogans.

Right
A poster showing the silhouette of a person holding a catapult, produced by the art collective 'The Syrian People Know Their Way' in 2011. A slogan in Arabic calligraphy reads: 'Civil disobedience and peaceful resistance'

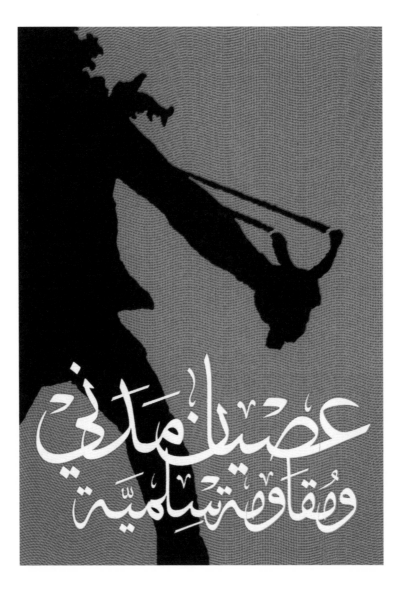

PUSHING THE BOUNDARIES

There are numerous manifestations of permitted dissent, in which traditional hierarchies are subverted, albeit within clearly defined parameters and for a fixed duration. Writing at the turn of the seventeenth century, the French lawyer Claude de Rubys said, 'it is sometimes expedient to allow the people to play the fool and make merry.'[26] Theatre and performance, for example, may provide a safe space in which people can act out their subversive fantasies, while numerous festivals have allowed for periods of 'merry-making', in which law and order is granted a temporary suspension. During such festivities the reign of anarchy is often tolerated under 'legal sufferance' by the authorities. As Noam Chomsky wrote: 'The smart way to keep people passive and obedient is to strictly limit the spectrum of acceptable opinion, but allow very lively debate within that spectrum – even encourage the more critical and dissident views.'[27]

Painted satirical papyri

The ancient Egyptians have such a legacy of gloomy, death-obsessed artefacts that it is a real pleasure to see what the workmen of the day were making during their breaks from creating yet more tombs and paintings of funeral rites for the pharaohs – funny animal drawings. These are not just Internet-style amusing cats but a sly parody of the immensely serious art they had to produce all day. **IH**

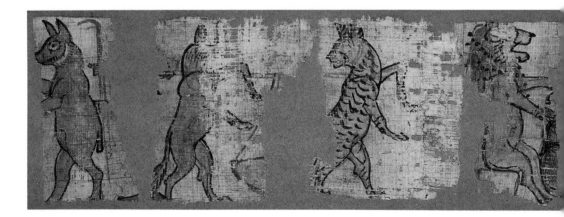

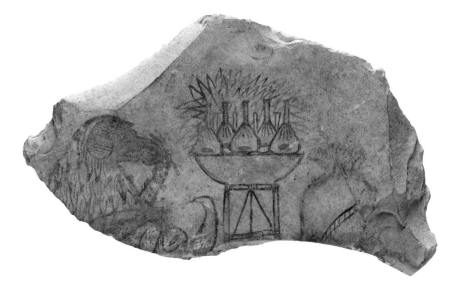

Above
Limestone ostracon with a scene depicting a monkey eating from a bowl filled with pomegranates, Egypt, Ramesside period (1307–1070 BC)

Below
Fragments of an illustrated papyrus showing animals engaged in human activities, Egypt, Ramesside period (1307–1070 BC)

A large body of material survives on papyri and *ostraca*, painted or inscribed limestone or pottery fragments, showing animals engaged in human activities. Most of it was excavated at Deir el-Medina, home to the artists who were employed by the pharaohs to construct and decorate the nearby tombs of the Valley of the Kings. These images upturn conventional hierarchies, upsetting the natural order of things, and for this reason they are commonly known as paintings of 'the world turned upside down'.

Illustrated here are two examples of 'the world turned upside down' from Egypt, including a painted papyrus fragment and a painted *ostracon*. The *ostracon* shows a monkey munching on pomegranates, whereas the papyrus is in the manner of formal painting and depicts a range of animals in human roles, imitating figures from funerary scenes.[28] In one picture we encounter an antelope and a lion, king of the beasts, sitting opposite each other playing *senet*, a game not dissimilar to modern draughts. Judging by the expression on the lion's

face, he seems to be winning.[29] Elsewhere on the fragment we encounter foxes herding goats, and a mouse sat on a high-backed chair being attended to by a cat, adjacent to a table loaded with offerings. In the latter part of the narrative a hippopotamus and an unidentified species of animal brew beer.

In the absence of accompanying literary texts the precise meaning of these paintings is unclear. We do not know, for example, if the animals illustrated were from popular stories or if they were meant to represent real people. What they do reveal is ordinary Egyptians' taste for absurdist humour, and perhaps a willingness to poke fun at the strict hierarchies that formed their society.

Opposite above
The cats castle besieged and stormed by the rats, published by John Overton, *c.* 1660

Opposite below
Detail from *The cats castle besieged and stormed by the rats* showing Master Tybet, Prince of Cat, guarding his castle from attack

The cats castle besieged and stormed by the rats, published by John Overton, c. 1660

The European tradition of 'the world turned upside down' is thought to have evolved independently from the ancient Egyptian tradition, possibly originating in the Middle Ages. This version appears to be the earliest known surviving English example of *The Cat's Castle*, first published by John Overton (1639/40–1713) in London around 1660.

Here, Prince Rat is shown storming a castle guarded by Master Tybet, Prince of Cat. From his field tent on the right, the rat directs his army to lay siege to the castle by land and by sea. An inscription at lower right reads 'if wee these cates can overcome and kill, of cheese and bacon we shall have our fill'.

By granting temporary licence to role reversal, the principles of 'world turned upside down' appear to subvert traditional hierarchies. Yet the absurdity of the notion that animals could take on the roles of humans merely serves to confirm the status quo, providing the 'opportunity to envisage such a revolution, and then to see how ridiculous it would be'.[30]

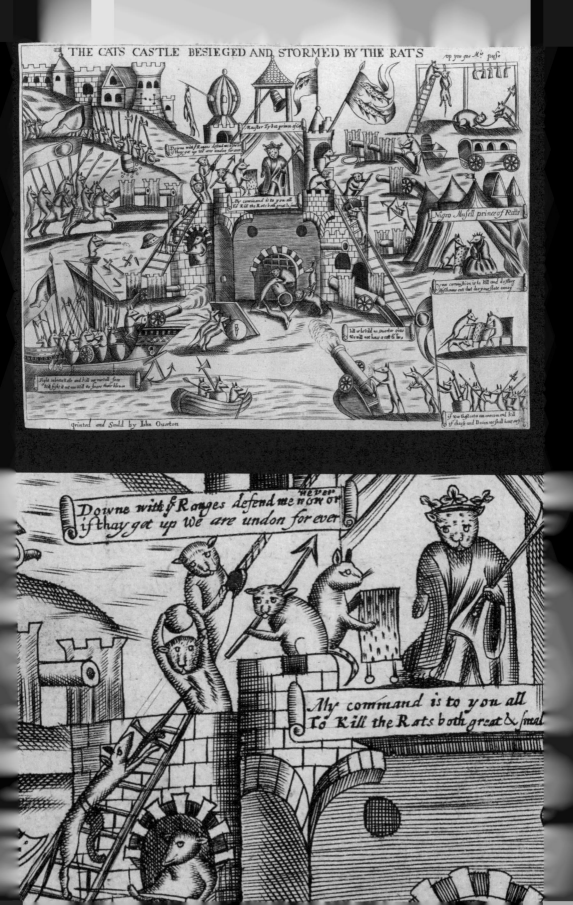

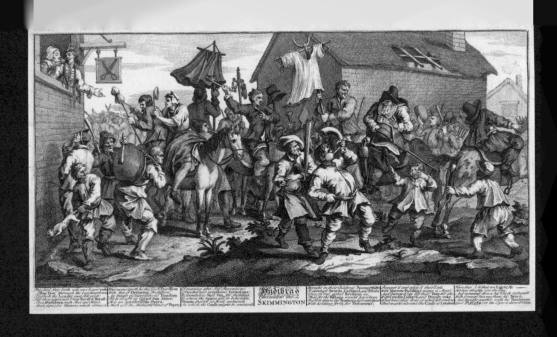

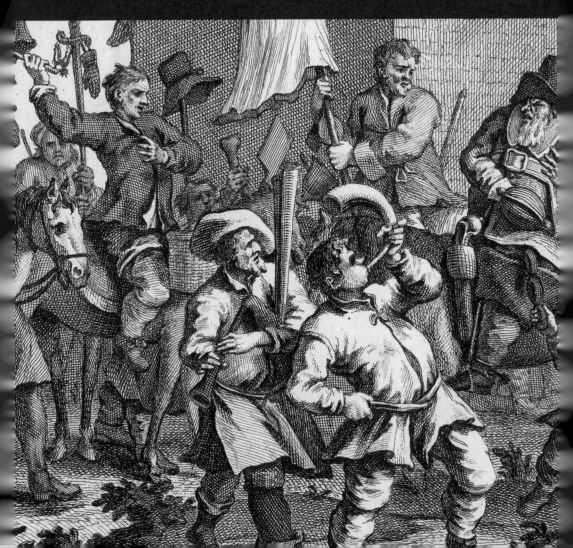

Hudibras encounters the Skimmington
William Hogarth, 1726

Charivari is a term for a folk custom known all over Europe, albeit
under different names and with variant themes. In England it was
usually known as a 'Skimmington', a 'Skimmington Ride' or simply
a 'Riding', and is illustrated in an engraving by the great satirical artist
William Hogarth (1697–1764). He engraved it for the 1727 edition of
Samuel Butler's satirical play *Hudibras*, about an errant knight. It
shows a riotous scene in which a shrewish wife and hen-pecked husband
are mocked by their neighbours. Cuckold's horns and a petticoat are held
aloft while 'rough music' is played, and a cat is thrown. Hudibras rides
into the crowd to protest at what he describes as a 'Devil's Procession'.

Originating in early modern France, charivari was once common
parlance to describe a custom that acted as a corrective to moral
behaviour that was disapproved of by the community. It routinely
began with a noisy procession accompanied by people banging on
pots and pans, hence another name, 'rough music'. Usually a baying
crowd, consisting mostly of young men, would gather at the dwelling
of the wrongdoer and make the person perform some humiliating act
of contrition. Sometimes, as shown in the Hogarth print, the 'rough
music' served to punish a violent and disorderly or unfaithful wife,
climaxing with the condemned woman being tied to a 'cucking-stool'
and paraded around to the jeers of the crowd. In some instances, the
stool was attached to a pole and the poor woman plunged into the
local pond. At other times the custom was associated with second
marriages, particularly if there was a significant disparity in the age
of the newlyweds. On these occasions charivari placated the dead wife
or husband, and any fines gathered might carry an important economic
function, since the children from the first marriage might need
financial compensation.[31] It was also a way for the young men of the
village to express their jealousy that a new bride had been plucked
from the pool of nubile women by an older man. The process could
follow this general outline:

> [The] recently remarried widower might find himself awakened
> by the clamor of the crowd, an effigy of his dead wife thrust
> up to his window and a likeness of himself, placed backward
> on an ass, drawn through the streets for his neighbors to see.
> Paying of a 'contribution' to the Lord of Misrule might quiet his
> youthful tormentors, but by that time the voices of village
> conscience had made their point.[32]

Part mob-rule, part madness and part recreation, in the view of the authorities a charivari developed from public nuisance to public disorder if it lasted for more than a couple of nights, or when dozens of young people joined in. Yet it was almost always localized in nature, with few links to broader rebellions or revolutionary movements.[33] Indeed, it was as much a part of the social fabric of a community, providing continuity and a marker of the stages of one's life, as it was an expression of anarchy. Continuing, in some places, until the mid-nineteenth century, its legacy was reflected in the title of the French satirical newspaper *Le Charivari*, first published by Charles Philipon in 1832 (see also pp. 158–60), and in the subtitle of its English counterpart, *Punch; or, the London charivari*.

In addition to charivari many otherwise solemn religious festivals have set aside time for merriment. For instance, Lent is preceded by Mardi Gras, while Ramadan concludes with Eid. In medieval Europe there was a tradition, linked to the Feast of Fools, in which children became 'Boy Bishops' for the duration of the festival. The 'clergy' would be made to attend mock masses and confessions and to lead an ass around the church.[34] They set up 'courts', issued their own 'coins' to spectators, and held judicial hearings for cases of ludicrous merit. The judgments that were passed down were not valid in the everyday world and yet real life 'was embedded in these carnivals…because Misrule always implies the Rule that it parodies'.[35] The organizations behind the festivities, usually local guilds, craft circles or families, were collectively known as the 'Abbeys of Misrule', and had origins as far back as the thirteenth century. The authorities for the most part tolerated the Abbeys of Misrule, though usually only because they turned over a portion of the fines they had gathered. The limits of legal acceptance were often breached, as evidenced by numerous edicts that were issued prohibiting masquerades, and the occasional arrests of 'abbots' for having criticized local officials a little too sharply.[36] From the mid-sixteenth century there were concerted attempts to abolish the Abbeys of Misrule altogether.

Glass goblet: Pantaloon

This glass goblet was made in Venice in about 1600. It is decorated with figures in masquerade, most likely from the *commedia dell'arte*, a popular component of the carnival in Venice where, using stock characters, travelling troupes of masked players would act out scenes of bawdy and licentious behaviour. They were often joined on stage by the organizers of the festivities, usually young males drawn from the wealthy elite. With their participation and encouragement, actors would mock the leading Venetian families. It became a running joke to portray the patriarch of these families, an otherwise important and influential man, as Pantalone, or Pantaloon, who is decrepit, sexually frustrated and senile. By doing so it gave the younger members of the family, who were constantly jockeying for power, the opportunity to mock their elders, granting them far greater influence than they could ever express in the real world.[37]

Below

A Venetian glass goblet with three enamelled figures in masquerade. Pantaloon (in blue) is pictured duelling with a servant (in yellow), *c.* 1600

Although of Italian origin, the *commedia dell'arte* was known all over Europe. In *The Merchant of Venice*, Shakespeare's Shylock shares some of Pantaloon's characteristics; he is an antisocial miser with a lazy servant and a daughter who longs to escape parental control.[38]

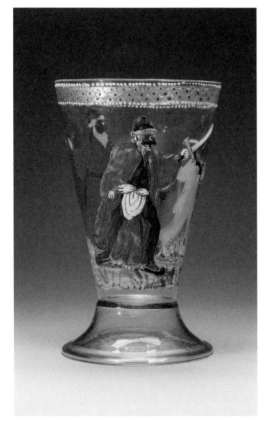
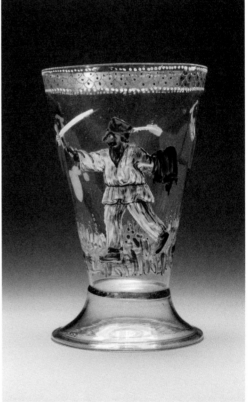

Karagöz and Hacivat

I was disappointed to find that *Spitting Image*, for which I wrote, was clearly nothing new – using puppets to deliver satirical points about current affairs and to make crude jokes about those in power was not as original as we thought when we were making the TV programme in the 1980s. However, I loved the idea that these puppet shows were most popular during Ramadan when everyone had been dutiful all day and needed a rather less high-minded break from their observances. **IH**

These shadow puppets are from Turkey, where there has been a popular tradition of shadow puppet theatre since the sixteenth century. The shows are given by a single puppeteer, who performs from behind a calico screen, which originally would have been backlit by candles, but is now usually replaced by electric lamps. The term 'shadow' is actually a little misleading because the puppets themselves are made from animal skin and are translucent, and when pressed against the calico their details are revealed to the audience. At the height of their popularity, between the sixteenth and nineteenth centuries, shadow theatre performances took place at a variety of celebrations including weddings and circumcisions as well as sultans' accessions. They were especially popular during Ramadan, the Muslim month of fasting, when people would retire to coffee houses in the evening to enjoy a show following the breaking of the fast.

Performances follow a specific structure commencing with an ad lib introductory dialogue between the lead characters, Karagöz and Hacivat, who are neighbours in Istanbul, and centre around some farcical plot. Next comes the main section with a fixed narrative, perhaps an epic poem, during which the two characters join the main cast, and the performance concludes with an unscripted epilogue. Karagöz and Hacivat are the typical odd couple: Karagöz is vulgar and yet cunning, whereas Hacivat is refined, well-spoken and plays by the rules. Performances incorporate slapstick and jokes, while the pair are supported by a cast of stereotypes of inhabitants of the Ottoman Empire, such as Arabs, Jews, Persians and Armenians. The largely unscripted introduction and epilogue give considerable freedom to the puppeteer, who can make the dialogue relevant to the audience by incorporating topical references, the 'news of the day' and salacious local gossip; and later, the epilogue applies the lessons learned by the central play's protagonists to contemporary events.

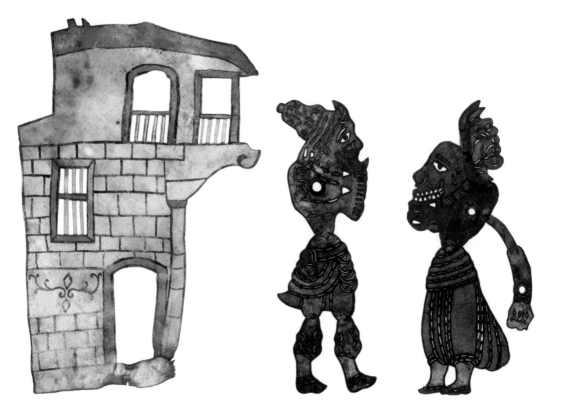

Above
Shadow puppets, Karagöz and
Hacivat, and a piece of scenery
used in traditional Turkish puppet
theatre, probably 19th or early
20th century

From their inception the shows were rather political. According to popular tradition, the first shadow puppet show was performed by a commoner who had been invited to the palace by the Sultan. Wanting to inform the Sultan about corruption among his ministers but afraid to speak out, the visitor instead communicated his complaint by giving a performance. Whether true or not, it indicates that political commentary was always considered integral to the shows. Indeed, they could be highly critical of a wide range of public figures including the Sultan's family, the Grand Vizier and other chief ministers, foreign ambassadors and army generals – if, for example, there had been a recent military defeat. The Sultan was usually exempt from direct criticism. Performances were also lewd, crude and offered a means by which the poorer classes, by identifying with Karagöz, could feel they were indirectly criticizing the higher classes. Akin to carnival, these shows subverted traditional hierarchies and power relations.[39] As a French visitor to Turkey in 1855 observed, 'a Karagöz show is a *risqué-revue*, as fearless as a militant newspaper'.[40] Political commentary was later banned, during the period of censorship imposed by Sultan Abdülaziz in the 1860s.

Karagöz (the name became shorthand for the Turkish version of shadow puppet theatre) spread throughout the Ottoman Empire to Syria, Egypt, Tunisia, Algeria and Greece, where it incorporated local characters and stereotypes. It became assimilated into local culture and yet retained its penchant for political commentary. In Algiers, for example, under French rule Karagöz shows expressed anti-colonial sentiment. In one scenario Karagöz beats French soldiers using a large phallus and Satan appears in a French uniform. All performances were banned there in 1843, although some continued in secret at rare intervals.[41] In Libya, political references in shows were banned after the Italian occupation in 1911.

Shadow puppet theatre shows suffered a decline in popularity in the twentieth century, not because of religious or political proscriptions, but due to the rise in film and television as an alternative form of entertainment. As with charivari, its political legacy continued in the name of a satirical newspaper, *Karagöz*, issued from the nineteenth century but particularly popular in the 1920s and 1930s. Since the 1970s shadow theatre has enjoyed a revival, but with less satirical content, as the two characters have been declared national cultural heritage by the Turkish authorities.

Day of the Dead figures

Everyone is mortal – even the wealthy, the powerful and the beautiful. Underneath the fine clothes and the trappings of success there is in the end merely a skeleton. The poor and the downtrodden might find this more comforting than the rich. **IH**

These papier mâché Day of the Dead figurines were made for parades in Mexico in the mid-1980s. Mexico's Day of the Dead celebration is most closely associated with the triduum Christian festival of Allhallowtide, comprising Halloween, which falls on 31 October, followed by All Saints Day and All Souls Day on 1 and 2 November. Traditionally it is a time of remembrance for saints, martyrs and all faithful Christians and in Mexico the festivities include parades and music combined with indigenous

Right
A papier mâché figurine in the form of a skeleton factory owner, used in Day of the Dead parades in Mexico, Pablo Morales, 1980s

Far right
A papier mâché figurine in the form of a skeleton 'Uncle Sam', used in Day of the Dead parades in Mexico, Linares family, 1980s

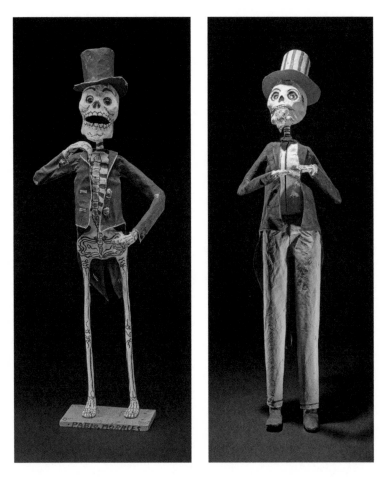

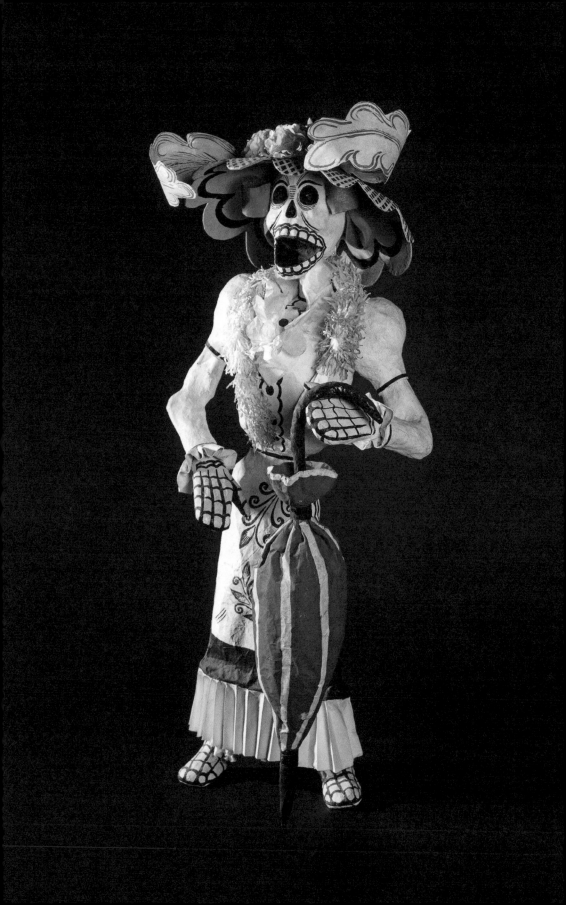

elements. The festival has developed a distinctive visual iconography dominated by skulls, calaveras (skeletons) and caskets, usually highly decorated and often humorous. Although not a direct descendent in the religious sense, in its modern incarnation the Day of the Dead nevertheless shares many characteristics with other festivals in which misrule and merriment are permitted, within certain boundaries, as well as 'the world turned upside down', particularly the subversion of traditional hierarchies and mockery of authority figures. The subjects are chosen to reflect contemporary world politics as well as local concerns. This could be anyone from the local factory owner to foreign powers. Illustrated here are skeleton caricatures of Uncle Sam, a factory owner and *La Calavera Catrina* ('elegant skeleton'), the design of the latter being based on a famous etching from 1910–13 by the celebrated Mexican artist José Guadalupe Posada (1852–1913).

Posada's purpose in creating *La Calavera Catrina* was, according to the distinguished Mexican poet Octavio Paz (1914–1998), to mock Mexican social mores: 'Posada does not want to reform or change society: he wants to portray it.'[42] Dressed in the costume of an upper-class European, the figure is a satirical portrait of aspirational Mexicans who, perhaps ashamed of their indigenous heritage, chose to emulate aristocratic behaviour. Posada used headwear as an indicator of sex, profession and social status in his prints and *La Calavera Catrina* is instantly recognizable owing to the overly elaborate and, by inference, ridiculous hat that she wears.[43]

IN YOUR FACE

In Britain over the course of the long eighteenth century, printmakers gradually refined the concept of satire, combining it with the Italian tradition of *caricatura* to produce what may be regarded as the first modern political caricatures. Early in the century, William Hogarth had shown that there was a market for expensive prints of topical subjects and the next generation of printmakers stripped back the complex literary iconography and simplified their designs to give sharp focus to their satire. Several publishers started to specialize in such material – sometimes dangerously political, sometimes merely witty digs at the celebrities of the day. The top end of the print trade was focused in the grander areas of London: S. W. Fores had a shop in Piccadilly; Hannah Humphrey in Bond Street and later in St James's. Others catered for a more bohemian audience in Covent Garden and Soho.[44] Today we regard the late Georgian period, 1760–1830, to be the heyday of the satirical print in Britain.

Satirical prints could target all manner of subjects and included leaders from both the main political parties. Another popular target was the monarchy, which had entered into a period of prolonged crisis during the unpopular and dysfunctional reigns of George III and his son George IV. The narcissism of many political leaders made them pleased to be included in any satirical print, but the monarchy felt at best bemused, and at worst genuinely wounded by such savage attacks. The Duke of Wellington once said that satires on the Prince of Wales (the future King George IV) damaged his esteem to such an extent that ridicule became his 'one fear'.[45] The Prince of Wales was in fact a prolific collector of satirical prints, though he avoided those in which the attacks were too personal.

It was understood that such images undermined the authority and the dignity of the royal family, but it was hard to prosecute without drawing attention to the print in question and giving more opportunity for mockery and derision. Libel prosecutions for images were much harder to pursue than for the printed word, owing to their visual ambiguity. From the 1790s onwards, satirical attacks on the monarchy achieved levels of audacity and outright rudeness not witnessed before or, perhaps, since. Publishers put up the money for production and attracted collectors to their shops, but the success of these works was dependent on the visual imagination and artistic skill of a small group of designer-printmakers, whose works were sold and copied throughout Europe, and are still sought after. Of these artists James Gillray was indisputably the most talented and the cruellest.

Fashionable Contrasts;–or–The Duchess's little Shoe yielding to the Magnitude of the Duke's Foot
James Gillray, 1792

Gillray knew what would sell a print – sex, the royal family and fashionable shoes…**IH**

George III's second son, Prince Frederick, Duke of York (1763–1827), about whom the famous nursery rhyme was written, was known to lose huge sums of money at cards. In 1791, a marriage was arranged for him with Princess Frederica of Prussia (1767–1820), who was

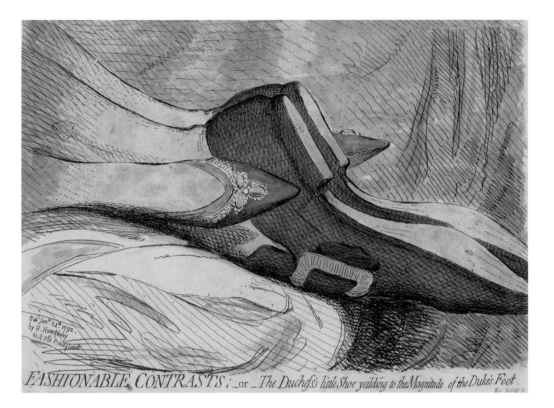

FASHIONABLE CONTRASTS; – or – The Duchess's little Shoe yielding to the Magnitude of the Duke's Foot.

Above
Fashionable Contrasts;-or-The Duchess's little Shoe yielding to the Magnitude of the Duke's Foot, James Gillray, 1792

expected to bring a dowry that would pay off his debts. In the event, she brought only £13,000, which was sadly inadequate. The marriage was not a success and the princess soon moved to live quietly in Surrey. Creditors pursued the duke's debts for more than twenty years after his death, but many never recovered their money.

Satirical prints at the time of the wedding played on the royal family's expectations of financial gain and also on the princess's diminutive stature, which caused fashionable ladies to attempt to squeeze their feet into shoes as small as hers. These famously tiny feet enabled Gillray to depict the newlyweds in their marital bed by this means alone, thereby avoiding a charge of obscenity even if there was no doubt about the couple's identity. Early impressions are extremely rare and the print must have been suppressed shortly after publication.

In 1809, when the duke was commander-in-chief of the army, a scandal brought him to the attention of the caricaturists again. It was revealed that Mary Anne Clarke, his mistress, had taken payment from officers promising that she could obtain promotion for them through her influence with the duke. As many as 200 satirical prints on the subject appeared and the duke was forced to resign his post.

A Voluptuary under the Horrors of Digestion
James Gillray, 1792

Attacks on gluttony, sexual amorality and reckless spending were as
popular in late-Georgian satire as they are in cartoons today. Here,
George, Prince of Wales (1762–1830), the future King George IV,
sprawls at a table, picking his teeth with a fork, his distended belly
bursting out of his waistcoat and breeches. On the table are the
remains of a joint of meat and decanters of port and brandy; empty
wine bottles lie on the floor and an overflowing chamber pot rests on
a stand, its contents dripping onto unpaid bills from the butcher and
baker. The shelf behind has remedies for piles and 'stinking breath' as
well as a box of Leake's Pills and a bottle of Velno's Vegetable Syrup,
famous cures for venereal disease. The doctor's (unpaid) bill lies below.
In the foreground a dice box has fallen beside a notebook in which
'Debts of Honor Unpaid' has been written; two other books suggest
that the prince has been gambling on horse races at Newmarket and
playing at the notorious card-table of Albinia Hobart and Lady
Archer. The view through the window shows the unfinished colonnade
of Carlton House, the opulent mansion that the prince had been
enlarging and filling with treasures for several years.

Hopeless with money, the prince had to be repeatedly bailed out by
the government. A grant from Parliament in 1787 to pay his debts of
over £200,000, including £60,000 for the completion of Carlton House,
had inspired another of Gillray's anti-royal prints, *Monstrous Craws*.
The present print with its pastel colouring and the soporific expression
of the prince might seem at first to be a gentler satire, but close
consideration shows that the attack is fiercely personal: the well-
dressed young man approaching his thirtieth birthday in a sumptuous
setting has the table manners of an uncouth peasant; he is an obese
drunkard; sexually promiscuous; a gambler who fails to pay his debts
and who abuses his credit with tradesmen; a spendthrift who knows
that Parliament will feel obliged to cover the cost of his extravagance.

In January 1796, Fores marked the birth of the Prince of Wales's
daughter, Princess Charlotte, by publishing Gillray's *The Presentation–or–
The Wise Men's Offering* showing the new father staggering drunkenly as
his Whig friends kiss the baby's bottom. The title gave the opportunity
for a charge of blasphemy against Gillray, Fores and James Phillips,
who worked for the printseller James Aitken. The charge seems to
have been dropped but it served as a warning and had the effect of
reducing the number of attacks on the royal family in satirical prints.

In the following year Gillray's loyalty was secured by a first annual
payment of £200 requiring him to produce prints in favour of
government policy. Thereafter, his prints about the royal family

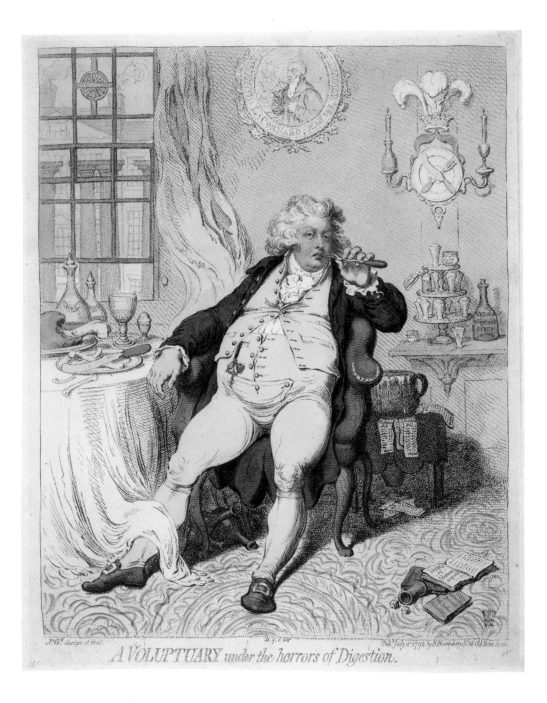

A VOLUPTUARY under the horrors of Digestion.

Above

A Voluptuary under the Horrors of Digestion, James Gillray, 1792

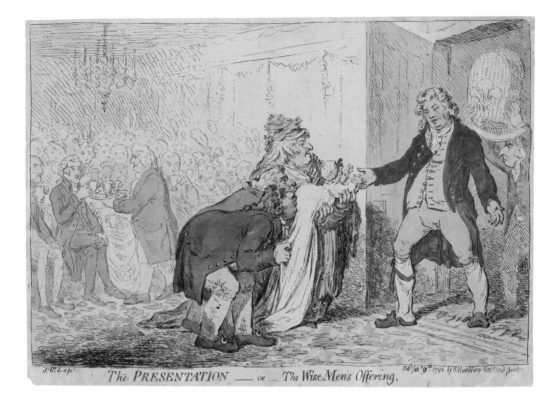

The PRESENTATION — or — The Wise Men's Offering.

became less obviously venomous. Some might argue that his designs became less adventurous once his targets were restricted, but his power as a propagandist is shown by the fact that Napoleon, whose height was average for the period, is remembered by the British as Gillray drew him: 'Little Boney', a tiny man with huge ambitions.

Above
The Presentation-or-The Wise Men's Offering, James Gillray, published 9 January 1796 by Hannah Humphrey

Opposite
Farmer Looby Manuring the Land, Anonymous, 1794–96

Farmer Looby Manuring the Land
Anonymous, 1794–96

Numerous caricaturists avoided difficulty with the law by publishing anonymously. This crude cheap print probably appeared in the mid-1790s when severe food shortages following the bad harvest of 1794 led to a rise of popular radicalism and riots in many parts of the country. King George III's supporters had represented him as the respectable 'Farmer George' in contrast to the indulgent lifestyles led by his sons, but here that image has been degraded. The Oxford English Dictionary defines a 'looby' as a 'lazy hulking fellow; a lout; an awkward, stupid, clownish person'. The 'looby' king defecates on the land, but 'has got wit' to profit from it ('to sack the golden grain'). The 'Toast' below calls for the overthrow of monarchies. 'Kate' who may take 'some care of these fine Lads' is Catherine the Great, Empress of Russia, renowned for her many lovers.

Farmer LOOBY manuring the Land.

1794. Dec

IS LOOBY only fit
To dung the verdant plain?
Yes, LOOBY has got wit
To fack the golden grain.

A TOAST.

MAY every Tyrant fall from power and ftate;
To be made Ploughmen quickly be their fate;
But that fome care of thefe fine Lads be taken,
May KATE be made to boil their broth and bacon.

Head–and Brains
Richard Newton, 1797

This is dangerous stuff. Chopped-off heads were very much in people's minds. There were, no doubt, those who wanted Newton's head on a plate. **IH**

By early 1797 the war with France had reached a turning point with Napoleon's first successes in Italy. Britain feared invasion and a campaign of loyalist propaganda prints was set in motion, but the young Richard Newton began to publish his own prints that were savagely critical of the government and royal family. This design for a print that was published on 5 May 1797 shows the Janus-like heads of King George III and William Pitt, Prime Minister since 1783, severed and served on a plate. Four years after the beheading of Louis XVI the subject is shocking and it is not surprising that the print itself survives in only one recorded impression. It must have been suppressed in Britain, but found its way to Paris where a copy was made in which the heads, still living, emerge from a single coat collar: George disdains any attempt at peace-making, 'La Paix Continentale Ouf!!!', while Pitt wonders how he can separate himself from this foolish king.

Above
Head–and Brains,
Richard Newton, 1797

Treason!!!
Richard Newton, 1798

> The English do love a joke about breaking wind. Newton's unsubtle joke is a perfect example of 'in your face' comedy: the country is depicted literally farting in the king's face. **IH**

In Britain in the late eighteenth century a nascent radical movement for parliamentary reform, drawing strength from developments in France and America, gave rise to the feeling that the end of entrenched privilege might be in sight. However, as violence in France increased with the mass execution of 'enemies' of the new regime during the Reign of Terror (1793–94), anxiety rose on the English side of the Channel. The British government, aided by loyalist societies all over the country, moved to suppress radicalism. Two 'Gagging Acts' against Treasonable Practices and Seditious Meetings were passed in 1795. William Holland, whose 'Caricature Rooms' in Oxford Street were something of a meeting place for raffish radicals, was imprisoned for a year for selling a pamphlet by Thomas Paine. Paine and other radicals were charged with seditious libel and many, including Thomas Spence (see pp. 24–26), endured lengthy prison sentences.[46]

This print by Richard Newton shows John Bull, the solid Englishman, farting at a print of George III whose disgusted reaction turns the portrait into a living caricature. William Pitt appears to the side, shouting in dismay: 'That is Treason Johnny'. In early 1798 the government was in difficulties, having dealt with naval mutinies, the threat of rebellion in Ireland, and anger from the wealthier classes about huge tax rises and the introduction of paper money in place of gold. Gillray was by now accepting payment to produce prints sympathetic to the aims of the government but Newton continued his opposition. He would surely have been prosecuted for this print, but he died of natural causes shortly after its publication, aged only 21.

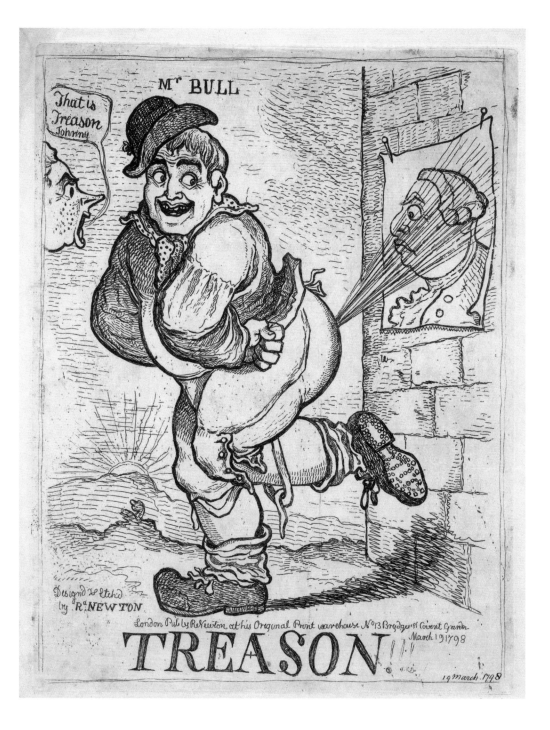

Above
Treason!!!, Richard
Newton, 1798

The Prince of Whales or the Fisherman at Anchor
George Cruikshank, 1812

George Cruikshank, the leading caricaturist of the next generation, hit hard at Napoleon and the French enemy, but he did not pull his punches when aiming at George III's dissolute and extravagant sons, especially George, Prince of Wales. With the collapse of the King's mental health in 1811 the prince had become Regent and his old Whig friends thought that they would take political power, but instead the prince kept the Tories in office.

In 1812, Cruikshank and his publisher embarked on a game of brinkmanship, producing a series of increasingly provocative prints about the Prince Regent. The first of these, *Princely Predilections*, was a satire on court gossip. The provocation did not go unnoticed: the Secretary of State is recorded to have consulted the Solicitor General about it, who replied that it was 'a most indecent and imprudent print but it would require so much of difficult explanation in stating it as a libel

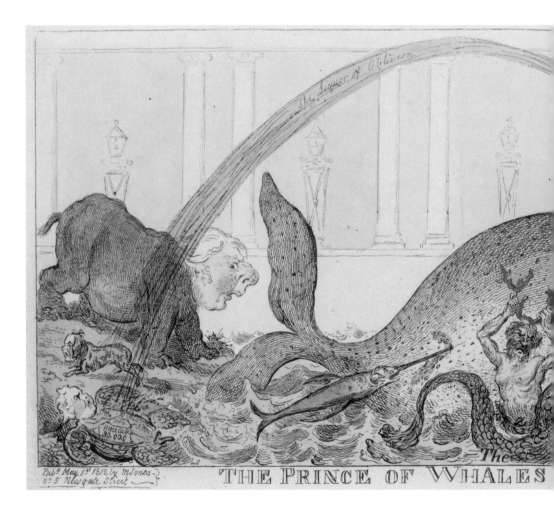

that it does not appear to us advisable to make it the subject of a criminal prosecution'.

The Prince of Whales or the Fisherman at Anchor, perhaps the most visually daring of the series, is a fold-out from *The Scourge*, or *Monthly Expositor of Imposture and Folly*, a current affairs magazine that ran from 1811 to 1815. Although claiming to be without political bias, the magazine often satirized the royal family and government, frequently by means of prints by the young George Cruikshank.

In this print, Cruikshank shows the Prince Regent as a huge whale swimming in 'The Sea of Politics' surrounded by creatures representing those who wished to enjoy his favour. He spouts 'The Liquor of Oblivion' over his old friends Lords Grenville and Grey and the politician playwright Richard Brinsley Sheridan while the golden 'Dew of Favor' falls over the Tories. Prime Minister Spencer Perceval has hooked the prince like a fish with a large anchor; a dolphin, a seal, an oyster, a shark, gudgeons and flat fish – all with the recognizable features of

Below
The Prince of Whales or the Fisherman at Anchor,
George Cruikshank, 1812

Tory politicians – crowd around eagerly. Notwithstanding his new political responsibilities, the prince only has eyes for his mistress, Lady Hertford, who appears as a mermaid; her husband, a merman, holds coral branches above his head like cuckold's horns. Meanwhile Mrs Fitzherbert, whom the prince had finally discarded after a relationship of thirty years, is vainly trying to attract his attention with a mirror. Cruikshank's composition was clearly inspired by Gillray's *New Morality* of 1798 (although that was a pro-government print), but the content was drawn from Charles Lamb's poem 'The Triumph of the Whale', which appeared in the radical journal the *Examiner* in March that year.

Between 1819 and 1822 George, as Regent and then King, spent around £2,600 attempting to suppress anti-royal satire, buying up plates, prints and copyrights from London publishers. This often succeeded only in encouraging the publication of even more offensive prints in the hope of a pay-off. He also bribed artists, and in June 1820 Cruikshank accepted payment of £100 'in consideration of a pledge not to caricature his majesty in any immoral situation'. Others took the money and carried on regardless, such as the radical printseller William Benbow. He was eventually arrested and charged with 'grotesque and ludicrous' seditious libels. The case was thrown out, but not before he had sat in prison for eight months, with the result that his business collapsed. Despite the money spent on bribes and attempted prosecutions, George IV continued to be plagued by satirical attacks for the rest of his reign.

NOT WHAT IT SEEMS?

Ridicule is generally regarded to be at its most effective when it is directed from below at the powerful and the privileged. The objects in this section were created to serve a different purpose, to harness the devastating potential of mockery to turn the public mood against those regarded by rulers as political enemies.

Smear campaigns are not an invention of modern politics and the methods deployed by political foes can resonate with our own times. Leaders are portrayed as weak, ineffectual, disrespectful of tradition, serial adulterers and financially irresponsible. By contrast, the instigator of such slander is (often hypocritically) depicted as a defender of liberty and a model of responsibility and moral virtue. In particular, men have long used sex and sexuality as a way of undermining powerful women.

The Verse Account of Nabonidus

It is extraordinary how much vitriol is contained in this innocent-looking piece of clay. This is a full-frontal attack on a ruler – but commissioned by another. IH

Overleaf left

A cuneiform tablet, known as the Verse Account of Nabonidus, which attacks the old king and praises the behaviour of the conquering king, Cyrus the Great, c. 539 BC

Overleaf right

A basalt stela, from which the name of Nabonidus, formerly to the right of the depiction of the king, has been removed, c. 539 BC. Agents of Cyrus appear to have missed the inscription of Nabonidus' name around the edge of the stela (not seen), possibly because it was housed in an alcove

Regime change often acts as a pressure relief valve for political discontent, presenting those who were disaffected under a previous ruler and legislation with the belated opportunity to vent their frustrations. The new ruling elite might even encourage protests aimed at their predecessor as a means of reinforcing their own claim to have effected real political change.

This cuneiform tablet is known as the Verse Account of Nabonidus, after the last king of the Neo-Babylonian Empire, 556–539 BC. It dates to around the time, or shortly after, he was deposed in a tumultuous series of events in Mesopotamia following the invasion of the Median king, Cyrus the Great, whose seat of power lay in what is now modern Iran. The tablet features a propaganda poem, an early recorded example of political slander, directed by Cyrus against the ruler he was in the process of vanquishing. Cyrus was politically astute and, like any successful modern politician, he knew how to exploit the weaknesses of his opposition. The verse tablet was part of a sophisticated campaign that sought to convince a potentially sceptical local population that the invading foreign king was better able to understand and respect Babylonian customs than their native ruler.

The verse is typical propaganda, attacking Nabonidus as a weak and ineffectual ruler and presenting Cyrus, by contrast, as the perfect king. It accuses Nabonidus of a range of evils, including blocking roads so that merchants could not pass, sacrificing his nobles in pointless wars, allowing arable land to go to waste, and various religious blasphemies. He is denounced, for example, for having pushed a deity called Sîn to prominence in opposition to the main Babylonian god Marduk, and for having built a temple to Sîn, described in the verse as 'a work of unholiness' that replicated the temple dedicated to Marduk at Babylon.[47] This was considered sacrilege.

The verse further records that Cyrus, having presented himself as the restorer of civil and cult structures, obliterated the physical memory of the deposed king by having his name erased from public monuments. One of these defaced monuments, an oval-topped stela now in the British Museum, has a blank space to the right of the depiction of the king where agents of Cyrus have carefully abraded the stonework to remove all written references to Nabonidus. The fate of Nabonidus is unknown, but unless he escaped into exile he was probably put to death.

First political caricature?

> The Assyrians were perfectly capable of producing beautiful statues but this seems to have been specifically designed to be ugly. It may be a very early political caricature, perhaps of a powerful courtesan whom the king had decided should be humiliated. If so, it's a very strange sort of thing to do, like an early version of 'revenge porn'. **IH**

This limestone statue of a female was excavated in Nineveh, in what is now modern Iraq, near an Assyrian temple dedicated to Ishtar, goddess of war, fertility and love. A cuneiform inscription on the back, now partly worn, enigmatically informs us that the Assyrian king Ashur-bel-kala (reigned 1074/3–1056 BC) erected this statue to provoke a reaction among the people. The inscription includes a joke curse, saying that anyone who attempts to remove the statue will be afflicted with a snake bite. It was once identified as Ishtar in her role as goddess of love, but by Assyrian standards of classical beauty its squat, rather plump frame renders it unattractive. Why, therefore, did the king commission a statue of a goddess for the enjoyment of the people, complete with a joke curse, that was aesthetically unappealing? A possible explanation for this rather odd situation is that the figure was intended to represent a caricature of a living person, perhaps a princess or courtesan who had betrayed the king. Rather than (or perhaps in addition to) having her executed, the king decided to distribute copies of this statue round the country as an act of public humiliation.

Opposite
Limestone statue of a woman, Assyria, 11th century BC

Opposite

Terracotta figure of a comic actor as Socrates, wearing a short tunic rolled down so that a swathe of drapery contains his large belly, Egypt, 3rd century BC

Caricature of Socrates

Greek comedy was an important outlet for political satire, sexual innuendo and for poking fun at well-known figures of the day. This statuette of a comic actor, with its distinctive pug nose and potbelly, is most likely a caricature of the philosopher Socrates (470/69–399 BC). He is lampooned in *The Clouds*, written by Aristophanes (*c.* 446–386 BC) in 423 BC. Aristophanes was a master satirist and succeeded in reducing the complex character of Socrates to that of a one-dimensional buffoon. In the play, Socrates makes his entrance in a basket suspended in mid-air, spouting the pseudo-philosophical explanation that 'I never could have rightly searched out celestial matters if I did not suspend my judgment and mingle my intellect with its kindred air'. He is impious, denying the existence of the pantheon of Olympian gods, and corrupts young Pheidippides, the story's central character. Under Socrates' guidance, Pheidippides learns how to defraud creditors, to defend father-beating, mother-beating and possibly also incest. In effect, he becomes a parody of Oedipus.[48] At the end of the play, Pheidippides' father restores piety and order by burning Socrates' 'think-tank' to the ground.

In a cruel instance of life imitating art, Socrates was put on trial by the city of Athens in 399 BC, charged of impiety and of corrupting the minds of youths. Athens at this time was on its knees, having suffered humiliating defeat in the Peloponnesian War and the subsequent loss of its empire. In these difficult times, the state demanded unquestioning obedience from its citizens. There was no tolerance for any self-determining moralist, especially one who advocated rational criticism of the social and political order, and Socrates was singled out as an inflammatory radical.[49]

In his trial speech Socrates referred to *The Clouds*. Acknowledging the hostility that the play had aroused towards him from the citizens of Athens, he contended that he 'comprehends nothing, either much or little' of this simplistic caricature.[50] It made little difference to the verdict: he was sentenced to death, and made to drink a poison draught made from hemlock.

Cleopatra

When I first saw these two objects I thought 'well, that's a really strong attack on Cleopatra, who was an incredibly powerful figure'. But actually, I fell into the trap too. It was much more state-sanctioned ridicule, closer to propaganda. Octavian's supporters wanted to make her relationship with Antony seem as seedy as humanly possible. **IH**

In Shakespeare's *Antony and Cleopatra*, Antony says to his attendant '[s]peak to me home, mince not the general tongue: name Cleopatra as she is call'd in Rome'.[51] Two objects in the British Museum's collection give a good indication of what Rome's citizens thought of Egypt's last pharaoh. One is a fragment of a marble relief, about forty centimetres wide. The preserved part of the relief shows the prow of a boat at which stands a boatman in a pointed hat. Behind him a man and a woman perform a sexual act. The figures are thought to be caricatures of Antony and Cleopatra. The other is a terracotta oil lamp showing a crocodile, emblem of Egypt, with a phallus attached to the tail upon which sits a naked female, presumed to be Cleopatra. These are both thought to be products of a slanderous campaign perpetrated against Antony and Cleopatra by supporters of Octavian (who would become the emperor Augustus) in the 30s BC. As historian David Stuttard notes, 'to provoke Roman moral outrage against the clever, charming, politically astute Cleopatra, Octavian had his spin-doctors portray her as morally dissolute, blackening her character'.[52] Its purpose was to strengthen Octavian's claim to be the legitimate successor to Julius Caesar at the expense of Antony, whose association with the Queen of Egypt proved to be his undoing.

Born in Alexandria, Egypt, in 69 BC, Cleopatra inherited a kingdom that was wealthy but weak, and Egypt was fully dependent upon the cooperation of Rome for its survival. However, when the queen was still young, Rome underwent seismic political changes that plunged it into civil war, resulting in victory for Julius Caesar. Soon after, in 48 BC, Caesar arrived in the Egyptian port and capital Alexandria where he met Cleopatra, whom he subsequently invited to visit him twice in Rome. She took her son with her, claiming that he was Caesar's child.

During her stay in Rome, Cleopatra was courted by Roman statesmen who were keen to ingratiate themselves with someone who obviously enjoyed Caesar's favour, but these overtures were somewhat forced. In a letter written after Caesar's death, the politician Cicero wrote 'I hate the Queen!…[Her] insolence, when she was living in Caesar's house in the gardens beyond the Tiber, I cannot recall without indignation.'[53] Cicero's views on Cleopatra were probably shared by the Roman political elite, who automatically regarded any non-Roman, especially a woman, as inferior.

The relative security enjoyed by Cleopatra because of her relationship with Caesar ended abruptly with his murder, in 44 BC. She quickly left Rome with her three-year-old son and headed back to Egypt, where she awaited the outcome of renewed civil war between Caesar's assassins and his supporters. In 42 BC, two successive battles in Macedonia gave overwhelming victory to Antony, who now assumed control of all Rome's eastern provinces, while Octavian ruled in the west.[54] Antony proceeded to summon Cleopatra to a meeting in Tarsus in the Roman province of Syria, primarily to discuss Egypt's strategic importance and role in his forthcoming eastern campaigns. The ancient writers inform us that she made a grand entrance, clothed as Venus, and created such an impression that Antony, although already married, was instantly smitten. They travelled back to Egypt together, where he stayed for the winter. Reflecting upon his later disastrous campaigns against the Parthian Empire, ancient writers would criticize him for having cut short his campaign season to be with her.

By the mid-30s BC Rome was awash with rumours of Antony and Cleopatra's alleged decadence. Seizing his opportunity, Octavian positioned himself as the arbiter of moral virtue and publicly criticized his rival. Antony's blunt rebuke was a clear indication that he appreciated how far his relationship with Cleopatra had turned Roman public opinion against him:

Why have you changed? Because I'm screwing the queen? She's my wife. And is this some new affair or has it been going on for nine years? And you – are you only screwing Livia [Octavian's wife]? Hurrah, if when you read this letter you have not been screwing Tertulla or Terentilla or Rufilla or Salvia Titiseniam or all of them. What does it matter where or in whom you stick your erection?[55]

Matters were not helped by the defection of Antony's private secretary, Lucius Plancus, to Rome in 32 BC. His salacious tales of Egyptian court life proved popular in a city already 'rife with tittle-tattle about heinous deeds in the East'.[56] The marble relief and oil lamp are, most likely, products of this publicly played out campaign of mudslinging between Antony and Octavian. The campaign was so successful that Cleopatra's reputation became almost irretrievably tarnished, as David Stuttard observes: 'the later Roman historian Dio Cassius wrote of her "insatiable sexuality", Boccaccio called her "the whore of eastern kings", Dante "a carnal sinner" and Florence Nightingale "that disgusting Cleopatra".'[57]

In 31 BC, the war of words between Antony and Octavian erupted into armed conflict, ending in a naval battle off the north-west coast of Greece, at Actium. The next year, with Octavian at the gates of Alexandria, and his own army deserting him, Antony is said to have committed suicide. Ten days later, having failed to agree terms with Octavian, Cleopatra was also dead. To commemorate his victory, Octavian issued coins featuring a crocodile along with the inscription 'Aegypto Capta', 'Egypt Taken'.

Right
A silver denarius issued by Octavian to celebrate the conclusion of his Egyptian campaign, 28 BC

CHAPTER 2
HIDDEN IN PLAIN SIGHT

Throughout history, there have been many instances of hidden, or at least semi-concealed, acts of resistance, in addition to the more overt examples discussed in chapter one. Everyday items such as clothing and jewellery or a utilitarian object may incorporate hidden messages, sequences of numbers or imagery; or by the way they are used they innately represent an ideological standpoint. Sometimes a generic utility object has become an emblem of a political movement. During the Czechoslovak Velvet Revolution in 1989, protestors jangled keys, symbolizing the unlocking of public space, and an invitation from the pro-democracy movement to the ruling communist party to 'go home'.[1]

The manner in which people dress can become an expression of political willpower, a form of shorthand or code that conveys a message understood only by the cognoscenti. The cleverness of such symbolism is part of its allure: a small act of triumph against the forces of oppression. Objects created by and for those who feel ground down serve as a reminder, perhaps, that better times are to come.

Opposite
Czechoslovak students offer
their keys symbolically to Václav
Havel, dissident leader and later
President of Czechoslovakia,
4 December 1989

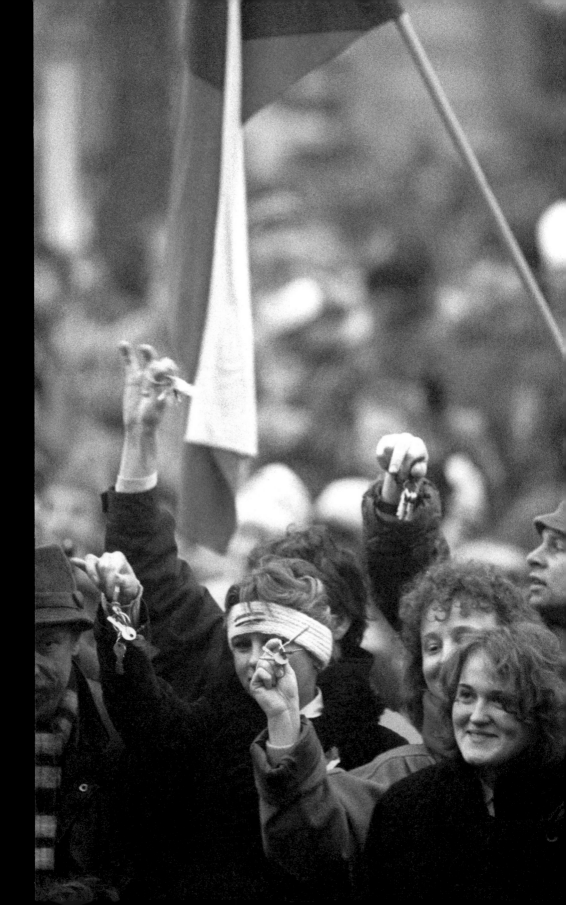

WEARING OUR RESISTANCE

It is often said that the word *sabotage* is derived from the old French word 'sabot', meaning wooden clog, because workers would throw their shoes into a factory machine during a labour dispute to disrupt production.[2] It is a nice story, but there is no defining historic event that links an act of shoe-throwing to the etymology of the word. It is perhaps fitting that even in language the desire for a suitably evocative protest story can occasionally outweigh dry historic fact. Nevertheless, the story illustrates one of many ways in which clothing has become a talisman for dissent.

What we choose to wear and the way in which we wear it can be used to reflect all manner of political, religious and social inclinations. For example, debates on religious doctrine often centre on which parts of the body can and cannot be revealed. At other times, reverting to indigenous costume has been a means of rejecting colonial values as well as helping to preserve fragile local economies. Indeed, European clothing has often become a synonym for foreign intrusion and oppression. Meanwhile, jewellery and other accessories might covertly incorporate imagery, thereby becoming portable keepsakes that demonstrate a hidden allegiance.

Below
A clog, sabot, with a carved wooden base and leather upper, Europe, 19th century

Right
Portrait of Charles I, c. 1660.
In the top left of the image is
a scene showing his execution
in 1649 and the inscription
'O horrible Murder'. Following
the Restoration in 1660, support
for the monarchy no longer
needed to be concealed

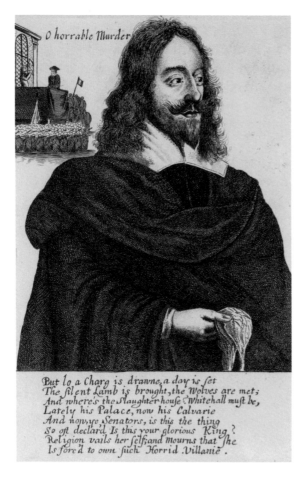

O horrable Murder

But lo a Charg is drawne, a day is set
The silent Lamb is brought, the Wolves are met;
And where's the Slaughter house? Whitehall must be,
Lately his Palace, now his Calvarie
And now ye Senators, is this the thing
So oft declar'd. Is this your glorious King?
Religion vails her self; and mourns that She
Is forc'd to own such Horrid Villanie.

Royalist finger ring

During the English Civil War (1642–51), and prior to the restoration of
the monarchy in 1660, many royalists chose discreet ways in which to
show their support for the monarchy and the memory of Charles I,
who had been executed in 1649. This gold finger ring has a hinged lid
inset with a square diamond, beneath which is concealed an enamel
portrait of the King.

Below
A gold finger ring with an oval
bezel opening as a locket, which
contains an enamelled portrait
of Charles I, England, 1640–60

Jacobite garter

In eighteenth-century Britain the development of machine-made
weave patterns made it easier to put mottos and amusing phrases into
hosiery.[3] This garter carries the phrase 'God bless PC and down with
rump'. It refers to the Jacobite rebellion of 1745 when Charles Edward
Stuart, 'Bonny Prince Charlie' or 'PC' in this motto, tried to reclaim

Below

A silk garter with the words 'God bless PC and down with rump', which allude to the Jacobite rebellion of 1745, woven into the pattern

the throne for the House of Stuart. The term 'rump' had become shorthand to describe a parliament dominated by a small faction that had expelled the rest of its members. A rump parliament had been responsible for ordering the execution of Charles I in 1649 and so it was entirely apt that it should be invoked in this context, which called for the second restoration of a Stuart monarchy.[4]

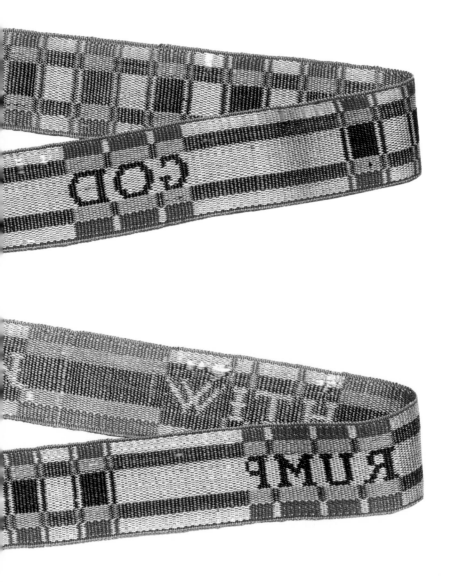

Merina shawl, *lamba akotofahana*

Using clothes as a statement of opposition was not a discovery of western teenagers in the twentieth century - what you wear has long been a way of expressing a view. It turns darker when it becomes not just a symbol, but a murder weapon. **IH**

Silk cloth was hugely important in pre-colonial Madagascar. It held emotive, cultural, economic and even political power among the various ethnic groups. The cloth, known as *lamba*, was worn as a shawl by the Merina aristocracy to denote status and to wrap their dead, with specific patterns and colours demonstrating ancestral allegiance. Silk cloth was also widely used as diplomatic gifts, particularly in the mid- to late nineteenth century as Madagascar's Merina Kingdom sought to stave off colonial ambitions.

With the European threat increasing from the mid-nineteenth century onwards the wearing of ancestral clothing, in particular the *lamba*, became more politicized. Under Queen Ranavalona I (1778–1861), Madagascar had pursued an isolationist policy to thwart colonial ambitions. Her son and successor, Radama II (reigned 1861–63), was far more open to European influence and passed several radical decrees including a law requiring the population to dress in

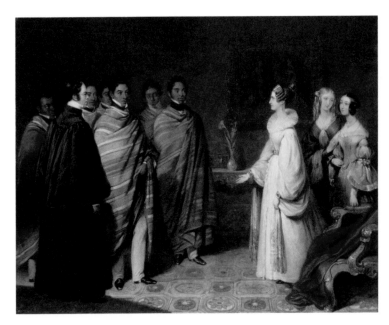

Left
Queen Adelaide receiving the Malagasy ambassadors at Windsor Castle in March 1837, Henry Room

Above
A striped Merina *lamba* thought
to have been owned by Queen
Ranavalona I, early 19th century

western-style clothing. This led to a popular uprising demanding the
restoration of ancestral dress.[5] Radama II was assassinated in 1863
by a group of his own soldiers, who threw a *lamba* over his head and
throttled him using a silk sash, thus avoiding the spillage of royal blood.[6]
At the first public appearance of his nobles and high-ranking officials
after his death, all were conspicuous by wearing their ancestral *lamba*.[7]

As French influence on the island increased, culminating with its
conquest in the 1890s, terminology associated with cloth came to
symbolize the preservation of ancestral rule in the face of foreign
oppression. The names of two major rebellions were thus derived
from fabric terms, the *Menelamba* ('red by their cloth') rebellion of 1895
and the *Sadiavahe* ('loin cloth of vines') movement, which fought a
campaign of sabotage against French rule in 1915–17.[8]

Mahdi *muraqqa'a* and *jibba*

You expect museums to display beautiful and ornate clothes but not
necessarily old rags. Yet this is the whole point of this ragged jacket.
It is a rejection of materialism and an affirmation of ascetic piety.
The so-called 'Mad Mahdi' was, actually, pretty clever and convinced
poor people to support him. What looked like poverty was, in fact,
spiritual riches. **IH**

In Kordofan province in Sudan in 1881, a Sufi holy man named
Muhammad Ahmad proclaimed himself the 'Mahdi', or 'rightly
guided one', the redeemer of the Islamic faith who would unite Muslim

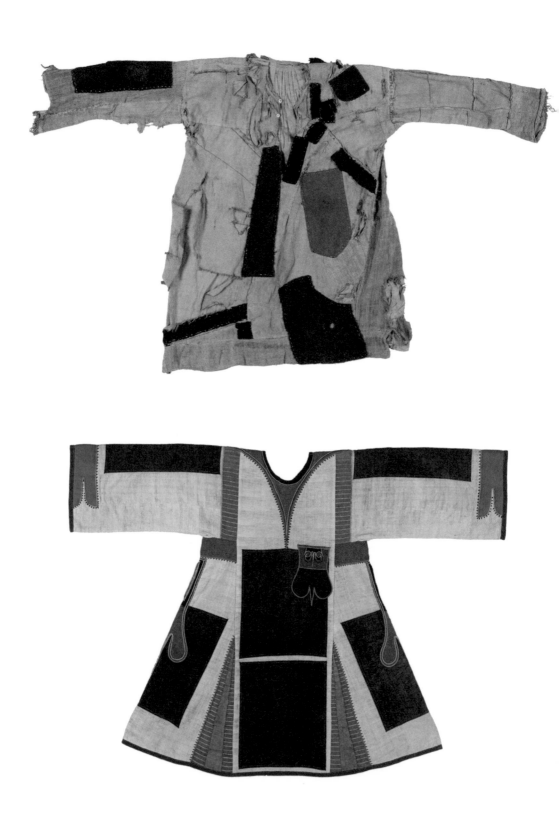

people in the region. A leader with political and military aims, by 1885 the Mahdi had successfully ousted the British-backed Ottoman-Egyptian government and established a Mahdist state. Most of his followers were drawn from the *darawîsh*, or 'dervishes', literally 'poor men', of Kordofan and Darfur. Initially their uniform was a patched tunic known as a *muraqqa'a*, its raggedness acting as a symbol of piety and contempt for worldly goods. The British Museum has a rare early *muraqqa'a* that was acquired in 1886 and probably dates from before the fall of Khartoum in 1885. The tunic is cotton and the patches are made from wool. This has symbolic significance, because the early Islamic ascetics who founded the Sufi orders also made their garments from wool. Indeed, the Sufi derive their name from *suf*, the Arabic word for wool.[9]

As the Mahdi gained victories in Sudan he renamed his followers *Ansar*, meaning 'the helpers'. At about the same time the *muraqqa'a* began to be replaced by a type of tunic known as a *jibba*. The *jibba* repurposed the patchwork motif for finely made garments, with brightly coloured panels of fabric evoking the earlier beggar-style outfits, except these were made exclusively from cotton.[10]

The British officer General Gordon engaged in a series of diplomatic overtures with the Mahdi when he was sent to the Sudanese capital by the Ottoman-Egyptian government in 1884–85. His brief was, ostensibly, to oversee the safe evacuation of government officials from the city, but upon arrival he declared that he would instead lead the defence of Khartoum against Mahdist forces. Both men were deeply spiritual and during an ensuing diplomatic exchange they tried to convert each other to their respective faiths. Gordon sent the Mahdi a fez, a red robe of honour, and the offer of the sultanate of Kordofan – a desultory offer since it was already safely in Mahdist hands. The Mahdi's reply stated that 'I am the Expected Mahdi, the Successor of the Apostle [Prophet] of God. Thus I have no need of the sultanate…nor of the wealth of this world and its vanity.' The robe was returned and with it came a gift – a *jibba* – along with an invitation to Gordon to convert. This was an exemplary moment in which, 'in a gesture worthy of Gandhi', the Mahdi 'reject[ed] the world of European politics and trade, filtered through Ottoman Egypt', preferring 'home-spun cotton to richly colored Turkish robes and the entanglements they trail'.[11] Gordon also spurned his gift, along with the invitation to convert to Islam. As the siege of Khartoum intensified he is reported to have been 'appalled at the thought of donning a "filthy Dervish's cloth" just to prolong his life'.[12] The manner of Gordon's death is unclear but popular tradition, immortalized by George William Joy's painting *General Gordon's Last Stand* (1893), has Gordon confronting Mahdist forces wearing his Governor-General's gold-braided blue uniform and red fez.

Below
A photograph showing the aftermath of the Battle of Atbara, 1898, during the Second Sudan War. The man wearing a bloodstained *jibba* is the captured commander of the Dervish forces, the Emir Mahmud, surrounded by a prisoner escort formed from the 10th Sudanese Battalion

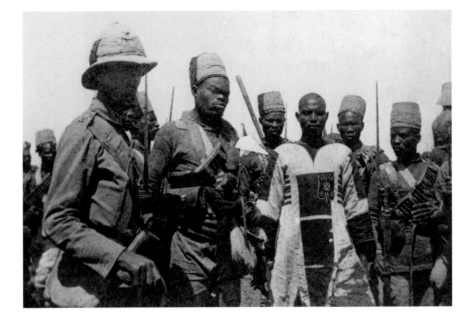

Bhagat Singh's hat

This small ceramic figurine (p. 97) dates from the late twentieth century. Its western-style hat will be immediately recognizable to anyone who is familiar with the life of Bhagat Singh, a leading figure in the campaign for Indian independence in the 1920s.[13] His association with the hat was the result of a single photographic portrait, an image that was widely reproduced and disseminated throughout India, becoming a symbol of defiance against colonial rule.

Singh was born in Lyallpur in what is now Pakistan in 1907. His political views developed early: at 12 he visited the site of the recent Amritsar massacre and by his late teens he was a committed revolutionary, favouring activism over the non-participation advocated by Gandhi and his followers.[14] In 1928, he helped to organize demonstrations in the Punjab and it was at one such rally in Lahore that the British police charged at one of the leaders of the Indian Independence movement, Lala Lajpat Rai. He was assaulted and gravely wounded, dying of his injuries ten days later. The Hindustan Socialist Republican Army (HSRA), of which Singh was a member, resolved to avenge his death by assassinating James A. Scott, the police superintendent responsible for ordering the charge. Singh and a comrade were chosen to perform the deed but they shot the wrong man, gunning down Scott's deputy, John P. Saunders. Saunders was also accused of having personally beaten Lala Lajpat Rai, enabling the HRSA to claim that justice had still been served.[15]

Now a 'marked man' wanted by the authorities, Singh went on the run. He cut off his Sikh *kesh* (long hair), discarded his turban and

Right
Photograph of Bhagat Singh, taken in 1929

adopted European dress. Knowing that even in disguise he could not evade capture for long, he resurfaced in April 1929 for one last act of protest, aimed at giving maximum publicity to the campaign for independence. This would be the planting of fake bombs in the Legislative Assembly in Delhi, making a loud noise but causing no damage. Propaganda leaflets were produced to be released during and afterwards, the first line of which proclaimed that there would be an explosion 'to make the deaf hear'.[16] Four days before the attack, the now famous image of Singh, still in European dress and wearing the felt hat, was taken by a professional photographer.

Singh was arrested after the bombing and copies of the portrait were sent to all the major newspapers. Censorship of the image proved futile, because it had already been so widely reproduced.[17] The Lahore-based newspaper *Bande Mataram* indicated its sympathies for the revolutionaries by publishing the photograph as a pull-out poster. The image thus became a symbol of defiance against British rule in India, an emblem of anti-imperialism that adorned the walls of peoples' houses and provided the campaign for independence with a hero figure to rival Gandhi in terms of popularity. At Singh's subsequent trial, witnesses were cross-examined in an effort to determine if he had been wearing the hat during the attack on the Assembly. Later, during his imprisonment, it was argued that he should be treated as a European prisoner because he wore a hat.

After spending twenty-three months in jail, during much of which he was on hunger strike, Singh was sentenced to death and hanged in 1931. He fully realized the propaganda potential of the image of him in the hat, and the fact that his execution would make him a martyr, releasing a wave of anti-colonial feeling that would irreparably undermine the justification for British rule in India. Shortly before his death he was passed a note asking if, given the option, he would prefer to live. He responded:

My name has become a symbol of Indian revolution. The ideal and the sacrifices of the revolutionary party have elevated me to a height beyond which I will never be able to rise if I live... If I mount the gallows with a smile, that will inspire Indian mothers and they will aspire that their children should also become Bhagat Singh. Thus the number of persons ready to sacrifice their lives for the freedom of the country will increase enormously. It will then become impossible for imperialism to face the tide of the revolution.[18]

Gandhi at his spinning wheel

This is an example of using an everyday object to put a political message into the household. It looks innocent enough but Gandhi and his followers knew what they were doing – the simple bucolic image is in fact an anti-colonial, pro-independence statement. To the Indian audience, spinning is being spun. **IH**

The lacquer dish illustrated was made in Burma in the 1930s, most likely to be sold to its large Indian community, and shows Mahatma Gandhi (1869–1948) in a typical cross-legged pose at his spinning wheel, or *charkha*. He would spin every day for about an hour, starting at 4 a.m., and encouraged members of his *ashram* (spiritual retreat) to do the same. In 1946, a visiting reporter from *Life* magazine noted that: 'Spinning is raised to the heights almost of a religion with Gandhi and his followers. The spinning wheel is sort of an Ikon to them. Spinning is a cure all, and is spoken of in terms of the highest poetry.'[19]

Gandhi called for the Indian nation to spin and weave *khadi*, a handwoven fabric, to promote Indian self-sufficiency. This was part of his broader policy of non-cooperation and non-violent resistance to colonial rule, one aspect of which required the boycott of foreign – and especially British-made – goods, and the wearing of *khadi* by

Left
Gandhi at his spinning wheel, photographed by Margaret Bourke-White for *Time* magazine, 1946

Opposite
A small lacquered dish made of coiled split bamboo featuring a depiction of Gandhi seated on a mat at his spinning wheel, Burma (Myanmar), 1930s

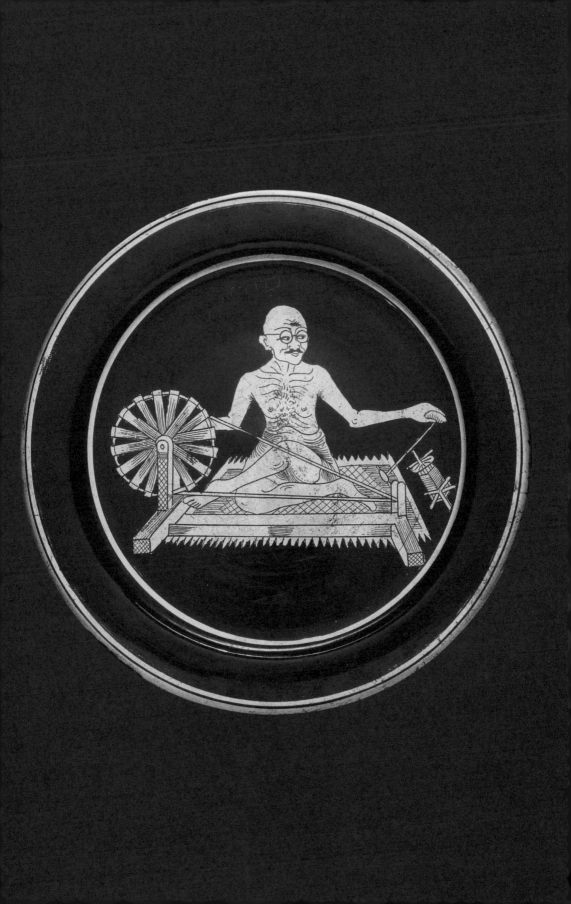

Indian nationals. The importation of machine-made thread and fabric from England was disrupting India's own production and the development of its textile industry. The *charkha* thus became an emblem of the independence movement, and was incorporated into the design of the flag for the Indian National Congress in 1931.[20]

Severed colonial heads

These two objects illustrate a practice of symbolically decapitating and wearing representations of colonial officials or heads of state. One is a beaded necklace from South Africa and the other is a popular print from Kolkata, India.

The beaded necklace was made by the Mpondomise people living in the district of Tsolo in the Eastern Cape in South Africa. Attached to the necklace is a snuffbox, of British manufacture, showing a portrait of King George V. It is thought that the wearing of an image of the British monarchy in bodiless form, while nominally supporting

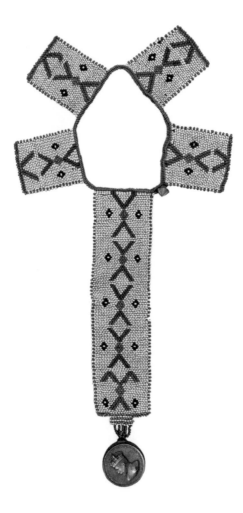

Left
Beaded necklace made by the Mpondomise people with a snuffbox showing the head of King George V, early 20th century

the status quo, was intentionally ironic: the head was to be worn as a trophy, a mock-victory over colonial rule.[21]

The popular print dates to around 1895 and shows Kali, the Hindu goddess of destruction. In this typical representation, she bestrides her consort, who lies calm and prostrate. In her left hand is a raised scimitar and she wears a necklace of severed heads to signify the death of the ego. Upon closer inspection, these heads appear to be distinctly European, or at least white and bearded. The nationalist movement appropriated this kind of image, whereby the goddess represented Mother India rising up against her colonizers, to awaken revolutionary fervour. Hardly surprisingly, therefore, colonial officials moved to suppress this print on the grounds that it was seditious.[22] It was a losing battle: a writer for *Jugantar*, a Bengali newspaper, stated in 1905 that '[t]he Mother is thirsting after the blood of the Feringhees [foreigners] (…) with the close of a long era, the Feringhee Empire draws to an end, for behold! Kali rises in the East.'[23]

Right
Popular print of the goddess Kali on the battlefield, wearing a necklace of severed heads, Chore Bagan Art Studio, *c.* 1895

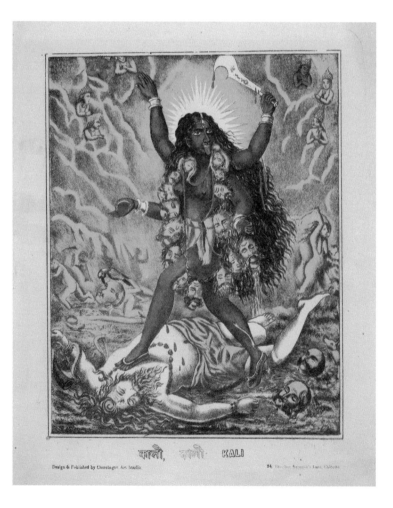

Palestinian *keffiyeh* and woman's scarf

The black-and-white fishnet-patterned *keffiyeh*, or man's head-cloth, became a unifying symbol of Palestinian national identity during the Arab revolt (1936–39). Since the 1960s it has featured prominently in the Palestinian resistance movement, especially after its adoption by Yasser Arafat (1929–2004), chairman of the Palestine Liberation Organization from 1969 to 2004. Arafat claimed that he wore his *keffiyeh* in a specific way, folding the cloth over his right shoulder so that it would resemble a map of his desired Palestinian state.[24] Although worn mainly by men, the *keffiyeh* was appropriated by many young Palestinian women living in the West Bank and refugee camps in Jordan in the 1980s, who turned it into a neck scarf. The one opposite, below, has woollen fringes in the colours of the Palestinian flag.
The Lebanese-Palestinian artist Mona Hatoum (born 1952) threw the dominating masculine associations of the *keffiyeh* into question by embroidering long strands of dark hair onto plain white cotton in her own version of the head-cloth, entitled *Keffieh* (1993–99).[25]

Left
Photograph of the Palestinian leader Yasser Arafat wearing the *keffiyeh*, 1980

Opposite above
A man's *keffiyeh*, 1920–48

Opposite below
A woman's belt made from a man's cotton black and white *keffiyeh* with fringes made in the colours of the Palestinian flag, 1980s

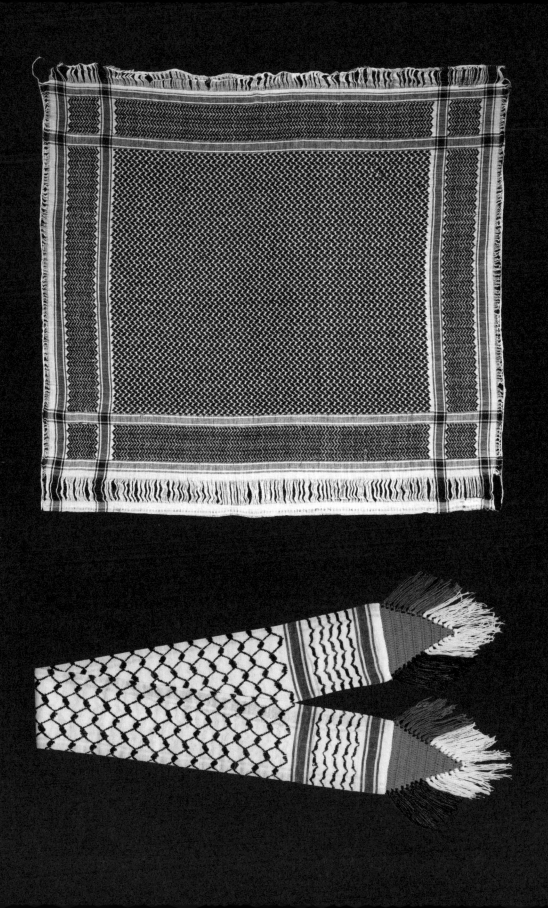

The hijab in Iran

The wearing of the Islamic veil, the hijab, in Iran, has long divided conservative and moderate elements. In the years that preceded the Iranian Revolution in 1979, some women welcomed the opportunity to abandon the hijab, as demonstrated in the aquatint *Escape* (1975) by the Iranian-American artist Nahid Hagigat (born 1943), in which a woman is shown removing her veil, 'as a gesture of longing for freedom and a protest against the patriarchal society'.[26] Other women resented what they perceived to be an attack on their religious rights, and they began to express their opposition to the Pahlavi regime by wearing headscarves. After the revolution, the wearing of the hijab was made mandatory, and this led in turn to mass protests on the streets of Tehran against the ruling. The sociologist Ashraf Zahedi has remarked how Iranian political regimes have assigned different meanings to the veil that correspond to their own ideologies. They

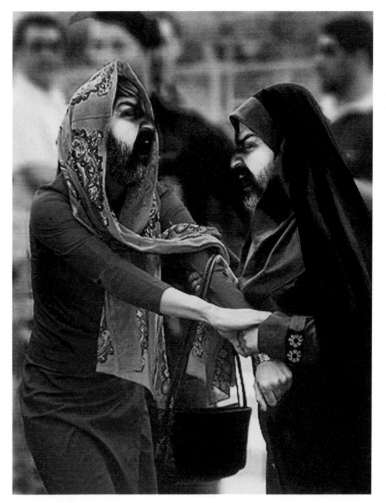

Left
Bad Hejab, Ramin Haerizadeh, 2008. With this work, Haerizadeh comments on state dress controls by superimposing his bearded portrait onto photographs of women challenging other women for refusing to follow these rules

Above
Escape, Nahid Hagigat, 1975

seek to construct an 'ideal' Iranian woman and in turn an image
of Iran as a 'modern or an Islamic country'.[27]

Clothing remains contentious in Iran. In 2009, during student
protests at Tehran's Amirkabir University of Technology, the state
authorities attempted to discredit one of the student leaders, Majid
Tavakoli, by circulating a story that he had been arrested trying to
escape from the campus wearing a woman's *chador*, a cloth that covers
almost the entire body except the face. The attempt to ridicule and
humiliate Tavakoli backfired, and soon digitally altered photos appeared
online showing Ayatollah Ali Khamenei and President Ahmadinejad
dressed in women's clothes.[28] In late 2017, women began a new wave
of protests against the country's compulsory hijab rules by standing on
telecoms boxes in Tehran with a headscarf held aloft. Images of these
protests, which usually ended in arrest, were taken by passers-by using
smartphones and widely circulated on social media.[29]

Umbrella Movement sketches

Communist China's policy towards Hong Kong, since it regained control
of the territory from Britain in 1997, has been governed by a set of
principles known as 'one-country, two systems', whereby Hong Kong
retains its capitalist economy and politics. This has been a cause
of friction between Hong Kong and the mainland, as the Beijing
government's attempts at reform have often been interpreted as
interference, aimed at undermining its political status. In September 2014,
students led a strike to protest Beijing's decision to pre-screen candidates
for the election of the Chief Executive, the region's top job. Tensions
quickly escalated as protest groups occupied several commercial areas,
including Hong Kong's central business district. Police used pepper
spray and later tear gas against the crowds of demonstrators. Protestors
found that the umbrellas they carried, besides protecting them from

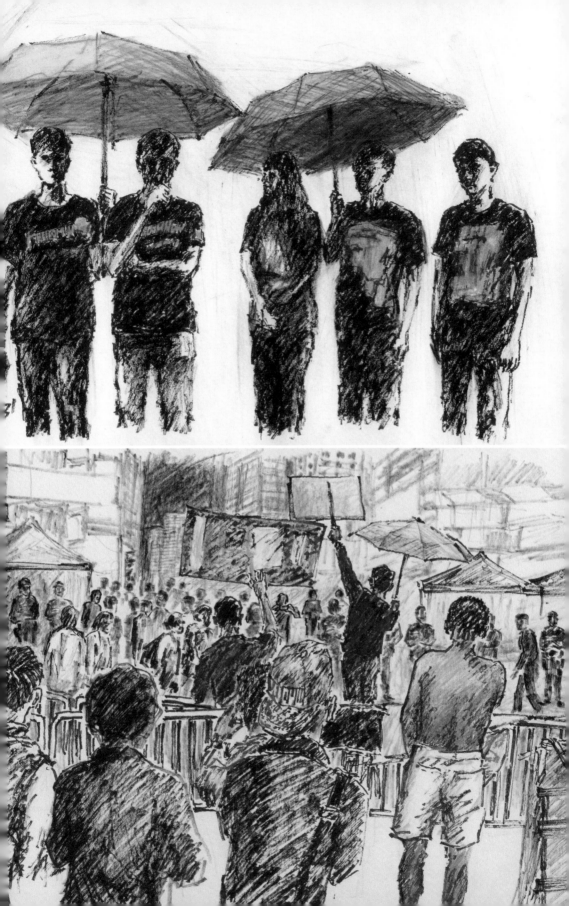

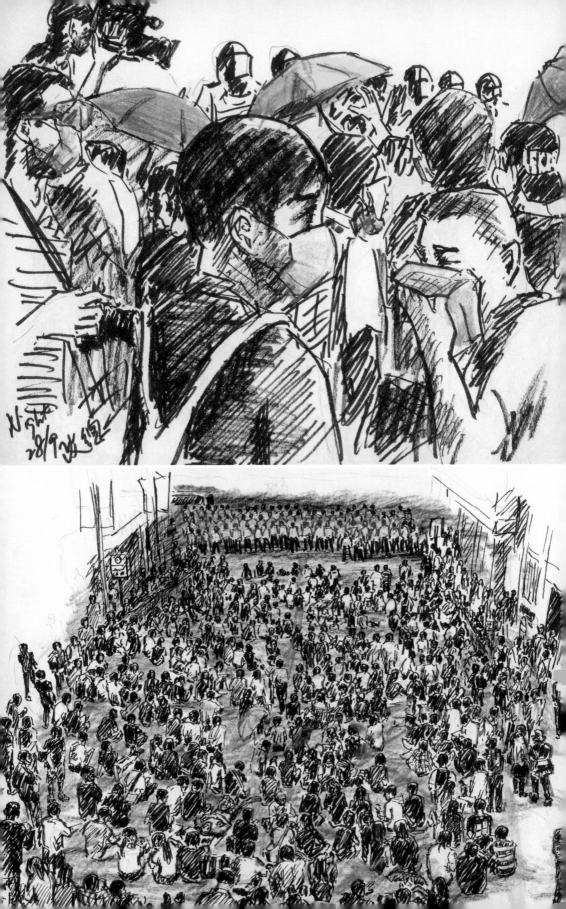

the rain and the sun, also afforded a degree of protection from these substances. Thereafter the umbrella became a symbol of the protests, and the 'Umbrella Movement' was born.[30]

Fong So, an artist and illustrator living in Hong Kong, began sketching and photographing the Umbrella Movement on 27 September 2014. He made daily excursions from his studio into the business district, taking his sketchbook and a pencil. Later, back at his studio, he worked up the sketches with pen, felt-tip and coloured pencil. At one point, he ran out of yellow pencil – yellow had also become strongly associated with the movement and was used as the background for many of its banners – and he had to resort to using crayon. Within a week, having completed almost eighty drawings, he had filled his first sketchbook. Over the next two months Fong So continued to draw on loose leaf and take photographs, until the police began forcibly to clear the occupied zone in the Mong Kok area on 25 November. The protests finally came to an end in mid-December 2014.

Pussyhat

On 21 January 2017, marches were held worldwide in support of a range of issues relating to women's rights. In Washington, DC, where the first of these marches was planned, the focus was on the newly elected president, Donald Trump, his policies and disparaging remarks made about women. Many of the protestors attending these marches chose to wear the same brightly coloured headwear – a knitted pink hat, dubbed the 'pussyhat'. It unified the marching crowds and thus reclaimed for women a derogatory word for female genitalia, a word used by Trump in a leaked recording, in which he had boasted about assaulting women.

The Pussyhat Project had been initiated by two friends, Krista Suh and Jayna Zweiman, who attended the same knitting class where they lived in Los Angeles, California. Krista planned to attend the march in Washington and wanted to knit a hat to keep her head warm. Jayna, who was unable to attend, wanted her voice to be heard *in absentia*. The shop that ran their knitting class created a simple pattern, which people of all abilities could follow.[31] Launching on 22 November 2016, details of the project circulated by social media and the idea of creating a sea of pink hats quickly gained traction. Over the next two months knitting circles and individuals all worked to produce pink hats that would be handed out to demonstrators on the day. The pattern has pointed ends which, when worn, give the appearance of cat ears, but marchers were encouraged to wear hats of any shape or shade of pink. The example illustrated here, for example, which was worn to the march on Washington, is in dark pink and has less pronounced 'ears' than other versions.

Opposite

A knitted 'pussyhat' worn during the Women's March on Washington on 21 January 2017, the day after the inauguration of President Donald Trump

Left

Women and men wear 'pussyhats' at the Women's March on Washington, 21 January 2017

Throughout history people have buried objects for a variety of reasons, all of which are of great benefit to archaeologists. Sometimes they put them underground for safekeeping, to be retrieved later; or items may be ritually buried, perhaps as an offering, or to accompany the dead in the afterlife. Being associated with sacred or ritual interment of bodily remains, these burials may be charged with symbolic significance. In this way, people can reinforce their own beliefs in contravention of current religious laws, for example by burying forbidden icons in places they aren't supposed to. At other times, an object such as a statue may be given a deliberately undignified burial as a show of disrespect to the leader it represents.

Opposite
Fired clay 'pillar' figurine of a female thought to be the goddess Astarte, 7th century BC

Figurine of a goddess

This fired clay figurine of a woman holding her breasts was found in an Israelite grave near Bethlehem. It stands less than twenty centimetres high and was once brightly coloured. It is thought to represent the goddess Astarte, the Hellenized form of the goddess Ishtar, a goddess of fertility, love and war. Clay figurines of this type were made throughout the Iron Age, broadly from 1200 to 539 BC and have been found in large numbers in excavations in the southern Levant. Hundreds have been discovered in Jerusalem alone, where they are most abundant.

Under the reforms of Josiah, King of Judah from 641/640 to 610/609 BC, the worship and representation of idols other than Yahweh was condemned, under punishment of death.[32] Yet these figures appear to have continued to be made and deposited in graves, suggesting that people ignored the legislation and carried on observing their old habits.[33]

The Meroë head of Augustus

> The person who buried the head of Augustus cleverly turned it and the world upside down. The seemingly omnipotent Roman emperor no longer looks down on everyone. They look down on him (even if they don't know it) because he is there, under their feet. **IH**

In 25/24 BC, a couple of years into the reign of Augustus, a Roman garrison in Egypt was attacked by Meroite forces. They came from the African Kingdom of Kush, located in Nubia, present-day Sudan. Having taken the local towns in southern Egypt, the Meroite forces reportedly pulled down the statues of Caesar and sold the inhabitants into slavery.[34] It is likely that a monumental bronze head of Augustus that is now in the British Museum once belonged to one of those statues. It was dragged south to the city of Meroë, situated on the eastern bank of the Nile, where it was buried face down just outside the doorway to a victory shrine. The manner of its burial appears to have been highly significant, positioned so that every visitor to the shrine would ritually trample over the head of the defeated enemy as they entered the building.[35] The swift and undignified burial of the head proved extremely fortunate for future archaeologists, since most Roman bronze heroic statues were melted down in later antiquity.

Left
A Sudanese workman poses with the Meroë head still *in situ* (or perhaps placed back in the position it was originally found for the photo), 1910

Opposite
The Meroë head, a bronze head from an over-life-sized statue of Augustus, 27–25 BC

Hiding sculpture during the English Reformation

The terms of the Royal Injunctions, first issued under Edward VI in 1547 and later, after the Elizabethan Religious Settlement of 1559, required that every ecclesiastical person 'shall take away, utterly extinct, and destroy all shrines, coverings of shrines, all tables, candlesticks, trindals, and rolls of wax, pictures, paintings, and all other monuments of feigned miracles, pilgrimages, idolatry, and superstition'. The systematic destruction of medieval religious imagery was an assault on Catholic worship and everything associated with it, with the result that, as the injunctions dictated, 'there remain no memory of the same in walls, glass windows or elsewhere'.[36]

Discovered in the chancel of St Mary's, Kettlebaston, in Suffolk in 1864, these sculptures (pp. 117–18) were found in the walls of the church during repair work to the fabric of the building, but why were they buried, and what does that tell us? During the Middle Ages, these sculptures would have played a central role in the devotional life of the parish community. Together, they were contained within a wooden frame, located on top of the high altar, where they would have served as a visual backdrop to the celebration of the mass. This made them targets of Protestant iconoclasm during the English Reformation.

Below
View of the chancel in the church of St Mary at Kettlebaston, Suffolk

These damaged sculptures suffered the opposite fate to the Meroë head of Augustus. They were buried as a mark of respect to preserve the fragments from the people who had destroyed them. The Protestant reformers who smashed up these Catholic images thought they had ended their power. But believers in the churches buried them and in later years they were resurrected, which is quite apt, really. **IH**

The sculptures were removed from their frame and were broken, either by dropping them or hitting them against a hard surface. The common link between the panels is that the heads of the figures represented no longer exist; they were not present in the burial spot and were probably removed after breaking to prevent any possibility of their reinstatement. The remaining fragments, now no longer open to abuse by image worshippers, were left within the church building and buried near its altar, presumably by the faithful of the parish. There are many other instances where alabasters were buried within the church walls after being damaged, which suggests that far from being a coincidence,

Right
A carved alabaster panel, depicting God seated on the throne and the crucified figure of Christ between His knees, found in the chancel wall in the church at Kettlebaston in 1864, 14th century

A fragment of a 14th-century alabaster panel, from the scene of the Coronation of the Virgin, found in the church at Kettlebaston. On the left-hand side of the fragment is the kneeling figure of the Virgin with her arms outstretched

Opposite below
The third fragmentary alabaster panel found at Kettlebaston shows the seated Virgin with her left hand against her body, 14th century. Her head and right arm are missing, but traces of paint and gilding are visible

Below
The wooden head and foot of Christ, fragments of a crucifix, 12th century, found at All Hallows church in South Cerney, Gloucestershire

their interment might be a form of ritual burial, and perhaps even a covert subversion of Protestant political injunctions against images.

Across the country at All Hallows church in South Cerney, Gloucestershire, a similar discovery lends weight to the theory that such deposits were widespread in England during the Reformation. In this instance, two fragments of a crucifix, dating to about 1130, were discovered concealed in the north-east wall of the nave. The crucifix had disintegrated owing to the humidity of the cavity but two fragments survive – the head of Christ in death and his foot.[37] Before the Reformation there would have been a crucifix situated between the nave and the chancel of almost every church in the country, but almost none have survived.

Over time, and as the Protestant Church became firmly entrenched, the existence of these buried sculptures was forgotten. Their rediscovery in the nineteenth century opens a window onto a violent and turbulent moment when politics, religion and images all clashed. It was the people of the parish who literally picked up the pieces and moved on.

The Stonyhurst Salt

I can imagine the rich, and obviously Catholic owners of this object saying to their guests 'of course, Catholicism has been banned, we wouldn't dream of having such items of Catholic worship here. By the way, this is a salt-cellar – would you like some?' **IH**

This elaborate salt-cellar stands about twenty-six centimetres high and is made from silver-gilt decorated with rubies and rock crystal. It was made in the 1570s from the recycled fragments of old reliquaries or ecclesiastical plate. Despite its transformation into a supposedly secular function it seems to have been constructed in such a way that it retains much of its religious associations. Rock crystal symbolized Christ's purity, and had been commonly used in the display of medieval reliquaries. The inclusion of garnets and rubies, unusual for a piece of secular tableware, was probably intended to evoke drops of blood, whether that of Christ or of Catholic martyrs. The Salt appears to be proof that people did manage to retrieve and save sacred items, and this is probably one of many examples of ecclesiastical ware that were carefully hidden away to be produced later.

Below
The Stonyhurst Salt, a salt cellar made of silver-gilt and rock crystal and adorned with rubies and garnets, 1577–78

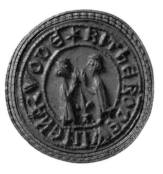
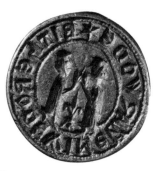

CONCEALED MESSAGES

Acts of subversion can be hidden 'in plain sight' through objects
with concealed, or semi-concealed words, phrases or numbers.
Occasionally pithy, sometimes serious, they range from sexist
jokes to anti-colonial commentary.

Sequences of numbers might be shorthand or code
referring to the date of a symbolic event, perhaps of a military
confrontation or a massacre. A recent parallel would be the
significance ascribed to the dates of terrorist atrocities, including
9/11 (11 September 2001) in the USA and 7/7 (7 July 2005) in
Britain. A memorable date may also contextualize the long
history of a political rivalry. In the late twentieth century in
Protestant stronghold areas of Northern Ireland and Scotland,
as well as cities with large Irish émigré communities such as
Liverpool, the date '1690' was a customary sight in graffiti and
in wall murals. It refers to the Battle of the Boyne, in which
Protestant forces led by William of Orange (later William III)
defeated the Catholics, led by the deposed James II of England.[38]

Some messages are extremely well concealed, or have been
put on objects that were intended for domestic use, never to
leave the relative privacy of a person's home. Other messages
are more easily discovered, hidden – literally – in the 'small print'.

There is a degree of ambiguity with some of the wordplay; in certain situations, one might question whether this was a deliberate act, while others leave us in no doubt as to the subversive intentions of the perpetrator.

Nebuchadnezzar II's brick

Many thousands of clay bricks made in ancient Babylon bear the king's name and titles, written or stamped in cuneiform before the clay was dry. This example carries the name of Nebuchadnezzar II (reigned *c.* 605–562 BC), second king of the Neo-Babylonian dynasty. He is perhaps best known today for having built the so-called 'Hanging Gardens' of Babylon, one of the Seven Wonders of the World. The brick was possibly made for one of his palaces. It also features a piece of graffiti: the name of one of the workmen, Zabina, who evidently thought it might be funny to scrawl his name in Aramaic before the clay dried. This was perhaps a mildly subversive joke on the arbitrary allocation of authority.

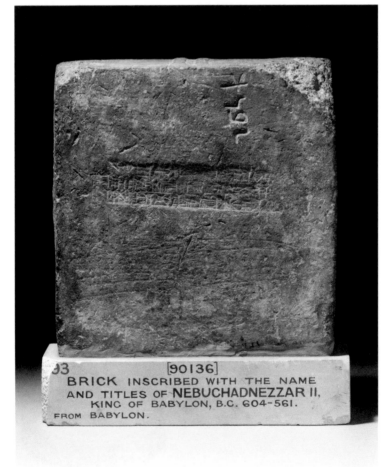

Left
A fired clay brick stamped with the name of Nebuchadnezzar II in cuneiform, and the name of a workman, Zabina, in Aramaic alphabetic letters, reign of Nebuchadnezzar II, 605–562 BC

Rude lyrics

Numerous songs by The Beatles were initially denied air time on the
radio by the BBC and stations abroad, usually owing to either drug
references or obscenity. The Beatles turned this into a game, trying to
include naughty words and phrases in songs without anyone noticing.
Girl (1965) has a 'tit, tit, tit' refrain mimicking The Beach Boys' 'la, la,
la' harmonies; *Day Tripper* (1965) includes the line 'she's a big teaser',
sounding suspiciously like 'she's a prick teaser'; and *Penny Lane* (1967)
features the lyric 'fish and finger pie' which, according to Paul McCartney,
was 'a nice little joke for the Liverpool lads who like a bit of smut'.[39]

Il Decameron 'corrected' by Rome, with later annotations [40]

This is a wonderfully scholarly protest about the censorship of a very rude book. The Church decided to rewrite Boccaccio's *Decameron*, removing all the sexual shenanigans involving nuns and priests. Marco Dotto wrote them back in. By hand. This was important because the point of the original book was not just to write about sex (although that was certainly part of it) but to show that it was the religious authorities claiming to be celibate who were in fact indulging most enthusiastically in 'the sins of the flesh'. **IH**

Written in the mid-fourteenth century by Giovanni Boccaccio (1313–1375), *Il Decameron*, is one of the great works of Italian literature. It features a hundred stories narrated by ten people gathered together, each telling a story a day over the course of ten days (Decameron comes from two Greek words meaning 'ten-day event'). Today *Il Decameron* is well known among students of Italian literature for its erotic stories, some of which involve the clergy or are set in places of worship.

The story illustrated here is that of Masetto of Lamporecchio, as told on day three. It is about a handsome young man who pretends to be deaf and dumb to gain employment as a gardener at a convent. The nuns, believing him to be mute, all scheme to sleep with Masetto, who quickly becomes worn out by his dalliances. One day the abbess passes him asleep on a bank in the garden, when a gust of wind conveniently blows up his shirt to reveal his naked body underneath. Consumed with desire, she also takes him to her quarters. Masetto is, by now, sick of this and reveals that he can speak, which the nuns assume to be evidence of a miracle.

This edition was published during the Reformation in 1573, at a time when the Roman Catholic Church felt particularly threatened and started to clamp down on works that mocked the clergy or depicted it in a bad light. The problem faced by the Church regarding *Il Decameron* was that by the sixteenth century it was already too well known, and too widely circulated, to be banned outright. Instead, the Church authorized the publication of what it described as the official 'corrected' version of the text, cleverly claiming to have 'restored' Boccaccio's original authorial work, explaining that his words had become 'corrupted' in previous versions. It was, in fact, heavily altered and redacted, having been purged of its religious rather than its erotic

content, which was too central to the plot to be omitted altogether,
by a team of clerical scholars in Florence led by a Benedictine monk,
Vincenzo Borghini (1515–1580). All references to the clergy were
removed and place names changed, thus preserving the dignity of the
Church. In the 'corrected' edition, the 'convent of nuns' in the story
of Masetto the gardener becomes a 'garden of damsels'.

Although the motives behind the Church scholars' emendations
and expurgations were known, they remained mostly unchallenged,
which makes this annotated copy of *Il Decameron* a rare exception.
Its annotations were written a century later by a scholar called Marco
Dotto, who helpfully re-inserted the censored details and re-corrected
Borghini's alterations, bringing the text back to its original version.
In a mini-essay at the back of the book, the otherwise unknown Dotto
voices his outrage at Borghini's butchery of the original text. He sees
his role as that of a physician, saving the text from the 'scalpel' of the
Inquisition by restoring it back to health.

'Thou shalt commit adultery'

> You can either believe that this is the most unfortunate mistake in the entire history of printing, or you can believe that it was deliberate. Of all the possible errors, one just happens to occur in the middle of the Ten Commandments in the bit about whether you can have sex with other people or not. Coincidence does not extend that far. I don't buy it! IH

Sometimes we cannot be sure whether an act of dissent is deliberate, or the result of an innocent mistake. This 1631 edition of the King James Bible, published under the names of Robert Barker and Martin Lucas, is known as the 'Wicked Bible' owing to a printing error in the Seventh Commandment (Exodus 20:14) that states: 'Thou shalt commit adultery.' In some copies, at Deuteronomy 5:24 another misprint changes 'God's greatness' to 'God's great asse'.

Left

A detail of a page from the 1631 edition of the King James Bible, showing the misprint of the Seventh Commandment at Exodus 20:14: 'Thou shalt commit adultery'

It is not known whether these errors were the result of deliberate sabotage, perhaps by a typesetter in the pay of a rival printer, or merely the result of a rushed print job. Regardless, the consequences were severe for Barker and Lucas. They were called to the Star Chamber where they were fined £300, a colossal amount at the time, for their carelessness. Barker bore the brunt of the fine, and would die penniless in a debtors' prison.

'Regit nummis animos et nummis regitur ipse'

'He governs minds by money, and by money is himself governed', reads the inscription on this medal of Sir Robert Walpole (1676–1745), a satire on alleged corruption at the heart of Walpole's Whig government. This is an altered version of a medal originally issued to commemorate Walpole's election to the Order of the Garter on 26 May 1726.[41] Original versions of the medal, by Johann Lorenz Natter, show a statue of Cicero on the reverse accompanied by the inscription, quoting Virgil's *Aeneid* (I.153), that reads 'Regit. Dictis. Animos', 'He governs minds by eloquence'. It is not known who made the altered version.

Britain's first Prime Minister was also the longest serving, holding the highest political office from 1721 until his resignation in 1742.[42] Throughout a long and divisive political career Walpole endured many scandals and allegations of impropriety. Some measure of this can be found in his entry in the *Oxford Dictionary of National Biography*, where the words 'corrupt' or 'corruption' appear no less than twenty-four times.[43] Judged by modern parliamentary standards, and even by those of the generation of politicians who followed, Walpole's methods were ethically dubious. He personally profited from office and counted among his personal enrichments the sale of his shares in the South

Below left

The front of a bronze medal featuring a bust of Sir Robert Walpole, with the inscription 'Robert Walpole, Knight of the Order of the Garter', Johann Lorenz Natter, 1741

Below right

The back of an altered version of the medal, with the inscription 'He governs minds by money, and by money is himself governed', c. 1741

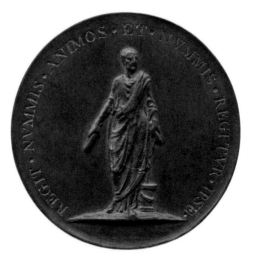

Left
The Stature of a Great Man or the English Colossus, George Bickham the Younger, 1740

Sea Company, just before the bubble burst in 1720. He also made wide use of patronage in the form of pensions, parliamentary places and other privileges, buying political support in both houses of Parliament and among the electorate. In this way, the wily and astute Walpole created a virtual monopoly on political power. An unimpressed E. P. Thompson declared that his regime had 'something of the sick quality of a "banana republic"'.[44]

Walpole's methods of government and his relative openness about them were seized upon by the Tory opposition and he was widely lampooned in written and visual satire. John Gay's *The Beggar's Opera* (1728) mentions a thief called after Walpole's nickname, 'Bob Booty'. Contemporary audiences would have also identified its main character,

the thief Peachum, as an allegory for the corrupt statesman. Illustrated here is a famous satirical print from 1740 by George Bickham the Younger showing Walpole wearing his Order of the Garter and posing as the Colossus of Rhodes. It is a comment on his political dominance and reluctance to enter war with Spain. The scroll in Walpole's hand reads 'Pray what dyou think ye T[ax]es are for? To squander away in a sea W[a]r? No! tis contrived by a G[arte]r & S[ta]r!' The inscription below, quoting Shakespeare, invites an unfavourable comparison between Walpole and Julius Caesar.

Literary and artistic attacks on Walpole's character never seemed to achieve much of political consequence, and he managed to remain aloof from the many crises that engulfed his cronies in government.[45] These included the South Sea Bubble, which claimed the scalp of the Chancellor of the Exchequer; the impeachment of the Lord Chancellor, the Earl of Macclesfield, for corruption, in 1725; and the expulsion of the MP Sir Robert Sutton for fraud, in 1732. Walpole's eventual downfall came about mostly as a result of policy failure: a poor election outcome, naval disasters in the war with Spain and the loss of a vote about a rigged by-election, which was treated as a vote of no confidence. He resigned from office on 11 February 1742.

Wilkes and the number '45'

> How brilliant is a magazine when the issue number of one edition becomes a national symbol of liberty? This was John Wilkes's enviable achievement and it is demonstrated in these seemingly mundane objects. **IH**

During the 1760s the number '45' became shorthand for radical sentiment in Britain. Its origins lie in a magazine, issue number 45 of the *North Briton*, published by the radical Whig politician John Wilkes (1725–1797). The British Museum has several artefacts relating to Wilkes and featuring the number 45, including a gold brooch and a teapot. On the teapot the number appears at the base of the spout.

A notorious hell-raiser (he was a member of the elite 'Hellfire Club' of political radicals), Wilkes's political career began with his election as Member of Parliament for Aylesbury in 1757. By 1762 he had begun to publish his magazine, which was highly critical of the Tory Prime Minister Lord Bute. Bute was a close ally of George III, having been his personal tutor when he was still Prince of Wales. Published on 23 April

1763, No. 45 of the *North Briton* vehemently attacked the King's speech to Parliament of 19 April, particularly the part about the recently concluded peace with France, which Wilkes regarded as too soft. The King's speech was, according to an editorial in No. 45, 'the most abandoned piece of ministerial effrontery ever attempted to be imposed on mankind'. The ministers responsible for its content were described as 'the foul dregs of [Bute's] power, the tools of corruption and despotism'.[46]

At George III's behest, on 30 April Wilkes was arrested and taken to the Tower. Released a week later under 'Parliamentary Privilege' – immunity from arrest – he immediately reprinted the issue as well as other seditious pamphlets. At this point he was found to be in breach of the 'Privilege' and expelled from Parliament, thereby forfeiting his immunity. In February 1764 Wilkes was found guilty of printing seditious material. A duelling injury prevented him from attending the trial, and he later absconded to France. Meanwhile, copies of the *North Briton* were ordered to be publicly burned, until a mob saved them from the bonfire.[47]

Four years later, still living in exile but with mounting debts and hoping for a pardon, Wilkes hatched a bold plan in which he would return to London as an outlaw and run for Parliament, hoping that his personal popularity with the common man remained undiminished. The rationale went that Wilkes 'did not *expect* to be elected'. His aim instead was to show that 'without an organization, without a canvas, without a patron, he could run in the election, speak from the hustings, shake hands with the voters', thus demonstrating to the world that 'the ministry was afraid to stop him and that he was a viable political force'.[48] His arrival in England proved his assumptions to be correct, inciting a popular following in which mobs of 'Wilkites' trailed him wherever he went, wearing their 'No. 45' badge-brooches, chanting 'Wilkes and Liberty' and the number 45.

Benjamin Franklin happened to be living in London during the chaotic 1768 election, and on one trip to Winchester he noted that for the first fifteen miles of his journey every door without exception was daubed with the number 45, and intermittently so for the remaining fifty miles. Carriages were halted by the mob on their way into London with the occupants being commanded to raise a toast to Wilkes. On one occasion a coach containing the Austrian ambassador was stopped. When he refused to toast Wilkes the mob dragged him from his carriage, turned him upside down and painted the number four on the sole of one shoe and the number five on the other. The ambassador is said to have stormed into Whitehall the next morning to complain, merely to be greeted with howls of laughter by ministers.[49]

Owing to Wilkes's popularity with the mob the government did not dare to issue an arrest warrant for him. When he presented himself to the authorities on 27 April 1768 he did so voluntarily, in part hoping that the ensuing trial would raise his profile still further. During his court case Wilkes became a figurehead for a grassroots movement that

Right
A porcelain teapot or punch pot with a cartouche at the base of the spout framing the number 45, Worcester Porcelain Factory, c. 1763–70

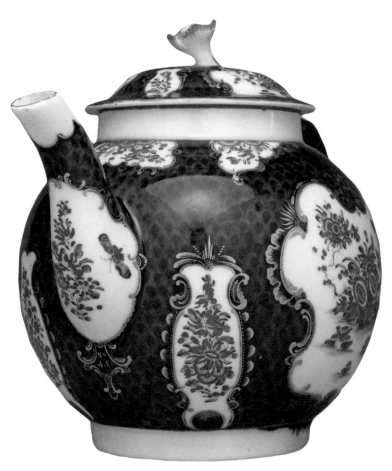

THE

NORTH BRITON.

N U M B E R XLV.

To be continued every *Saturday*. Price Two pence Halfpenny.

SATURDAY, APRIL the 23, 1763.

The following advertisement appeared in all the papers on the 13th of April.

THE NORTH BRITON makes his appeal to the good fenfe, and to the candour of the ENGLISH nation. In the prefent unfettled and fluctuating ftate of the *adminiftration*, he is really fearful of falling into involuntary errors, and he does not wifh to miflead. All his reafonings have been built on the ftrong foundation of *facts*; and he is not yet informed of the whole interiour ftate of government with fuch *minute precifion*, as now to venture the fubmitting his crude ideas of the prefent political crifis to the difcerning and impartial public. The SCOTTISH minifter has indeed *retired*. Is HIS influence at an end? or does HE ftill govern by the *three* wretched tools of his power, who, to their indelible infamy, have fupported the moft odious of his meafures, the late ignominious *Peace*, and the wicked extenfion of the arbitrary mode of *Excife?* The NORTH BRITON has been fteady in

in reality had few other ways to express its voice. He was held at King's Bench Prison, where a mob gathered every day to demand his release, burning boots as a pun on Lord Bute. On Friday 10 May violence broke out and troops opened fire, killing six or seven people, an event now known as the Massacre of St George's Fields.

Wilkes was eventually convicted, fined and sentenced to twenty-two months in prison.[50] In later life he held several political positions, serving as a sheriff and alderman in London, as Lord Mayor and latterly as Member of Parliament for Middlesex. His reputation as a radical was shredded when, during the Gordon Riots of 1780 (an anti-Catholic protest against the Papists Act of 1778), he ordered troops under his command to fire on a crowd, killing hundreds and injuring hundreds more.

'Tender longing, sweet hope'

This is a type of *notgeld*, 'emergency money', issued by municipal authorities in Germany after the outbreak of the First World War, and continuing until 1924. This was because, at first, the government was unable to supply low denomination coinage owing to a metal shortage, and later because the currency experienced high inflation, before collapsing completely during the hyperinflation of 1923. *Notgeld* designs are extremely varied and reflect the local culture and tradition of the areas in which the notes were issued. The note shown here was issued in Niederlahnstein, a town on the banks of the Rhine, in 1917.

On the back of the note the engraver has included two seemingly innocuous images of a hock of ham on the left and turnips on the right. The tiny script in the circle above the ham hock, a comment on food shortages, reads 'zarte Sehnsucht süsses Hoffen', a line from a poem by Friedrich Schiller that translates as 'tender longing, sweet hope'.

Right
The front of the Niederlahnstein *notgeld* ('emergency money'), 1917

Below
The back of the *notgeld* and a detail showing the altered inscription 'zarte Sehnsucht süsses Hoffen' above the ham. It should read 'Stadt Niederlahnstein/1917'

Above the image of turnips is the inscription 'so leben wir, so leben wir', a line from an old German song that translates as 'thus we live, thus we live'.

By the latter stages of the First World War, when this note was issued, the Allied naval blockade of Germany was beginning to bite, causing widespread food shortages. It created a great deal of social tension, with farmers accused of hoarding produce, while they in turn accused people from towns of stealing crops. The notes were recalled and the engraver reportedly arrested as soon as the messages were discovered.

'We shall get home rule'
Lacquered betel box

Lacquer is made from the sap of a tree. After being boiled until thick, it is applied in thin layers to a woven bamboo frame. Each layer is dried before applying the next one, so an object can take months to produce. The result is like a natural plastic and was popularly used for household, royal and monastic containers in Burma (Myanmar). This example was made to hold betel. Comprising a betel leaf, lime and the nut of the areca tree, the preparation was a mild stimulant, like tobacco, and was chewed extensively in Burmese society. As elsewhere in Asia, it was offered to guests as a sign of hospitality, much like a cup of tea in Britain.

Above
Above the turnips on the reverse of the *notgeld* the engraver has altered the inscription to read 'so leben wir, so leben wir'

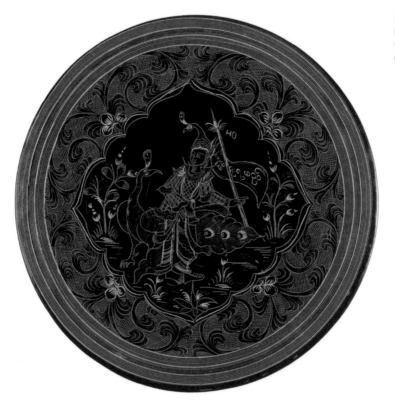

Left
Lacquered betel box made from woven split bamboo, Burma (Myanmar), early 20th century

This box displays nationalist sentiment by anticipating the end of colonial control through a political message inscribed on the lid. The banner held on a pole by the female figure is inscribed in Burmese, 'hum ru ya me', or 'we shall get home rule'. Someone appears to have started but not finished writing the same phrase out in Latin script, hence the 'HO' to the right of the banner.[51] Burma became a British colony in the nineteenth century as chunks of territory were gradually annexed over the course of three conflicts, known as the Anglo-Burmese Wars, the first of which was fought in the years 1824–26. By 1885, the entire country had become a province of British India.

The campaign for independence began to gain traction after the First World War. Maintaining close links with the Indian National Movement, the Young Men's Buddhist Association, the principal political organization in Burma by the 1920s, advocated the adoption of the Indian policy of non-cooperation with the British government.[52] By regarding Burma as part of British India, the colonial administration added an ideological and political complication to the campaign for independence, raising the question of whether an independent Burma should form part of a larger Indian Federation, or if it should sever its ties completely. Historically the states had been close, and Burma had a sizeable Indian population. At the same time, factions within the Burmese independence movement were demanding equal status, an argument that found agreement in India as well. In 1922, Gandhi wrote that 'I have never been able to take pride in the fact that Burma has been made part of British India. It never was and never should be. The Burmese have a civilization of their own.'[53] The separatist factions gradually prevailed and, by the mid-1930s, the Burmese nationalists were negotiating independently with the British government, with the country's status being formally recognized as distinct from India in 1937. Burma was occupied by Japan during the Second World War. Following a brief spell back under British rule it finally gained independence on 4 January 1948.

'We are the unwilling led by the unqualified to do the impossible for the ungrateful'

This US-made Zippo lighter was engraved for a soldier in the US armed forces who, according to the inscription on the fuel chamber, was posted to Vietnam in 1970–71. Zippos engraved with messages about the Vietnam War are common, not least because most GIs carried them. They had many uses, from lighting cigarettes to igniting stoves to cook popcorn, and their shiny cases provided makeshift mirrors for shaving in the bush. Notoriously, they were also used to set fire to the houses of suspected Vietcong. The ubiquitous Zippo

WE ARE THE UNWILLING LED BY THE UNQUALIFIED TO DO THE IMPOSSIBLE FOR THE UNGRATEFUL

LET ME WIN YOUR HEART AND MIND OR I'LL BURN YOUR GOD DAMN HUT DOWN

E. E. GRONAU
VIET NAM
70–71

FIGHTING FOR PEACE IS LIKE FUCKING FOR CHASTITY

Above
A Zippo cigarette lighter used during the Vietnam war, 1970–71. Inscriptions on the lighter identify E. E. Gronau as its former owner

Left
Lt Don Burchell sets fire to one of the huts in a Viet Cong training camp discovered by elements of the 1st Infantry Division during operations in the Lai Khe region, South Vietnam, 15 November 1965

became a portable memento of a tour of duty, giving dates of service, and they often displayed the emblem of a unit or division.

The messages engraved on the casing of this Zippo – 'fighting for peace is like fucking for chastity'; 'we are the unwilling led by the unqualified to do the impossible for the ungrateful'; and 'let me win your heart and mind or I'll burn your god damn hut down' suggest that the soldier was against the war, or at least had grown cynical about the conflict. He may have been an unwilling draftee, although not necessarily: there was widespread resistance within the armed forces by this stage of the war. In 1967, returning soldiers had formed the group 'Vietnam Veterans Against the War', touring the United States and testifying to the atrocities they had seen committed. In 1970, some members of the armed forces banded together as the Concerned Officers Movement, and in 1972 pilots of B-52 bombers began to refuse certain bombing missions.[54]

'Sexy' rupees

'Can you spot the hidden message, kids? Oh dear.' This is so childish that it made me laugh. **IH**

In 1968, the government of the Seychelles updated its currency, ordering new notes to be printed by the British-based security printer Bradbury, Wilkinson & Co. Featuring the portrait of Queen Elizabeth II, the new designs also showcased various aspects of Seychelles flora and fauna. Not long after its issue, it was noticed that the palm fronds on the 50 rupee note, to the right of the portrait of the Queen, spell out the word 'SEX'. It quickly became popular among collectors and, in 1972, when the *Sun* picked up the story under the headline 'Whoopee! Sexy Rupees Make a Mint', it was selling at up to three-times its face value.[55]

Initially, it was thought to have been an accident of design but then, on the design of the 10 rupee note from the same series, the word

'SCUM' was discovered concealed in coral to the left of the turtle. A coincidence seems unlikely, especially since neither word is visible in the original drawings by local artists Wendy Day Veevers-Carter and Mary Harwood. This suggests that a rogue engraver at the UK-based printer deliberately altered the designs.[56] The identity and motives of the culprit remain a mystery.

Du Fu [writing] self-criticism
Hua Junwu (華君武), 1980

In 1958, the great Chinese cartoonist Hua Junwu (1915–2010) visited London where he met his British counterpart David Low (1891–1963), who reportedly asked if there was any satire in China. As Hua Junwu observed, outsiders 'seemed to imagine that the Communist Party of China and the Chinese government had banned or were afraid of satire'.[57] At that point Hua enjoyed a comfortable position as director of

the arts and culture section of China's communist newspaper, the *People's Daily* (Renmin Ribao). But then, during the Cultural Revolution, 1966–76, the situation changed and Hua Junwu, along with many other intellectuals, suffered persecution and was forbidden from drawing satirical cartoons.

This scroll painting depicts Du Fu (712–770), the sage of Chinese classical poetry, at his desk writing self-criticism. It is based on an earlier cartoon Hua Junwu created in 1961. Revisiting the theme in 1980, he subtly altered it to refer to the Cultural Revolution, during which intellectuals were made to write essays of a self-critical nature. The reveal is in the title, which has a deliberately miswritten character, mocking the vast number of political slogans and posters that circulated with errors. Hua Junwu produced several versions of the painting, which he gave to friends. This example is dedicated to the translators Yang Xianyi and Gladys Yang, husband and wife, who were put in jail during the Cultural Revolution.

'64'

This 5 RMB postage stamp, designed by Yin Huili (殷会利, born 1962), was issued in 1992 by China Post to commemorate the Barcelona Olympic Games. It features six runners competing in a race, of whom three have numbered tops reading, from left to right, 64, 9 and 17. This sequence of numbers led to the stamp being interpreted as a coded reference to the crackdown of student-led protests that centred on Beijing's Tiananmen Square in June 1989, often referred to as 'June 4th', 'Six-Four' (六四) or simply '64'. The alleged connection with the stamp and 4 June was widely reported in the Hong Kong and Taiwanese press, and is claimed to be the reason for the stamp's withdrawal from circulation.[58]

Calendar dates have a long history in Chinese cultural memory. Since 1912, when the government of the newly established Republic

of China abolished the lunar calendar, dates have been referred to according to the Gregorian calendar. Following this convention, a simple numeric sequence can convey a deeper political meaning, as author and historian Alfreda Murck explains:

> The founding of the Republic of China on October tenth 1912 is still today celebrated in Taiwan as 10-10 or Double Ten (shuang shi 雙十). The May Fourth Movement (wu si yundong 五四運動) is named for the date in 1919 when students angrily protested against the unjust terms of the Treaty of Versailles. Their protests galvanized others to demonstrate around China, inspiring a sense of shared culture and nationhood. There followed a series of 'national humiliations' that were indicated by the numbers of the dates on which they occurred. Thus September 18 (9-1-8, jiuyiba 九一八) in 1931 marked the beginning of the invasion and subsequent annexation of Manchuria by Japanese troops. Likewise, for generations of Chinese, 7-7 (qi qi 七七) has been an abbreviation for the beginning of the second Sino-Japanese war (7 July 1937).[59]

Opposite above
A machine-printed cotton *kanga*, Abdulhaq Kaderdina, Kenya, 2002. The *kanga* bears an inscription in KiSwahili meaning 'I have no secrets but I have an answer'

Opposite below
Najib Balala (third from the left), then Kenyan Minister for Tourism, on his way to a meeting of hoteliers and investors on the Kenyan island of Lamu on 3 October 2011

On the postage stamp the link between the first number, '64', and the date of the protests (June 4th) seems straightforward enough. A slightly more laboured interpretation of the other numbers has been offered, concluding that '17', '1+7' = '8' and the '9' of the second runner completes the '89' of the year. Yet another interpretation reads the numbers 917 (*jiu yao qi* 九一七) as a homophone for 'soon will arise' (就要起), because in 1992 people were expecting that the condemnation of the Tiananmen demonstrators was about to be reconsidered, although in the end that did not happen. It is not known if the numbering of the runners' tops was deliberately intended to reference the Tiananmen protests. Yin Huili has since received more commissions to design stamps, suggesting that, in the government's view, the link was a coincidence.

Printed cloth (*kanga*)

Kangas can be used to communicate a range of messages, including political pledges. This *kanga* bears an inscription in KiSwahili: 'SINA SIRI NINA JIBU', meaning 'I have no secrets but I have an answer'.[60] It was commissioned by the Kenyan politician Najib Balala (born 1967) who was seeking election in 2002, in an attempt to unseat the Mvita constituency MP Shariff Nassir. Concealed within the slogan with which he was campaigning is a play on words, containing the additional message: 'SI NASIR', 'No to Nasir', and 'Ni Najib', 'Yes to Najib'. Najib Balala won the seat and served as MP from 2002 to 2007.

CHAPTER 3
THE ART OF DISSENT

The role of the artist and artisan has been implicitly recognized throughout this book. It is partly through their wit and creativity that an object can be exploited for its subversive potential. In this chapter, we look more closely at objects where imagery is either partially concealed or conveys a double meaning – one straightforward, the other potentially subversive. Many works of art contain allusions to earlier works by another artist, or perhaps to a different genre. Across the visual arts, practitioners have incorporated familiar themes to create works that mock, challenge or criticize authority and social convention.

Sometimes subversive imagery is easy to spot, but other images can be read as allegories or metaphors for a specific political situation and rely on deep cultural knowledge to reveal their meaning. Indeed, many objects that express anti-colonial sentiment have exploited a lack of in-depth cultural awareness to lampoon the authorities successfully. Others still are only identifiable because there is accompanying documentary evidence to support an alternative reading of the artist's intentions.

Artists have sometimes courted controversy by putting jokes in their work, perhaps a witty commentary, mocking artistic convention and even the institutions that may one day collect what they have produced. They have tried to evade detection by adding layers of ambiguity to their art, but it hasn't always been successful. Some of the artists featured in this chapter lived in exile, while others were either persecuted or suffered commercially and critically because their work was considered subversive by the authorities. Indeed, numerous artists drew on their previous persecution for inspiration, and some of their creative responses are included.

Musical allusions

Having gained acclaim for his early work, the Russian composer
Dmitri Shostakovich (1906–75) later suffered persecution during Stalin's
cultural purges when he was accused of writing music that was atonal,
dissonant and 'formalistic'.[1] His compositions are full of allusions to
traditional music and borrowed motifs. Notably, he drew on *Klezmer*,
traditional Jewish music, and incorporated its melodic motifs into
his *Piano Trio No.2* (1944). Jewish culture was regarded as anti-Soviet,
particularly under Stalin, and its inclusion in Shostakovich's music
has been interpreted as an act of dissent: 'in the depths of his heart',
wrote his son Maxim, 'he despised the system'.[2]

'A satisfied foreskin means a happy person'
Limestone *ostracon*

> Have workmen on building sites always been keen on sexual commentary? These workmen put their thoughts down on fragments of stone that were found in an excavated rubbish pit at about the same time as the discovery of Tutankhamun's tomb. **IH**

The Egyptian village of Deir el-Medina sits across the river Nile from Luxor. It was home to many of the artisans and craftsmen who built the tombs in the vicinity between about the sixteenth and eleventh centuries BC, during the New Kingdom period.

Excavations of the site commenced in the early 1920s, at about the same time as Howard Carter's sensational discovery of the tomb of Tutankhamun in the nearby Valley of the Kings. Yet the excavations at Deir el-Medina revealed a very different kind of treasure: here, beside the ruins of ancient dwellings, thousands of inscribed or painted *ostraca* were found in rubbish pits. A combination of dry soil and lack of later habitation created the perfect conditions to preserve these objects so that they could be recovered and studied by Egyptologists more than three thousand years later.

The subject matter of the pieces is very varied, providing a valuable snapshot of everyday life among the Egyptian non-elite. Some are evidently documents of a semi-official nature, for example lists recording absenteeism of workers on the tomb of Ramses II, while others record more personal information such as shopping lists or business transactions, marriages, divorces, and fragments of prayers.[3] The *ostraca* are too irregular in shape to have been used for long-term storage, and were most likely created as draft versions of documents. Ironically, it is these that have survived, while the final versions committed to papyrus have often long-since vanished.

A small proportion of *ostraca* are not writings but drawings, such as the one shown here that depicts an erotic scene and dates to the late Ramesside period, 1307–1070 BC. The drawing follows the aesthetic conventions of Pharaonic art such as that used in tomb paintings: for example, the way in which the eye of the female is drawn as if it were viewed from the front, even though her head is turned back at what seems to be an impossible angle, while her legs and those of her sexual partner are shown in profile. This could be just an informal expression of sexual desire or perverse thoughts, but the scribe's skills were used to depict something that would never be acceptable in formal art.

The scribe was obviously familiar with tomb paintings, and had perhaps worked on them personally. Crude though this sketch is, he (or so we assume) obviously understood the complex rules that defined Egyptian pictorial representations of the human body. Furthermore, the hieroglyphic inscription, which reads 'a satisfied foreskin means a happy person', shows that they counted among a minority, probably less than one per cent of the population, who could read and write.

This *ostracon* is not the only erotic scene from the Ramesside period to have parodied formal tomb painting. In an unfinished tomb at a mortuary complex at nearby Deir el-Bahri, known as the 'cave of the scribes' since its walls were used for practising literary works, a piece of ink graffiti still *in situ* features a female in an almost identical pose of sexual submission. The tomb is above the mortuary temple of Queen Hatshepsut, who reigned from about 1479 to 1457 BC. In that scene, the female figure may be interpreted as a caricature of the Queen herself, engaged in a sexual act with Senenmut, her Chief Steward, with whom she was rumoured to have had a relationship.[4] A commoner by birth, Senenmut gained the highest possible rank of office, and was permitted to place his tomb at the side of the royal complex, the construction of which he oversaw.

We might imagine, therefore, that the artists of these fragments had been employed to paint the magnificent tomb of a New Kingdom pharaoh or a high-ranking official, and made these sketches to keep themselves idly entertained during an afternoon off. The works might have been irreverent practice pieces, but they were obviously executed by educated individuals with subversive intent. Some may have been intended as satire on the latest court gossip, while others were designed to subvert official tomb iconography, and hence the funerary customs that were so highly revered by the Egyptian noble classes.

Right
Limestone ostracon with an erotic drawing and a hieroglyphic inscription on the far left, Egypt, Ramesside period (1307–1070 BC)

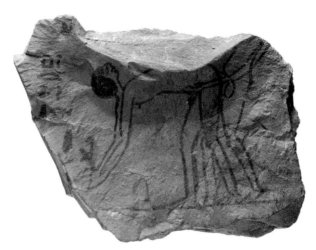

Naukratic figures

Sometimes objects may be regarded as subversive because their iconography diverges from what we might regard as 'official'. They convey individualistic behaviour and a stubborn refusal to conform to the imagery preferred by the state.

The city of Naukratis was situated on the Canopic branch of the Nile in northern Egypt, about forty-five miles from the sea. Founded in about 630 BC, it was a lively and vibrant metropolis, judging by the archaeological evidence, remaining the primary port of Egypt until about the third century BC. The site was discovered in 1884 and during successive excavating seasons thousands of small figurines were found. Ranging in date from around 620 BC to about 200 BC, many had been mass-produced in terracotta from moulds, while others were made from faience or carved in soft limestone. Distinct from elite representations of the religious pantheon, Naukratic figures challenge our perception of religious iconography in ancient Egypt, showing how ordinary people viewed their gods.

The main group of figurines are known as ithyphallic, meaning 'erect penis'. They depict a plump Egyptian child god with shaved head and side-lock, identified as Horus-the-child, although the Greeks knew him as Harpocrates. Victorian scholars initially dismissed the figurines as erotica, deeming them unsuitable for public display or study. Excavating in the 1898–99 season, the archaeologist Clement Gutch wrote that the 'large number of indecent types perhaps ought to be added to the list, but a discussion of their types is profitless'.

Horus-the-child was a symbolic representation of the future king, integrating the ruling dynasty into the everyday religious experience of Egyptians. He also symbolized the fertility of the Nile inundation, the annual flooding of the river that was vital for crop irrigation. In elite representations, exemplified by a cast bronze statuette in the British Museum, Horus-the-child is shown seated in formal pose. He wears the striped 'nemes' wig surmounted by a uraeus, emblem of royalty, over his forehead. A plaited side-lock is attached to the right side of the 'nemes' to symbolize his youthfulness and to indicate that he is heir to the throne of his father, Osiris. He holds his right index finger to his lips, a convention in Egyptian art to signify youthfulness, as does his slight chubbiness. Statues such as this have been found in exclusive temple sites, the areas where ordinary Egyptians would never have been permitted to enter.

By contrast, ithyphallic Horus-the-child figurines are dynamically poised, with grotesquely exaggerated phalluses that wrap around, or form the base of, the statues, becoming cushions and supports for other items. Often they carry frogs, symbols of the flood, while others

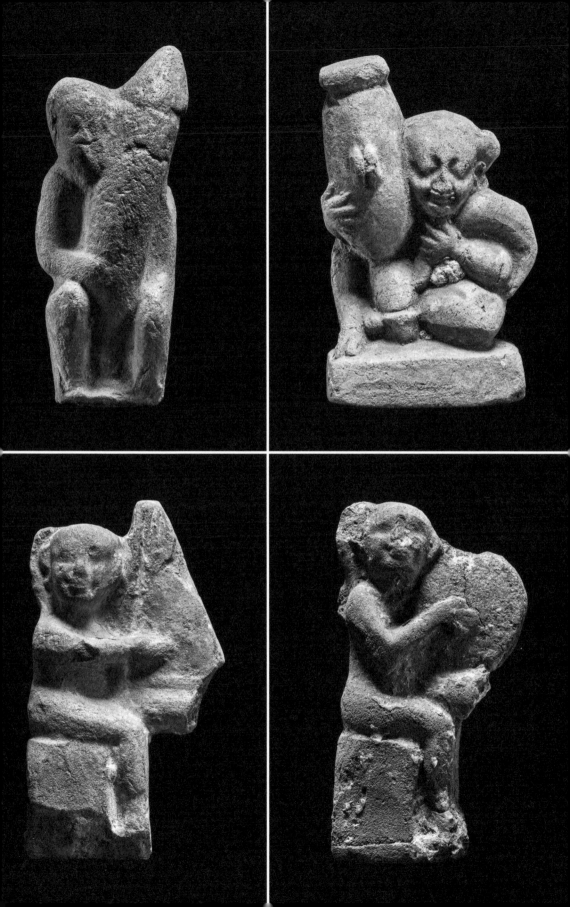

hold objects used during the annual religious festivals, processions and rituals including wine amphorae, libation bowls and musical instruments. Other figure groups depict mythical scenes, such as the return of Isis-Hathor, her union with Osiris and the conception of Horus. That event marked the New Year and was thought to induce the Nile flood, celebrated in Egypt as the 'Festival of Drunkenness'. Acquired from shrines during (and to commemorate) certain festivals, these powerful objects operated as protective amulets and were used in magical-medical rites by the populace. Some were deposited as votive offerings in the Nile during the festivals, while others were found in domestic dwellings.

Naukratic figures are, therefore, a manifestation of ordinary Egyptians' understanding of their religion, its pantheon, landscape and calendar, whose candid representations of fertility reflect the everyday concerns of the inhabitants for fertility, health and wealth. Furthermore, they demonstrate a deliberate rejection of official state religious iconography in favour of localized practice. Compared to elite representations of Horus-the-child in bronze, the contrast between 'high' and 'low' art could not be more pronounced.

The Strangford Shield

> Even in the Museum's famous Greek sculptures there is hidden trouble. The artist here made the mistake of literally putting himself in the picture. This was a dangerous act of defiant vanity – Pheidias was far too lowly for his portrait to be up there on the goddess Athena's shield, among the gods and heroes on the Parthenon. He would have fared much better if he'd just written 'Anon' at the bottom of it. **IH**

Many artists have chosen to hide in plain sight, including self-portraits in works in which they are not the intended subject. This show of vanity is not usually considered rebellious. When, however, an artist chooses to defy religious convention by placing themselves prominently within a major public commission, the consequences of such a discovery can be more severe. One act of subversive hubris is said to have landed its perpetrator in prison, and it happens to be in what is arguably the most famous public commission in the British Museum's collections, the Parthenon sculptures.

Named after a former owner, the Strangford Shield isn't, strictly speaking, one of the Parthenon sculptures.[5] It is a Roman copy, from

about the third century AD, of the Greek original, now lost. The original shield is said to have been made from gold and ivory, and it was part of a twelve-metre high colossal statue of Athena that stood in the cella, the inner chamber of the Parthenon on the Athenian acropolis. It was the work of Pheidias (c. 480–430 BC), the most important sculptor, painter and architect in classical antiquity. He was commissioned to work on the Parthenon by the Athenian statesman Pericles (c. 495–429 BC). The shield of Athena features the Amazonomachy, a mythical battle between Greeks and Amazons (all-female warriors), with a Gorgon's head at the centre. Its theme was unlikely to have been the invention of Pheidias, more likely it was approved as part of the programme for the whole of the Parthenon.[6] Whereas the original shield was huge, thought to have been a little less than five metres in diameter, this copy is much smaller, having a diameter less than fifty centimetres across, and it is broken in half.

Right
The Strangford Shield: Roman marble copy of the shield of the gold and ivory statue of Athena from the Parthenon, AD 200–300

In a story related by the Greek writer Plutarch (*c.* AD 45–120),
Pheidias is said to have flouted convention by including portraits of
both himself and Pericles on the shield. Plutarch says that he 'carved
a figure representing himself as a bald old man lifting up a stone with
both hands, and also…a particularly fine likeness of Pericles fighting
an Amazon. The position of the hand, which holds a spear in front
of Pericles' face, seems to have been ingeniously contrived to conceal
the resemblance, but it can still be seen quite plainly from either side'
(*Pericles*, 31.4). One can clearly see the 'bald old man', as described by
Plutarch, on the Strangford Shield, below the head of the Gorgon.

Including a personal portrait on a temple sculpture was no doubt
impious. It was equally foolish for Pheidias to depict himself shoulder-
to-shoulder with Pericles, implying that he held equal status with the
leading Athenian politician of the day. Pheidias had not intended his
secret portraits to be discovered but, according to Plutarch, his close
personal relationship with Pericles had brought him enemies.
Professional jealousy apparently led to his betrayal by an artist he had
employed. Plutarch says that he was thrown into prison where he fell
sick and died (*Pericles*, 31.5). Other accounts state that he was poisoned,

others still that he survived and escaped into exile. The punishment of Pheidias seems unnecessarily severe; it is possible that the story is either incorrectly told or more complicated. There was some suggestion, for example, of embezzlement. Pheidias was accused of siphoning some of the forty talents (about a ton) of gold in tribute money that was intended for the statue, which he strenuously denied, asking for the gold on the statue to be removed and weighed.

In Plutarch we are fortunate to have a written source that provides additional context to the scene illustrated on this shield. It invites the question of how many other subversive images and messages might be concealed in the Parthenon sculptures, and indeed elsewhere in other sculpture collections, set to remain hidden because no literary sources survive to offer up their secrets.

Fascination of Nature
Xie Chufang, 1321

This seemingly beautiful scroll shows that there is a long tradition of Chinese artists having to conceal subversive messages in their work. Seven hundred years ago, this artist created what first appears to be a delightful study of natural life, but turns out to be a damning allegory of rapacious life under the Mongol invaders. The implication is that the new regime has reduced civilized humans to behaving like insects. **IH**

Observations on the natural world had emerged as a favoured genre in Chinese art by the time of the Song dynasty, which ruled China from AD 960 until 1279. It features in a range of media including porcelain, furniture, textile design, architectural ornaments, prints and paintings, with flower and bird images being especially popular. Nature paintings were not merely representations of the world of animals, flowers, plants and insects, however, but also offered a parallel to human existence. Humans, it was implied, should empathize with and learn from nature.

This scroll, the only known surviving work by the artist Xie Chufang, is a depiction of insect and plant life, continuing the meticulous attention to detail perfected under the Song.[7] Each scene represented along the three-and-a-half-metre painted section is centred upon a plant, or cluster of plants, surrounded by anatomically correct insects, both on the ground and airborne.[8] As the scenes unfold it becomes clear that we are witnessing a struggle for survival between predators

and their prey. Ants dismember a butterfly, while a toad lies in wait for a straying insect under the large leaf of a common plantain. In one deadly scene a cicada lies helpless on its back as a praying mantis descends, while in another the cicada is already within its grasp. This scroll painting has been interpreted as an allegory for the difficult times faced by China during a period of intense political and cultural upheaval, a result of the Mongol invasion in the later thirteenth century that culminated in the overthrow of the last Song dynasty emperor in 1279. It was the first time in history that China had been subjected to foreign rule. The repercussions were huge: many scholars loyal to the Song retired into seclusion, refusing to participate in the political and cultural life of the new regime.

China was still under Mongol occupation when the scroll painting is believed to have been completed, in 1321. Xie Chufang's painting is accompanied by a series of poems in Chinese, probably composed by contemporaries of the artist, including this verse:

Small insects labour to eat, each to his own,
Hiding and spying, ambushing, they prey on each other.
Immoral men seek profit not according to justice,
Their wisdom is also at the level of those kinds.[9]

The signature seal accompanying the verse carries the name Chen Shen, who has been identified as a *yimin* or 'left-over subject', a former member of the literati who went into self-imposed exile. Chen Shen, along with many other scholars, faced a dilemma: 'whether to work for the new Mongol dynasty and survive, or remain loyal to the fallen

Above
Fascination of Nature,
Xie Chufang, 1321

Opposite
Detail from the *Fascination of Nature* showing a toad lying in wait for an insect under the leaf of a common plantain

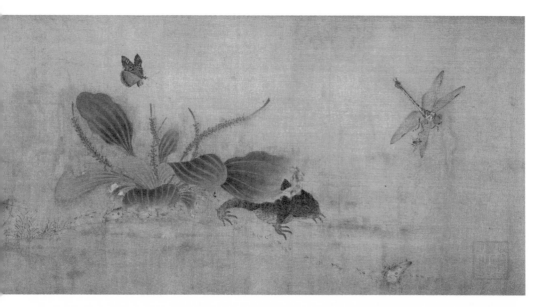

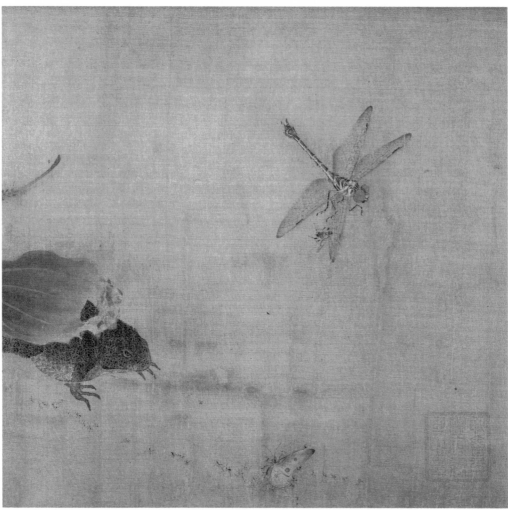

Song imperial dynasty and starve'.[10] He chose the latter, abandoning his candidacy for state examinations, by which scholars were recruited for government service, following the fall of the Song. In any case, state exams were abolished shortly afterwards by the Mongols. He entered self-imposed seclusion and by the 1320s was in hiding, one of many poets and painters who were either unable or unwilling to cooperate with the Mongol government. He and others, including the painter of this scroll, expressed their frustrations by concealing metaphors in their work.

Croquades faites à l'audience du 14 nov. (Cour d'Assises) Charles Philipon, 1831

Caricaturists often notice a simple physical characteristic of a target which then comes to define them. In this case Philipon decided that the King looked like a pear and made a wonderful drawing of Louis Philippe turning into the fleshy fruit. Add in the double meaning of the French word *poire* – pear or idiot – and you have a classic of the genre. **IH**

For most of the nineteenth century France had the most stringent censorship laws of any country, banning almost anything that was perceived to be critical of the monarchy or the government. During the few periods in which censorship laws were not so strict, the French government, being extremely sensitive to satirical imagery, often prosecuted artists and publishers for libel: 'a large percentage of the poor were illiterate, but they were not blind, and although thus relatively immune to subversive printed words, they were considered highly vulnerable to printed pictures.'[11] Journalist, publisher and caricaturist Charles Philipon was one such victim of the libel laws; he was brought to trial in November 1831 charged with *lèse majesté*. His satirical newspaper *La Caricature* had recently published a series of pieces that were increasingly critical of Louis Philippe I (reigned 1830–48).

Prosecution in relation to the printed image has always been difficult: caricatures are, by their nature, grotesquely exaggerated, and one could always mount the defence that they were never meant to be taken seriously. During his trial Philipon emphasized this point, drawing a sequence of sketches in which Louis Philippe gradually metamorphoses into a pear. In support of his defence, Philipon argued that the King's image represented the government and that the satires

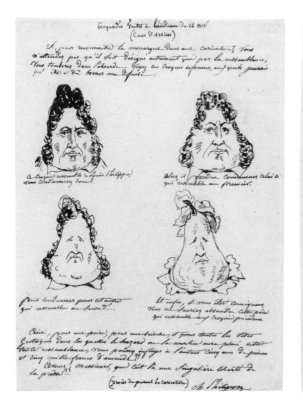

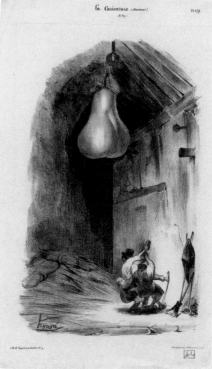

Above left

Croquades faites à l'audience du 14 nov. (Cour d'Assises) ['Sketches made at the hearing of 14 November'], Charles Philipon, *La Caricature*, 1831. Four sketches of King Louis Philippe I's head, which progressively show his resemblance to a pear

Above right

Ah! his!... ah! his!... ah! his!... ['Heave-ho! Heave-ho! Heave-ho!'], Honoré Daumier, *La Caricature*, 19 July 1832. Daumier's satirical print shows three figures in a barn hoisting an enormous pear symbolizing Louis Philippe

were not expressly directed against Louis Philippe. Realizing that he could do little to affect the outcome of the case, Philipon had turned the trial into a *coup de théâtre* setting out 'to demonstrate the absurdity of the prosecution's case that the [former] caricature was seditious… by proving that anything could be held to resemble the king.'[12] Showing the King as a pear was also a play on words, because the French word for pear, 'poire', can also mean 'dummy' or 'simpleton'. The four sketches were published in *La Caricature* on 24 November 1831.

At the end of the trial Philipon was given a six-month prison sentence and fined 2,000 francs, but he possibly had the last laugh: thereafter pear imagery became indelibly associated with the popular image of Louis Philippe. *La Caricature* published more prints showing just a pear, including the lithograph illustrated, by Honoré Daumier (1808–1879), in which three figures inside a barn hoist a giant pear. Pear graffiti reportedly began to appear on the streets of Paris and elsewhere in France. Also illustrated is a cartoon by Auguste Bouquet, *Voulez vous aller faire vos ordures plus loin, polissons!* ('Kindly take your filth elsewhere, you brats!'), which appeared in *La Caricature* in 1833. The viewer is supposed to recognize immediately that the graffiti being drawn represents the King, making the point that even children were in on the joke.[13]

In 1835, the French government codified the first in a series of laws whereby 'no drawings, engravings, lithographs, medallions, prints, or

Above
*Voulez vous aller faire vos
ordures plus loin, polissons!*
['Kindly take your filth elsewhere,
you brats!'], Auguste Bouquet,
La Caricature, 17 January 1833

emblems of any kind may be published, displayed, or sold without
the prior authorization of the Ministry of the Police of Paris or the
prefects of the departments'. This made it all but impossible to publish
political satire in France, and *La Caricature* was forced to close.
Censorship would remain law in France until the abdication of Louis
Philippe during the 1848 Revolution. It was then re-instated after 1852,
during the Second French Empire of Napoleon III.[14] Censorship laws
were eventually repealed in 1881, but in 1893 France passed its first
anti-terror legislation. These laws were immediately condemned as *lois
scélérates*, 'villainous laws', owing to their curbs on freedom of expression.

Theatre censorship in France

In addition to the printed image, censorship in France impacted upon all published texts, music and theatre. Plays were redacted and some were banned altogether, especially during periods of political crisis. Until 1864 theatres had to apply for licences to operate, and the number of performance spaces was therefore greatly reduced. Despite the restrictions, or perhaps because of them, theatres remained complicit in the defiance of censorship. One method, perfectly legal, was to publish a play in its uncensored state. Audiences would buy the manuscript and follow the text during a performance, filling in the censored gaps in the audible dialogue *en masse*. As a play neared the end of its theatrical run performers might gain in confidence themselves, gradually reinserting redacted elements. The bureaucracy of the dramatic censorship was not extensive enough to provide an observer at every performance and besides, at the end of a run any threat of closure was largely impotent.[15] The audience, clearly complicit in these games of cat and mouse with the censor, must have delighted in what was being played out before them.

Right
Illustration from Victor Hugo's play *Le roi s'amuse* [The King amuses himself], first performed in 1832, but banned after a single evening. Although set in the 16th century, the play was perceived as an attack on Louis Philippe. Print by Adolphe Lalauze after François Flameng, *c.* 1885

Tricking the authorities[16]

> We lived in Nigeria when I was a child, in the early 1960s, just after it had achieved independence from Britain. My parents brought back carved heads and decorated fabrics to England with them when we moved home, which added an exotic flavour to our house in Sussex. So, when I saw these doors, I recognized the skill of the artist but was delighted to find out that the panels were also quietly having a laugh at people like us. IH

These door panels were carved by Ar'owogun of Osí, Ekiti, in Nigeria. He established a workshop at Osí in the late 1890s and during a career spanning several decades carved many sets of doors for local Yoruba chiefs. The examples shown here, at more than two metres high and each consisting of seven panels in low relief, are masterpieces of Yoruba craftsmanship. The carving mixes traditional motifs, such as women holding baskets, with images of colonial administrators, identifiable by their 'pith' helmets, depicted riding motorcycles. They are accompanied by local attendants, who stand on the motorcycle mudguards. Others are shown smoking pipes or playing musical instruments. It is now believed that these figures don't just represent colonial assistants, the apparatchiks of empire, but Eshu-Elegba (Areogun), a god in the Yoruba pantheon who acts as a messenger between the human and spirit world. He is a very important god, because he takes prayers and sacrifices to the other world, and therefore needs to be honoured and placated. However, he is also a prankster who plays tricks and jokes, and who is defiant and irreverent in the face of authority. It is thought that on these door panels the joke is directed against the colonial authorities. Fiona Savage, a specialist in West African history, explains:

Opposite
Three wooden door panels by Ar'owogun of Osí, Yoruba people, Nigeria, early 20th century

> Eshu has a mischievous nature and subverts authority as part of his role as mediator between humanity and the gods. He is also sexually provocative and the pipe can be interpreted as a phallic symbol. In effect, he is depicted on some door panels as being disrespectful and provocative towards the agents of colonialism! The imagery was deliberately designed to be ambiguous, so that there can be no right or wrong way of interpreting them. To me this is a part of their charm.[17]

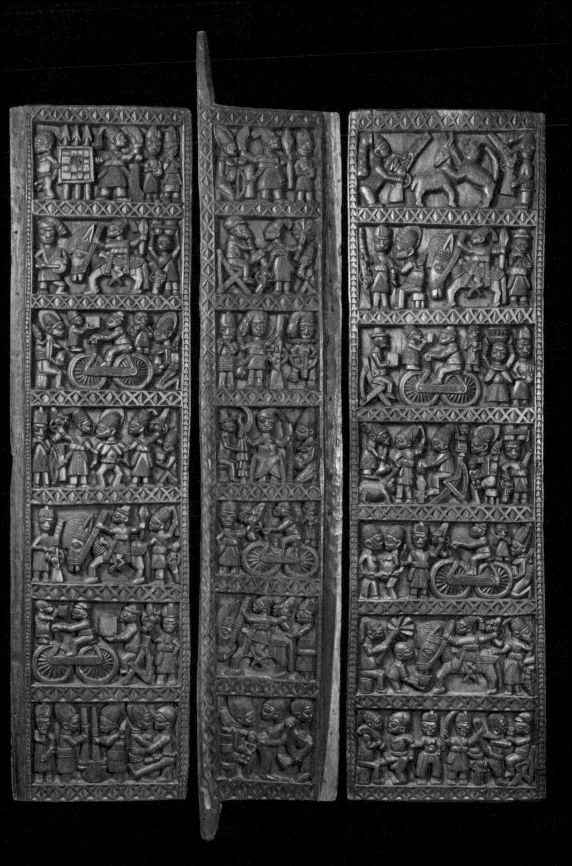

NIGERIA—PAVILION AND CRAFTSMEN'S WORKSHOPS.

Above
British Empire Exhibition
poster, 1924

Left
Photographic postcard of the
Nigeria pavilion and craftsmen's
workshops where the doors were
displayed at the British Empire
Exhibition, 1924

The panels were brought to England and displayed at the British
Empire Exhibition at Wembley in 1924. One can imagine the artist's
delight in the irony that his anti-colonial imagery was to be included
in an exhibition intended to celebrate and strengthen ties between
Britain and its colonial subjects.

Chinese Republican-era tea wares

In China, the decoration of tea wares is as old as the tradition of tea drinking, with the surface of the ceramic providing a canvas where painting and calligraphy may be combined. The messages these pieces convey became increasingly politicized in the early twentieth century, especially during and after the collapse of the Qing dynasty in 1911. The fall of the Qing meant that China's major ceramic producing city, Jingdezhen, lost its royal patron and had to turn to the commercial market. Responding to these new possibilities, ceramic designs began to incorporate symbolism and imagery that reflected diverse political allegiances.[18] One such teapot, decorated with black peonies, is now in the British Museum.

Kilns were very capable of producing ceramics with a range of polychrome enamels, and the choice of monochrome on this teapot is probably charged with symbolic significance. The images on the teapot resemble a dark purple blossom known as the so-called 'inky peony' (*mo mudan*), which was particularly rare, and therefore associated with high status. Furthermore, the inversion of colour is reminiscent of a line from a poem by Qu Yuan (*c.* 340–278 BC), called 'Embracing Sand'. In his lament for his disgrace by the court, Qu Yuan writes that 'white is changed to black; the high are cast down and the low made high'. Since at least the Song dynasty (960–1279) colour reversal had been a metaphor for gross injustice and misfortune, suggesting that this teapot was created for Manchus who mourned the collapse of the Qing, identifying with the loss of status and position that the metaphor invoked.[19]

The tea ceremony itself could also be loaded with symbolism and political meaning: '[l]ate Qing dynasty guide books are said to have advised readers to be aware upon entering a teahouse of political meanings signaled by teapot and teacup placement'.[20] Five cups arranged in the shape of an X, with the cup at the centre left empty, could be construed as code for restoring the Ming, the dynasty that preceded the Qing. Cognoscenti would activate the code by filling the centre cup and then draining it. Five cups in a U-shape with the cup at the bottom filled with tea while the remaining four were left empty, was meant to express support for the overthrow of the Qing.

A second teapot in the British Museum dates from the time of the Manchurian incident when, in 1931, the Japanese military faked a Chinese dissident attack on a Japanese-owned railroad as a pretext for invasion. The teapot, featuring a mountainous scene with trees and a river, is a metaphor for patriotism and nationalist fervour. The association of landscape with Chinese nationalism has a long history, stretching back at least as far as the opening line of a poem by Du Fu

that begins with the phrase '[t]he Kingdom is shattered, mountains and rivers remain' (*guopo, shanhe zai*). The scene on this teapot therefore acts as a metaphor for continuity in the face of adversity. On the reverse, also referencing the Japanese invasion, is the inscription 'never forget the country's shame' (*wuwang guo chi*).[21]

'The skin of the leopard is beautiful, but inside it is war'

Mobutu was a brutal and corrupt military dictator (supported by the West for a very long time). Any act of opposition had to be subtle not to be dangerous and this example uses Mobutu's carefully cultivated symbol of the leopard against him. **IH**

Raffia cloths of this type are commonly woven into clothing in the Democratic Republic of Congo (DRC). This cloth, however, has a fringe border and its slightly unusual dimensions, at just more than sixty centimetres square, means it was unlikely to be worn but more probably used to decorate the interior of a private dwelling. Its design shows a leaping leopard and a Congolese proverb that reads *la peau du leopard est belle, mais l'interieur c'est la guerre* ('the skin of the leopard is beautiful, but inside it is war'). This is possibly a political comment in opposition to the dictatorship of Joseph Mobutu (also known as Mobutu Sese Seko), president of the Democratic Republic of the Congo, which he renamed Zaire, from 1965 until 1997.

A committed nationalist and anti-colonialist, Mobutu's political career began in the late 1950s as personal aide to Patrice Lumumba, president of the Congolese National Movement, whom Mobutu betrayed to his death in 1961. There followed a succession of weak governments until Mobutu staged a second coup in 1965, deposing the president and establishing a one-party authoritarian state. Aged only thirty-five when he seized power, his youthful countenance might account for the references to superficial beauty in the raffia cloth proverb.

The archetypal military dictatorship, Mobutu's regime practised or condoned torture, deaths in detention and public hangings.[22] Stripping the country of its European influences, he began to foster a personality cult based on easily recognizable African symbols, such as a leopard, that presented him as an all-conquering warrior hero. In public he adopted a distinctive costume consisting of a Tanzanian-style suit with leopard-skin hat.[23]

At the expense of the Congo's already fragile economy, Mobutu proceeded to treat the state treasury as his personal piggy bank, amassing a personal fortune estimated at up to five billion US dollars, which he held mainly in Swiss bank accounts. One French official dubbed him 'a walking bank vault in a leopard-skin hat'.[24] While the country languished in economic stagnation and civil unrest, Mobutu treated himself to countless luxuries including a fleet of Mercedes cars,

Opposite
A fringed square of woven raffia cloth featuring a leaping leopard and Congolese proverb meaning 'the skin of the leopard is beautiful, but inside it is war', 1970s–90s

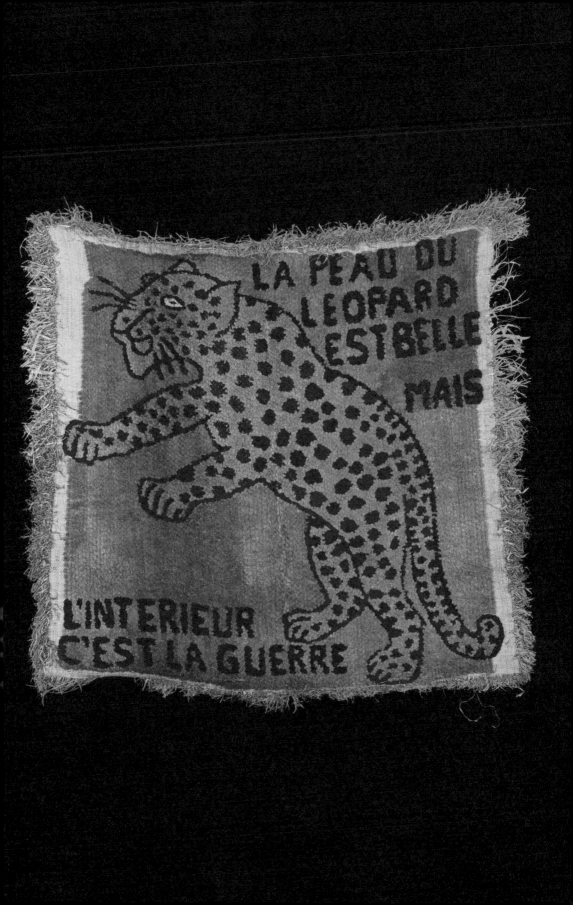

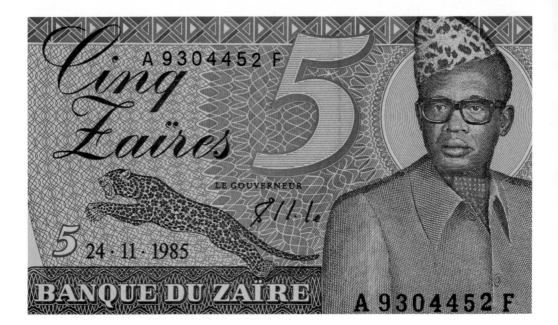

mansions on the French Riviera, lavish parties and a collection of
14,000 bottles of wine all of 1930 vintage, the year of his birth.[25]

Mobutu's regime counted on the support of the West for its survival,
which saw him as an ally against the Soviet Union. He was once described
by US President George Bush, as 'one of [America's] most valued
friends'. This support ended along with the Cold War and in the 1990s
Mobutu was forced to implement democratic reforms, entering a
power-sharing deal. He was eventually deposed amid civil war in 1997.
Already ill with cancer, he died a few months later in exile in Morocco.
The DRC underwent political and economic reforms in the 2000s, but
its recovery from the civil war has been long and slow, and it still counts
among the least developed or politically stable countries in the world.

Czechoslovak 1 koruna coin

Sometimes the biggest stories come in the smallest packages. A protest
against the government of Czechoslovakia remained a secret for years
after the end of communist rule in 1989. It concerns the design of the
1957 Czechoslovak 1 koruna coin, which features a woman kneeling to
plant a linden tree sapling. It was designed by Czech sculptor Marie
Uchytilová-Kučová (1924–1989), and the model was an imprisoned
scout leader. This absurd scenario – whereby a dissident became the
emblem of a regime that had persecuted her – would have remained
secret, except that the 'model', Bedřiška Synková (born 1935),
came forward to explain her story in the early twenty-first century.

In the mid-1950s the Czechoslovak communist party clamped down
on many independent organizations, including those for young people,

such as the international Scout movement, which was targeted owing to its religious foundations. It founded an alternative youth association, the Pioneers, based on socialist values. Nineteen-year-old scout leader Bedřiška Synková ignored the ban, assuming that the authorities wouldn't trouble themselves to enforce it. As she later said, 'we weren't doing any harm to anyone, that was not our intention, but we saw no reason to respect the ban on Scouts organizations because it was not clear why it was imposed'.[26] She was arrested in 1955 and sentenced to ten years' imprisonment. Barely a year later the competition was launched to design the new Czechoslovak 1 koruna coin.

At the time, Synková's mother was employed as a secretary at the Prague Academy of Fine Arts, where the sculptor Marie Uchytilová-Kučová was teaching. After hearing about the girl's plight, the sculptor asked the mother for a photo of her daughter and based her coin design on it, as the imprisoned scout later recalled: 'she was so angry about what happened to me. She told my mother – bring me her photograph and I will try to get her on the one-crown coin. But nobody must know about it.'[27] The sculptor reportedly positioned the kneeling female figure facing west, indicating where her political sympathies lay.

The judges disliked Uchytilová-Kučová's submission, selecting another competitor's. Ironically, the Minister of Finance personally overturned their decision, vetoing the winning design in favour of the secret subversive version. It was duly engraved by the Mint and became the main coin of Czechoslovakia, being issued right up until the separation of the Czech and Slovak Republics in 1993. The motif was widely reproduced, including being adopted as the logo of the Slovak State Savings Bank.

Below
Czechoslovak 1 koruna coin,
1957

Opposite above
Marie Uchytilová-Kučová, designer
of the Czechoslovak 1 koruna
coin, photographed holding
a model of the coin in 1980

Opposite below
Detail from a Slovak State Savings
Bank book, showing the logo that
incorporated the design of the
1 koruna coin, 1970

Overleaf left
Woven Afghan war rug with a
wide, deep red border featuring
a convoy of tanks with machine-
guns, 1980s. The central image
is of an Afghan soldier attacking
a Russian soldier

Overleaf right
Woven Afghan war rug with a
central design featuring repeated
rows of helicopters and tanks,
and abstract patterns woven
between the two green outer
borders, 1980s

Owing to the tireless and heroic efforts of her mother, who took the unusual step of delivering her application to the Central Committee of the Communist Party in person, the young scout was released from prison after five years. As she later recalled, 'what worked in our favour was that the party leaders did not trust one another – there was fear of putting a foot wrong and they didn't know if the person who brought it was somebody important'.[28] Incredibly, this was sufficient to ensure that the application moved swiftly through the bureaucratic channels, all the way to the country's president, Antonín Novotný, whose signature was required on the form.

After she came out of prison, Bedřiška Synková met Marie Uchytilová-Kučová for the first time, the latter gifting the former with one of the newly minted 1 koruna coins. After the failure of the Prague Spring in 1968 Synková defected, later moving to Switzerland. The sculptor continued to teach at the Prague Academy of Fine Arts. She died on 16 November 1989, a day before the start of the Velvet Revolution that led to the overthrow of the communist regime in Czechoslovakia.

Afghan war rugs

As far as I can tell, Russian imperialism gets a fairly easy ride in the Museum collection, so it was interesting to come across a twentieth-century protest opposing Soviet, rather than Western intervention, for a change. Interesting, too, to find that rugs are another everyday item through which dissent can be expressed. These seemingly traditional designs work by making you do a double take. At first you see just a pattern and then on a second look you notice the less than traditional Russian military hardware. **IH**

Across the Indian subcontinent, Iran and Central Asia, the production of intricately patterned woven rugs is an important, centuries-old class of work for women and girls. Numeric patterns and colours have to be committed to memory, requiring a great deal of skill and attention to detail, with the result that designs tend to stay static. A notable exception is a genre of rug weaving developed by the Baluch women of Afghanistan, called *aksi*, or 'pictorial' rugs. These combine flowers, trees and geometric shapes with animals, people and landscapes.[29] A sub-genre of these, known as 'war rugs', came to prominence during the Soviet-Afghan War (1979–89). The earliest examples introduced war imagery as subtle interventions amid abstract floral and leaf

borders, among which one might find various kinds of Soviet weaponry including helicopters, MiG jets, assault rifles and hand grenades. Later, war iconography dominated the main field as on another rug illustrated here showing an Afghan soldier attacking a Russian soldier, while an Afghan and a Russian soldier look on (p. 174). In the style of traditional miniature paintings of scenes from the *Shahnameh* (Book of Kings), the medieval Persian national epic, the Russian soldiers are depicted as horned white demons ('divs' in Persian). The hero of the *Shahnameh*, Rustam, is represented here by the Afghan soldier who slays the evil White Div.[30]

After 2002 weavers in the region outside Kabul added a further genre that might be termed 'War on Terror' rugs. It is thought that the inspiration for many of these designs may have been propaganda leaflets dropped by the US during the invasion of Afghanistan following the September 11 attacks in 2001.[31] Smaller in size and featuring only overt imagery, these rugs were probably made for American soldiers, who could roll them up and carry them home as mementos of their tour of duty.

I Modi

There have been many moralizing outbursts in history, usually aimed at checking perceived licentious behaviour. During the Renaissance, at the behest of the Catholic Church there was widespread censorship. As a result, very few leading artists produced works that were explicitly erotic.

I Modi, which translates as 'The Positions', might best be described as the Italian Renaissance's answer to the Kama Sutra.[32] They were a group of erotic engravings drawn by Giulio Romano, a former student of Raphael, and engraved by a printmaker, Marcantonio Raimondi, in about 1524. The engravings show heterosexual couples engaged in a series of sexual acts, assuming postures 'that are energetic and explicit, fanciful enough to amuse, yet close enough to the possible to give the appearance of models of erotic dexterity.'[33] And what was worse, said the Renaissance art historian Giorgio Vasari, 'for each position Messer Pietro Aretino created a most obscene sonnet. So that I do not know which was worse: the vision of Giulio's drawings to the eye, or the sound of Pietro's words to the ear.' He piously added that 'one should not employ God-given gifts (as so often happens) for disgraceful purposes and in completely detestable things.'[34]

The prints were greeted with uproar and were banned by Pope Clement VII. Giulio Romano escaped to Mantua and Marcantonio was thrown in prison. Fortunately he had powerful friends, including Cardinal de' Medici and Baccio Bandinelli, who served the pope in Rome and were able to secure his release. Efforts by the Church to suppress and destroy *I Modi* were almost a complete success, and the earliest surviving

engravings exist as little more than a handful of prudishly pruned
fragments. A group of these, mostly consisting of some oddly angled heads
and torsos, is in the British Museum. Most of what we now know about
them comes from sixteenth-century woodcut copies. These are artistically
poorer in quality but at least convey the basic outline of the positions.

Surviving impressions of *I Modi* were secretly circulated in defiance of
the censorship, and among those who saw them were the maiolica painter
Francesco Xanto Avelli, known simply as Xanto. He incorporated the
scenes into some of his painted ceramics, but concealed the reference by
painting the figures clothed. One such dish in the British Museum
features an allegorical scene showing the Battle of Pavia in 1525 (p. 178).
The fallen figure seen at the lower centre of the composition is the
defeated king, Francis I. The way in which he is lying directly replicates
that of a reclining female in one of the Positions. The print illustrated
(p. 179) is a later copy after the lost original. On the dish Francis I is fully
clothed and instead of embracing a lover he clutches a shield.

Removed from its original context and minus the sexual partner the figure strikes a rather odd pose, to the extent that one might initially call into question the artist's abilities at figure drawing. This reflects Xanto's scissors-and-paste technique in constructing allegories, often with his own explanation and a literary reference on the back with his signature and date, affirming his status as artist and poet. His willingness to compromise technical virtuosity to reproduce a scene from *I Modi* leaves little doubt, therefore, that this was a deliberate and symbolic act. It also reflects the high level of visual literacy that he expected from the wealthy elite, or cognoscenti, who bought his dishes, and who could read and enjoy these coded messages.[35] As Dora Thornton, Curator of Renaissance Europe at the British Museum says, the dish was a calculated dare: 'Grayson Perry is not the first modern artist to make political points through pornography on pots. You were supposed to recognize Xanto's sources and his inventiveness in giving them new meaning.'[36] Since all the ceramics were signed by him and he identified the subject on the reverse, we can assume that his actions carried minimal risk to himself.[37] But what was the message? By evoking a position associated with female sexual submission in the minds of his contemporaries, Xanto may have been attempting to emasculate Francis I, humiliating him by implying his impotence as king.[38] Francis I had been recently defeated

in battle on Italian soil by Charles V, emperor of Spain. Xanto's attack on Francis I might have been further motivated by antipathy towards the pope. Clement VII (1523–34) was one of several popes elected from the Medici, the leading Tuscan family. Clement's personal failings, namely his inability to negotiate successfully the complexities of continental power-brokering, eroded his own power-base in Italy. As pope during the Italian War of 1521–26 he constantly switched sides, at times favouring Francis I and at others Charles V, who had a claim to territory in Italy. He was powerless to stop the Sack of Rome by mutinous troops of Charles V in 1527, and he was held morally accountable by many Italians for the widespread destruction, interpreted as divine retribution on a corrupt city. At the time of the Battle of Pavia, Clement was supporting Francis I. Perhaps Xanto's adaptation on his dishes of motifs from the very prints banned by the pope, was his own act of rebellion. It was an artistic means of giving Clement VII, Francis I's one-time supporter, the proverbial middle finger.

Bank Restriction note

This may be my favourite object in the exhibition. I wrote a play about the publisher William Hone and his friend the cartoonist George Cruikshank (with my cartoonist friend Nick Newman). This great satirical double-act produced combinations of witty words and arresting pictures. They were funny and bold and this imitation banknote is a savage attack on the Bank of England's draconian forgery laws. By making a forged note themselves, they were protesting the persecution of the poor who resorted to using forgeries. It looks like a real banknote and then you notice the grim details. Priceless. **IH**

The son of a celebrated eighteenth-century caricaturist, George Cruikshank (1792–1878) combined his father Joseph's cutting satire with a concern for social injustices. An example of one of his satirical prints is included earlier in this book (pp. 68–69), but this work focuses our attention on his career as an activist. It is an imitation banknote, known as a 'skit note'. In 1818, Cruikshank wrote that he had seen two women hanging from the gibbet while walking down Ludgate Hill. Their offence, he learned, was to have passed forged £1 notes. The Bank Restriction note was his response – a mock forgery or a gruesome parody, depending how one interprets it, of a Bank of England note – published by William Hone (1780–1842) in 1819. The Bank's emblem, Britannia, is shown devouring an infant, a metaphor

Opposite above
Bank Restriction note, George Cruikshank, published by William Hone, 1819

Opposite below
Detail of Cruikshank's Bank Restriction note showing Britannia devouring a child. Four ships sailing under the banner 'Transport' reference the punishment awaiting those convicted of possessing forged notes

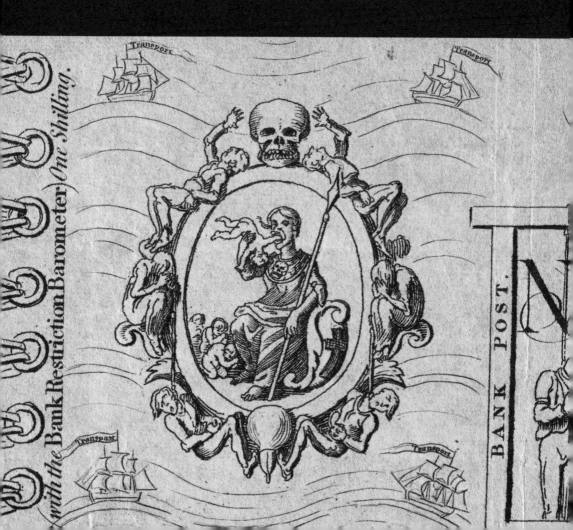

Bank Restriction.

No AD LIB to No AD LIB

BANK POST. BANK POST.

During the Issue of Bank Notes easily imitated, and until the Resumption of Cash Payments, or the Abolition of the Punishment of Death,

For the Govr. and Compa. of the
BANK OF ENGLAND.

J. Ketch.

BANK RESTRICTION NOTE
Specimen of a Bank Note — not to be imitated.
Submitted to the Consideration of the Bank Directors and the inspection of the Public.

Published by WILLIAM HONE, Ludgate Hill.—Price... the Bank Restriction Barometer, only One Shilling.

Entd. at Stationers' Hall.

with the Bank Restriction Barometer) One Shilling.

Transport

BANK POST.

for state executions that compared hanging to cannibalism. The pound symbol is substituted for a noose and eleven hapless men and women swing from the hangman's gibbet. Below are the words 'For the Govr: and Compa: of the Bank of England'. The chief cashier's signature is replaced by 'J[ack] Ketch', after the notorious seventeenth-century executioner.[39] The note was sold for a shilling and proved highly lucrative, earning Cruikshank and Hone around £700.

The title of Cruikshank's parody took its name from the Bank Restriction period when war with France forced the British government to cease issuing gold coins. Instead it relied upon a vast network of private banks, informally regulated by the Bank of England, to issue low-denomination currency notes in England and Wales.[40] These included the first £1 and £2 notes in 1797, which resulted in a massive increase in the amount of paper money in circulation. This in turn led to a corresponding rise in counterfeiting.

Deliberately forging or altering a note was considered a capital offence, punishable by death. Controversially, it was also a capital offence to be either in possession of or to 'utter', meaning to pay with, a counterfeit banknote.[41] This was a particular problem with smaller denomination notes owing to low literacy levels among the poorer class, which affected a person's ability to spot a forgery. When banknotes were all high-denomination they circulated almost exclusively among the wealthy and educated classes. People further down the social strata were now using banknotes, which meant that an innocent mistake could result in arrest. The Bank of England employed the law firm Freshfields to prosecute counterfeiters and utterers, which it did so with vigour: the odd execution would provide a much-needed deterrent to other would-be forgers, reasoned the Bank.[42]

Old Bailey banknote forgery trials record that between 1804 and 1834 fifty-eight people were hanged for counterfeiting offences.[43] A far greater number, several hundred in total, entered a plea bargain, in which they pleaded guilty to possessing or uttering forged notes and received a lesser sentence, usually fourteen years' transportation to Australia. This was effectively a life sentence since there was little hope of ever returning. The ships surrounding the infant-devouring Britannia on Cruikshank's note may be a reference to this punishment.

Prisoners convicted of uttering were put in jails around the country, sometimes waiting months or even years for the next convict transport. Conditions were usually awful and the health of many prisoners suffered. Newgate Prison in London was particularly notorious, and one can see why from a contemporary description of its women's cells:

Nearly three-hundred women, sent there for every gradation of crime, some untried, and some under sentence of death, were crowded together in the two wards and two cells…Here they saw their friends and kept their multitudes of children… they slept on the floor at times one hundred and twenty in one ward, without so much as a mat for bedding, and many of them were very nearly naked…Everything was filthy to excess, and the smell was quite disgusting. Every one, even the Governor, was reluctant to go amongst them.[44]

While awaiting transportation, many destitute convicts contacted the Bank of England begging for charitable assistance. It is a bizarre irony that the Bank was to provide financial support to the very people against whom it had pursued prosecutions. The case of 20-year-old Elizabeth Denham was not unusual. She had been arrested in November 1820 and charged with 'having Uttered a Forged one Pound Note',[45] but entered a plea bargain and was sentenced to fourteen years' transportation. Destitute

Right
An interior view of Cold Bath Fields Prison, in which Thos Ranson was unlawfully confined…, Thomas Ranson, 1818. Ranson was sent to Cold Bath Fields Prison in Clerkenwell in 1818, charged with having uttered a forged £1 note but acquitted when the note was proven to be genuine. An engraver by trade, he produced this print in response to his treatment

in Newgate Prison with her two small children, subsisting on the prison allowance of only bread and water, she wrote to the Bank (or dictated her letter to someone who could write), begging for financial assistance:

> Pardon the Libberty I take In Writeing to you but being very Much Distressed So Much I know not what to do I have young baby sucking att my breast my triall Is More then I can bear I have Partted with my Cloths to help support my dear Child I have not one Freind In the world to give me the smallest releif.[46]

The Bank granted her an allowance of 7s. 6d. a week. She was also granted a final payment of £5 when she and her children embarked on the *Providence* for New South Wales six months later, in June 1821. Denham could be considered fortunate, because most pleas were unsuccessful. Women without children were often ignored, as well as those under sentence of death and those who out of necessity continued to deal in forged notes while in jail. Relief was refused to male prisoners unless they were willing to provide information that would lead to the arrest and conviction of other forgers.[47]

As the text of Cruikshank and Hone's Bank Restriction note indicates, there were three possible solutions to the problem of counterfeit notes, the first being to make notes less easy to imitate. The Bank, to an extent, recognized this and organized public competitions inviting the submission of more secure designs. However, printing costs, as well as a desire to maintain visual uniformity eventually overrode these considerations.

A second solution was to resume payments in coin. This was acted upon with the reintroduction of the gold sovereign in 1821 and the withdrawal of many low-denomination notes, which was another reason why it was not deemed necessary to improve note security. Cruikshank and Hone's third and final suggestion was that the punishment for forgery should be changed and it was, eventually. The death penalty for counterfeiting was repealed in 1832 although transportation for forgery offences continued, intermittently, until transportation was officially abolished in Britain in 1868.

Great Japan Zero-Yen Banknote
Akasegawa Genpei, 1967

In 1963, Akasegawa Genpei (1937–2014), a member of Tokyo's avant-garde, had black-and-white replica 1,000-yen notes printed to use in his work. The initial print run of 300 was mailed out to advertise his solo exhibition. A further 2,700 were printed to be used in large-scale collages, a TV performance work in which the notes were burned, or to be cropped and inserted into the art magazine *Keishō*. Even though the notes were printed on one side only, his work attracted the attention of the Tokyo police and he was visited by investigating officers in January 1964.

Akasegawa no doubt knew that there was an element of criminality to what he was doing, and he self-consciously referred to his reproduction notes as 'counterfeits'. Moreover, he was aware that, since 1961, the police had been investigating, without success, a separate case of counterfeit 1,000-yen notes, designated *Chi-37*. Much to Akasegawa's irritation, the Japanese paper *Asahi Shimbun* erroneously conflated his case with *Chi-37*. Referring to the mistake in an essay, 'On capitalist realism', Akasegawa wrote '[b]y the way, my printed matter that became a legal matter of sorts, contrary to my intentions, is not a counterfeit but a model of the 1,000-yen note. It differs from a counterfeit or a real 1,000-yen note in that in my intention and in its actuality it is "unusable", and thus a model of the 1,000-yen note stripped of the function of paper currency.'[48]

Akasegawa and his 'co-conspirators', the printers, were eventually indicted in October 1965, charged under an obscure nineteenth-century Meiji-era law that criminalized the imitation of currency and bond certificates. The decision to do so was curious, especially since prosecutors and detectives had in February 1965 suggested that there was no case to answer. There were suspicions among the avant-garde community that the case was politically motivated: the investigation came at a time of heightened leftist activism in opposition to the ratification of a treaty with Korea.[49] At the ensuing trial Akasegawa and the two printers were found guilty and sentenced to three months hard labour. Akasegawa appealed twice against his conviction, but it was finally upheld by the Supreme Court in April 1970.

This print, several times the size of a real banknote, was made by
Akasegawa in December 1967. It was the first work to be developed after
the initial verdict, a parody of a 500-yen banknote and a self-proclaimed
'worthless' work of art. It reproduces several aspects of a genuine 500-yen
note, including a formal portrait of Japanese statesman Iwakura Tomomi
(1825–1883), except that his face appears to have been eaten away by
acid.[50] Also, given its size, there is no possibility that this print could be
confused for a genuine note. The reverse includes a triple portrait of
the printer Johannes Gutenberg, his patron, Johann Faust, and assistant,
Peter Schöffer. The inclusion of these portraits may have been intended
to invoke freedom of the press and, by extension, freedom of artistic
expression. Akasegawa advertised the 'note' by inviting people to
'exchange' 300 yen for it, with the mocking remark that, if everyone
did so, soon there would be no real money left in circulation. In effect,
this work became his act of 'revenge' against the Japanese government.[51]

Above
Great Japan Zero-Yen Banknote,
Akasegawa Genpei, 1967. An
inscription on the note reads
'Rebellion is justified/It is right
to rebel', a Maoist slogan favoured
by Japanese student protesters

Two Owls
Huang Yongyu, 1977

> Dissent, like beauty, can be in the eye of the beholder. This proved dangerous in Mao's China where someone reading a message into a work of art could have fatal consequences. It is not entirely clear whether the artist meant his original owl painting to be disrespectful, but after serious trouble with the authorities this second one certainly was. IH

Many artists were persecuted during China's Cultural Revolution, 1966–76. In March 1974, a group of painters, most of whom specialized in traditional ink painting, were charged with blaspheming 'the Socialist system', or, in other words, the State. Their paintings were displayed in the *Black Painting Exhibition*, at Beijing's National Art Gallery, a show not dissimilar in spirit to the *Degenerate Art* exhibition held in Munich in 1937.[52] Included in the exhibition was a painting of a winking owl by Huang Yongyu (born 1924), a painter and printmaker who had taught at the Central Academy of Fine Arts in Beijing since the 1950s, along with this label:

> Huang Yongyu produced this Owl in 1973. The owl, with its one eye open and the other closed, is a self-portrait of the likes of Huang. It reveals their attitude: an animosity toward the Proletarian Cultural Revolution and the Socialist system.[53]

In Chinese culture the owl is sometimes regarded as 'a creature of darkness and ill omen' whose cry is heard with dread.[54] Painted three years before Mao Zedong's death, Huang's winking owl was probably interpreted by the monitors of Mao's Cultural Revolution as a metaphor for his declining health. Huang himself has always maintained that his original winking owl painting was not seditious.

There followed months of interrogation sessions at the Central Academy, where Huang was urged to 'confess' to his antisocialist tendencies. The controversy eventually reached the ears of Chairman Mao himself, who, irritated by the overreaction, is alleged to have retorted: '[a]n owl habitually keeps one eye open and other closed. The artist does possess the common knowledge, doesn't he?'[55] Mao's dismissive response to the accusations probably saved the artist from further persecution. Huang Yongyu was duly exonerated and, perhaps by way of apology

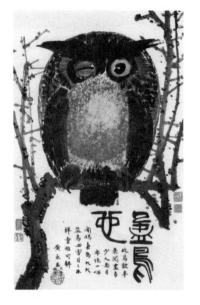

for his treatment, he was commissioned to design a monumental tapestry to be hung in Mao's mausoleum after his death in 1976.

In 1977, Huang produced another owl painting, *Two Owls*, a reference to his earlier work, which is now in the British Museum. His winking owl may not have featured a deliberately seditious message, but this version was unequivocal in its attack, including an inscribed message denouncing Wang Mantian, organizer of the *Black Painting Exhibition*. As Huang's inscription notes, Wang Mantian had killed herself after the Gang of Four was arrested in October 1976. Here is a translation:

> Owls have always had reputations of being auspicious and inauspicious. I had been interested in these birds for years, painted them casually and had no intention of making oblique comments through the depiction [of owls]. That ridiculous woman Wang said these birds were inauspicious and made up complicated meanings. [Her] dreadful intentions and accusations were so clear that needed not to be spelled out. [I] hear Wang has committed suicide. The ancient saying [of owls being] inauspicious has become a true portrayal [of her situation].[56]

In short, therefore, this is a story of an artist being accused of dissent in a work that may or may not have been created with subversive intent. Although eventually acquitted of the charge, Huang's persecution effectively turned him into a dissident. Acknowledging the absurdity of his situation, his quote on the *Two Owls* painting concludes with the statement that 'fate makes fun of man in a bizarre way'.

42/42　밭일

Field Work and *Grandmother II*
O Yun, 1983

> The authorities in South Korea were scared of communism in the North but ended up acting like their enemies. This irony, like most ironies in dictatorships, was probably lost. **IH**

Under the military government of South Korea's Fifth Republic (1981–87), democracy was suspended and freedom of speech was severely compromised. This drew a response from the artistic community in the form of a movement called 'Minjung misul' or 'People's Art'. More than just a political movement, Minjung misul was a reaction against Modernism and art for its own sake. It called for iconography to reflect the lives of ordinary citizens, under a repressive regime beset by growing income inequalities. The military government attempted to suppress the movement, leading to the arrest and imprisonment of many artists. These two woodblock prints by O Yun (1946–1986), featuring a scene of backbreaking labour and an anguished portrait of an elderly woman, reflect the main purpose of the movement, to expose the harsh reality of life for South Korea's citizens, and the quest for democracy and civil liberties.

Opposite
Field Work, O Yun, 1983

Right
Grandmother II, O Yun, 1983

'Say yes to vodka; papa Mikhail says no to vodka'

The front of this porcelain plate reproduces a famous anti-alcohol poster, *HET!* ('Nyet!/No!'), from the 1950s, by Viktor Govorkov. To the right is an image of Mikhail Gorbachev (born 1931), last General Secretary of the Soviet Union, and an inscription that subverts the original meaning of the poster. The rudest message of all is reserved for the underside of the plate, a satirical image of Lenin raising both middle fingers.

From 1985 to 1987 Gorbachev carried out an anti-alcohol campaign that included partial prohibition. Prices of alcohol were raised, sales were restricted and people caught drunk at work or in public were prosecuted. The imagery on this plate would surely have been considered dangerously subversive by the Soviet government in the 1980s. It is probable, therefore, that the object dates to the time of, or shortly after, the collapse and dissolution of the Soviet Union in 1991.

Left
HET! ['Nyet!/No!'] Viktor
Govorkov, 1954

Right

Porcelain plate featuring a reproduction of Govorkov's 1954 poster, alongside a portrait of Mikhail Gorbachev, probably after 1991. The text reads: 'Say yes to vodka; papa Mikhail says no to vodka'; the underside of the plate features a satirical image of Lenin

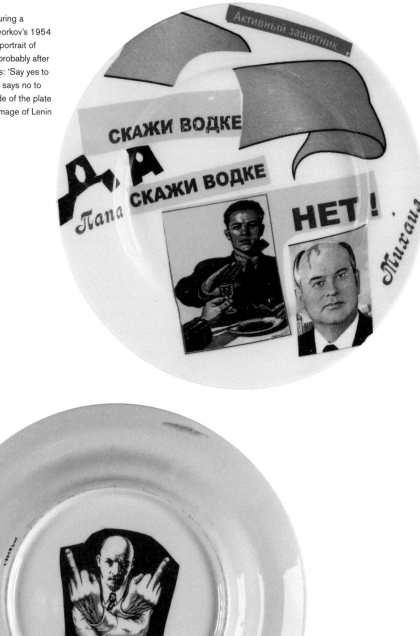

Phantom Landscape III
Yang Yongliang, 2007

> Dissent does not have to be specifically political in a personal sense to be effective. This beautiful picture is an environmental protest contrasting the beauty of the countryside in China's past with the post-industrial state of today. It may also be suggesting that even though things do not seem to change, continuity can be deceptive. **IH**

From a distance this print appears to be an idyllic landscape reminiscent of ink fan paintings by artists such as Xia Gui, a master of China's Southern Song dynasty (1127–1279). Such works used brush and ink techniques to create misty mountainous landscapes. When seen up close, however, one finds that this composition dissolves into a series of digitally manipulated photographic images. The foregrounded trees materialize into pylons, and the distant peaks into a mass of skyscrapers. It is a critique of rapid urbanization and its encroachment on Chinese rural life. Commenting on his work, the artist says that the 'ancient Chinese expressed their appreciation of nature and feeling for it by painting the Landscape. In contrast, I make my Landscape to criticize the realities in [before] my eyes.'[57] The print is signed, but instead of the traditional seal the artist has used a square stamp designed to resemble a manhole cover.[58]

Left
Mountain Market, Clearing Mist,
Xia Gui, early 13th century

Opposite
Phantom Landscape III,
Yang Yongliang, 2007

景市山水圖·時夏一 10/15 二〇〇七 柳泗澤

Learn from Comrade Lei Feng
Qu Leilei, 2012

Lei Feng (1940–1962) was a soldier in China's People's Liberation Army. He was killed in an accident in 1962 and his diary, full of praise for Mao Zedong, was published a year later. It is now thought to have been written by the Chinese Communist Party as a work of propaganda. Through publication of the diary, Lei Feng became a national hero and an emblem for the nobility of the revolutionary spirit in China. Here (opposite) he is depicted in the guise of a terracotta warrior, part of the vast army that secretly guarded the tomb of China's first emperor, Qin Shi Huang. The figures were produced on assembly lines in workshops where limbs were made separately and then attached, with faces part-made using moulds. Depicting Lei Feng here in the guise of a terracotta warrior, one of 8,000 buried with the emperor, who died in 210 BC, suggests that the relationship between individual and state has changed little in China over 2,000 years.

Below

Stone statuette carved in the
form of a squatting human
figure, early 20th century

Fake statuette of a seated god

Artists and craftspeople have occasionally subverted the institutions that collect, study and display objects, producing works and gallery interventions that mock the role of museums as custodians of cultural history.

Shown here is one of a group of similar statuettes purchased by the British Museum in the 1930s. The Museum had bought them believing them to be ancient depictions of Yemeni seated gods, but they were later identified as forgeries. Reinforcing the deceit, the workshop that churned out these bog-standard fakes appears to have been secretly mocking the art market by deliberately carving the figures so that they resemble a person sitting on a western-style lavatory.

In its 250-plus year history, the British Museum has purchased numerous objects in good faith, only for them to be later identified as fakes. Some have enjoyed long periods on display before being found out, after which they are usually banished to the Museum stores in embarrassment.[59]

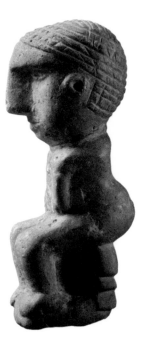

Peckham Rock
Banksy, 2005

This is a very neat example of dissent at the expense of the British Museum itself. Not only does it mock the pomposity of the whole process of collecting and exhibiting old artefacts, but it also suggests that you can stick anything in the Museum and no one will even notice for days. Very funny – though I am not entirely sure the Museum thought so at the time. **IH**

In May 2005, the anonymous graffiti-artist Banksy installed, without permission, a hoax artwork mimicking a cave painting in one of the British Museum galleries. It shows a stick-like figure pushing a shopping trolley, and was accompanied by a mock information label with a fake museum registration number. The text of Banksy's label read:

This finely preserved example of primitive art dates from the Post-Catatonic era and is thought to depict early man venturing towards the out-of-town hunting grounds. The artist responsible is known to have created a substantial body of work across the South East of England under the moniker Banksymus Maximus but little else is known about him. Most art of this type has unfortunately not survived. The majority is destroyed by zealous municipal officials who fail to recognise the artistic merit and historical value of daubing on walls.

Two years earlier Banksy had pulled a similar stunt at Tate Britain, shuffling in disguised as a pensioner to hang an oil landscape painting defaced with police tape on the wall of a gallery. The hoax was discovered when the glue holding the painting in place failed, causing the work to come crashing to the floor.[60] The 'installation' at the British Museum remained on the wall for three days before it was discovered by Simon Wilson, one of the gallery managers. However, staff were only alerted to the hoax after the artist himself publicized his actions, as Wilson explains:

It popped up on Banksy's website, urging people to come to the Museum and try and find it. There was a photo of it *in situ* online. From the colour of the wall I had a decent idea of roughly where it was, so I headed up to the Roman Britain

gallery where I found it on the east wall. I remember it seemed well mounted and the accompanying label looked 'legit'. I was the first member of Museum staff to spot it but I was beaten to the discovery by a visitor, who got his pic snapped next to it and uploaded online before we could take the work down.[61]

The British Museum released a press statement at the time of the incident saying it was seeing the funny side of it, but was 'reasonably confident that it hadn't been up for that long, maybe a couple of days'. The spokesperson added that it 'looked very much in keeping with the other exhibits, the explanatory text was quite similar'.[62]

Having been removed from the wall by staff, the work was returned to Banksy upon request. Featuring in a Banksy solo show at the Outside Institute in 2005, it was described as 'on loan from the British Museum' even though the Museum had never formally accessioned it. The work was then retained by the artist, who included it in *Banksy versus Bristol Museum* at Bristol Museum and Art Gallery in 2009. It returned to the British Museum for this exhibition, under invitation, for the first time since its original installation.

CONCLUSION

Whether they wanted to overthrow the state, reform society, let off steam or just get a laugh, they all dared to 'make' a protest. IH

This book began by looking at how publicly visible acts of subversion gain traction, and ended with an appreciation of the skill, daring and wit of those willing to take the risk. It has been a story with objects at its heart – their creation, adaptation, use and misuse. Through these objects and their histories, we may better understand how people have learned to question the social, political and religious constructs that impact upon their lives.

Objects capture lost moments in time, perhaps of longing or hope for what was to come. A Burmese lacquer box anticipates the end of colonial rule, while a finger ring with a portrait of Charles I, who was probably dead by the time it was made, becomes a lament for what had already passed. If history is written by the victorious, then through these objects we may witness the other half of the conversation, of the downtrodden, disenfranchised and defeated.

It requires only a glance at the range of assembled material to appreciate that there is no defined aesthetic for subversive expression.[1] The creators of these objects made use of the skills and materials available to them and of their professions – weavers, engravers, printmakers, sculptors and jewellers, to name but a few. Some objects may have been finely crafted, requiring time, expensive materials and specialist expertise for their construction, while others have been mass-produced for everyday use. Although the way many of these objects reached the British Museum and similar institutions varied, the journey can be as crucial to our understanding of them as when, and why, they were created. Our appreciation of the subversive intent of the Yoruba door panels is heightened by knowing that they came to the British Museum via the British Empire Exhibition, adding an ironic and deeply funny twist to the anti-colonial narrative.

I think a successful caricature, or a successful bit of satirical object-making, makes people think of the person or subject in a different way. It may crystalize an opinion that's forming, it may change the direction of view, it may make people think twice, and I think that's the best anyone can hope for. IH

Any relationship that has a power imbalance can create tension, which may be released through some act of physical defiance, no matter how small and seemingly insignificant. From satire to bleak irony, humour – that most elusive of topics – is a theme common to many of these objects. Where free speech is permitted, grotesque exaggeration ridicules and exposes the weaknesses of those in power. Humour lightens the mood, perhaps becoming a mechanism by which people can cope with perceived injustices. Among the numerous visual allusions made in Gillray's *A Voluptuary*, for example, are references to the Prince of Wales's numerous debts. The irony was surely not lost on Gillray or his contemporaries that it was they, UK taxpayers, who were footing the bill. In less permissive societies humour may be concealed, for example on a majolica dish in which the French king is portrayed in a sexual position, or in a print that visualizes another as a giant pear. The inventiveness of the artist enables him or her to attack leaders more safely and effectively than is possible through written commentary. It also ensures greater publicity, for the simple reason that people prefer a joke to a sermon. Aware of the damage that ridicule can wreak, rulers have often failed to see the funny side, ruthlessly suppressing all forms of satire. Alternatively, they deflect it against a hated enemy. The callous attacks meted out on Cleopatra by her political enemies, bear witness to the effectiveness of such practices.

Dissent is chaotic, but it is also an integral part of political, public and private discourse. Certainly, its story is far more complex than recounting the interplay of one group of people

who exert power, and another who defy it. The example of John Wilkes illustrates how someone may even be a part of the political establishment from which they are dissenting. Likewise, objects such as a penny defaced with 'Votes for Women' illustrate how quickly the outsider's voice can become absorbed by the political establishment.

In many instances the process of defining authority and implementing change may be interpreted as collaborative for, as Gandhi wrote, even 'the most powerful cannot rule without the co-operation of the ruled.' [2] His efforts to encourage Indian textile production, as illustrated on a lacquer dish, were part of larger struggles to resist British rule through collective non-compliance. It may serve as a warning of intent, that if those in power fail to make necessary concessions, then the people may just claim them by force.[3]

> We know that in the modern world it is easier to find dissent and that it is tolerated in more societies. What I really wanted to do with my selection of objects was balance that awareness with evidence that this has been going on a long time. I think every new generation imagines that the past is full of these rather sad creatures who weren't as clever or as enlightened as us, but there are certain basic functions that we all share: birth, copulation and death, with defecation in the middle. The other basic function is to laugh at the fact that the human condition is what it is. **IH**

Political awakenings are thought to occur owing to the combination of specific events and local circumstances.[4] In the present, dissent is everywhere. Most nations have elections (albeit not always free), political parties, associations, pressure groups, trade unions and many other campaigning organizations, which were practically non-existent five hundred, a hundred or even fifty years ago.[5] Modern political badges illustrate that there usually exists, in modern societies, a robust and extensive framework for people to engage with specific campaigns for policy change. From early attempts

to define, challenge and question concepts of authority to modern protest movements, this book serves as a reminder that societies are not monolithic, but plural. People have long realized that to challenge or mock one's god, priest or earthly authority is not unthinkable or, indeed, unspeakable. Examples of individual behaviour, such as defacing a brick, painting a sex scene in the manner of formal tomb painting, worshipping a forbidden idol or depicting a world of subverted hierarchies, all of which took place more than 2,500 years ago, may be interpreted as small, yet profound, acts of wilful disobedience.

The questions that keep arising are: why do people commit acts of disobedience and why, by creating these things, do they expose themselves to the danger of being discovered? Apart from the possibilities of effecting real change, many acts may be perpetrated without any intended outcome. Indeed, some appear to have no point at all. Why, for example, did an engraver hide rude words in the imagery on a banknote? The simple answer would be because they could. Perhaps such acts provide a sense of control for the individual, that one can challenge society's rules, both written and unwritten, while achieving some measure of influence. It might provide a way of coping with oppression, a form of catharsis through physical effort, as is perhaps demonstrated by raffia cloth from the Democratic Republic of Congo, which audaciously subverts the emblem of a ruthless dictator, or a Libyan banknote with the portrait of Gaddafi torn out. These objects do not necessarily add to our knowledge of how or when a leader might be deposed, but they can help us to understand why few might mourn their passing.

There is, of course, financial gain to be made by those canny enough to realize the market potential for material disobedience. For every artist such as the painter of *Fascination of Nature* (who, it may be recalled, had retreated into seclusion), there have been many more who capitalized on their experiences at the hands of the authorities. Akasegawa Genpei, the Japanese avant-garde artist, is one such example. He created an artwork that deliberately referred to his earlier prosecution, sales of which helped pay for his defence. In Afghanistan in

the 2000s the war-rug industry evolved so that it could appeal specifically to a new market (US troops), while Banksy's profile was raised significantly by his interventions at the British Museum and Tate. A misguided or mistimed act can result in prosecution, or worse, as the sculptor of the Parthenon discovered, but it can also be extremely lucrative, both commercially and critically.

> Unsurprisingly, I'm quite pro-dissent. I think it leads to a healthier world. **IH**

The biblical narrative tells us that the first humans to walk the earth were pre-programmed to disobey, and they were not the last. Ultimately, these objects and their histories teach us that, while progress is certainly not linear, long-term efforts to stifle freedom of expression and opposition are a losing proposition.[6] We have witnessed how, even if only for a moment, unjust or objectionable persons and policies may be challenged. They address broader questions of how we shape our societies, our continual attempts to define the principal authority figures in our lives, and where our allegiances lie. These objects offer a nuanced view of civilizations old and recent, demonstrating how people from different ages and cultures have been rude about their leaders and gone out of their way to ignore the rules. And this activity continues; right now, people around the world are physically 'making' their next protest.

Notes

Introduction: pp. 14–17

1. Flood, Catherine and Grindon, Gavin (eds), 2014. *Disobedient Objects* (London: V&A Publishing), p. 9.
2. Mannheim, Karl, 1936. *Ideology and Utopia: Collected Works of Karl Mannheim Volume One* (London: Routledge), p. 179. See also Kirby, John D., 1955. 'Are Morals Subversive?', *American Journal of Economics and Sociology*, 14:4, p. 335.
3. The subversive interpretation derives from an unpublished catalogue of pilgrim badges by B. Spencer, 1996 (copy held in the British Museum's Britain, Europe and Prehistory Library). See also Attwood, Philip, 2004. *Badges* (London: British Museum Press), p. 7.

Chapter 1: Getting away with it: pp. 18–81

1. Charles Philipon in *La Caricature*, 3 January 1833, quoted in Goldstein, Robert Justin, 1989. 'The Debate over Censorship of Caricature in Nineteenth-Century France', *Art Journal*, 48:1, p. 10.
2. Swift, Jonathan, 'On the Death of Dr Swift', 1731. See Ogborn, Jane and Buckroyd, Peter, 2001. *Satire* (Cambridge: Cambridge University Press), p. 12.
3. Davis, Natalie Zemon, 1975. *Society and Culture in Early Modern France* (Stanford: Stanford University Press), p. 97.
4. Goldstein, Robert Justin, 1989. 'The Debate over Censorship of Caricature in Nineteenth-Century France', *Art Journal*, 48:1, p. 10.
5. Cameron, Vivian P., 1989. 'The Challenge to Rule: Confrontations with Louis XVI', *Art Journal*, 48:2, pp. 150–54.
6. Elliston, Frederick A., 1982. 'Civil Disobedience and Whistleblowing: A Comparative Appraisal of Two Forms of Dissent', *Journal of Business Ethics*, 1:1, p. 24.
7. Bonnett, Alastair, 2014. 'Introduction', in Bonnett, Alastair and Armstrong, Keith (eds). *Thomas Spence: The Poor Man's Revolutionary* (London: Breviary Stuff Publications), p. 2.
8. Marangos, John, 2014. 'The Economic Ideas of Thomas Spence: The Right to Subsistence' in Bonnett, Alastair and Armstrong, Keith (eds). *Thomas Spence: The Poor Man's Revolutionary* (London: Breviary Stuff Publications), p. 66.
9. Spence did not execute the engraving himself but worked with a series of collaborators, notably C. James.
10. Bell, R. C., 1987. *Political and Commemorative Pieces Simulating Tradesman's Tokens 1770–1802* (Felixstowe: Schwer Publications), p. 234.
11. Thomas Hardy, quoted in Mee, Jon, 2014. 'Thomas Spence and the London Corresponding Society, 1792–1795', in Bonnett, Alastair and Armstrong, Keith (eds). *Thomas Spence: The Poor Man's Revolutionary* (London: Breviary Stuff Publications), pp. 53–54.
12. Or 'Spencean Philanthropists'.
13. Anon., 1913. 'Queer Propaganda', *The Globe*, 23 October, p. 8, col. d.
14. Alsop, B., 2014. 'Militant Tactics', *British Museum Magazine*, 78, pp. 52–53.
15. Rosen, Andrew, 1979. 'Review: Separate Spheres: The Opposition to Women's Suffrage in Britain by Brian Harrison', *American Historical Review*, 84:4, p. 1057.
16. Chafetz, Janet Saltzman and Dworkin, Anthony Gary, 1987. 'In the Face of Threat: Organized Antifeminism in Comparative Perspective', *Gender and Society*, 1:1, p. 47.
17. In 1913 Scotland Yard announced that it was keeping an eye out for coins defaced by anarchists, although it is unclear how it intended to trace the perpetrator(s). See Hockenhull, Thomas, 2016. 'Stamped all over the King's Head: Defaced Coins and Women's Suffrage', *British Numismatic Journal*, 86, p. 238.
18. 'Nuestra ac/cion cotidia/na es la guerra forjan/do el futuro deseado/Garcel 77'.
19. The message reads:
 'The Communist Party of China is not the same as China, loving the country is not the same as loving the evil Party The CPC will be destroyed, the people who have withdrawn from the Party will survive
 Look now at the "Nine Commentaries on the Communist Party" Withdraw from the 3 Party organizations phone line 001-416361-9895
 https://w8.orgoro.com'
20. Hockenhull, Thomas, 2015. 'Illegal Acts', *British Museum Magazine*, 82, p. 11.
21. Calomino, Dario, 2016. *Defacing the Past: Damnation and Desecration in Imperial Rome* (London: Spink and the British Museum), p. 20.
22. Meldrum, Andrew, 2010. 'Failed State of the Press: Zimbabwe's Battle Against Journalism Continues', *Harvard International Review*, 32:3, p. 50. Meldrum was kicked out of Zimbabwe in 2003.
23. Ibid.
24. As suggested by Attwood, Philip, 2004. *Badges* (London: British Museum Press), p. 10.
25. Ibid., p. 12.
26. Quoted in Davis, Natalie Zemon, 1975. *Society and Culture in Early Modern France* (Stanford: Stanford University Press), p. 97.
27. Chomsky, Noam, 1998. *The Common Good* (Berkeley: Odonian Press), p. 43.
28. Department of Ancient Egypt and Sudan, 1992, 2007. *The British Museum Book of Ancient Egypt* (London: British Museum Press), p. 165; Houlihan, Patrick F., 2001. *Wit & Humour in Ancient Egypt* (London: Rubicon Press), pp. 112–13.
29. Houlihan, Patrick F., 2001. *Wit & Humour in Ancient Egypt* (London: Rubicon Press), p. 65.
30. O'Connell, Sheila, 1999. *The Popular Print in England* (London: British Museum Press), p. 124.
31. Davis, Natalie Zemon, 1975. *Society and Culture in Early Modern France* (Stanford: Stanford University Press), p. 106.
32. Gillis, John R., 1974. *Youth and History, Tradition and Change in European Age Relations, 1770–present* (New York: Academic Press), pp. 30–31.
33. Tilly, Charles, 1976. 'Major Forms of Collective Action in Western Europe 1500–1975', *Theory and Society*, 3:3, p. 366.
34. Davis, Natalie Zemon, 1975. *Society and Culture in Early Modern France* (Stanford: Stanford University Press), p. 98.
35. Ibid., p. 100.
36. Ibid., p. 118.
37. Jordan, Peter, 2010. 'In Search of Pantalone and the Origins of the Commedia dell'Arte', *Revue Internationale de Philosophie*, 64:252, pp. 216–17.
38. Bate, Jonathan and Thornton, Dora, 2012. *Shakespeare: Staging the World* (London: British Museum Press), p. 167.
39. Smith, James, 2004. 'Karagöz and Hacivat: Projections of Subversion and Conformance', *Asian Theatre Journal*, 21:2, p. 188.
40. Louis Enault, quoted in And, Metin, 1975. *Karagöz: Turkish Shadow Theatre* (Istanbul: Dost Publications), p. 83.
41. And, Metin, 1975. *Karagöz: Turkish Shadow Theatre* (Istanbul: Dost Publications), p. 87.
42. Paz, Octavio trans. Phillips, Rachel, 1979. 'The Enduring Art of Engraving', *Artes de México*, 199, *Actualidad Gráfica – Panorama Artístico: Obra Gráfica Internacional 1971–1979*, p. 105.
43. Adès, Dawn and McClean, Alison, 2009. *Revolution on Paper: Mexican Prints 1910–1960* (London: British Museum Press), p. 54.

44. The standard work for such prints is the British Museum catalogue: George, M. Dorothy, 1935–54. *Catalogue of Political and Personal Satires in the British Museum, vols V–IX* (London: Trustees of the British Museum). It lists over twelve thousand examples for the period; many more must have been made that have since disappeared from view.

45. Gattrell, Vic, 2006. *City of Laughter: Sex and Satire in Eighteenth-Century London* (London: Atlantic Books), p. 220.

46. Living in exile, Paine was tried and convicted of seditious libel in absentia.

47. Translated by Oppenheim, A. Leo, in Pritchard, James B. (ed.), 1969. *Ancient Near Eastern Texts Relating to the Old Testament* (Princeton, NJ: Princeton University Press), pp. 312–15.

48. Zuckert, Michael, 1984. 'Rationalism & Political Responsibility: Just Speech & Just Deed in the "Clouds" & the "Apology" of Socrates', *Polity*, 17:2, p. 277.

49. Kirby, John D., 1955. 'Are Morals Subversive?', *American Journal of Economics and Sociology*, 14:4, pp. 337–38.

50. Zuckert, Michael, 1984. 'Rationalism & Political Responsibility: Just Speech & Just Deed in the "Clouds" & the "Apology" of Socrates', *Polity*, 17:2, p. 274.

51. Shakespeare, William. *Antony and Cleopatra*, Act I, Scene II: 102.

52. David Stuttard, private correspondence, 2017.

53. Grant, Michael, 1972. *Cleopatra* (London: Phoenix Press), p. 96.

54. Ibid., p. 105.

55. Suetonius, *Augustus*, 69. Quoted in Stuttard, David and Moorhead, Sam, 2012. *31BC: Antony, Cleopatra and the Fall of Egypt* (London: British Museum Press), p. 129. This passage has generated a great deal of scholarly discussion owing to the reference to Cleopatra being Antony's wife. It is now generally assumed that they were never married. See also Grant, Michael, 1972. *Cleopatra* (London: Phoenix Press), p. 185.

56. Stuttard, David and Moorhead, Sam, 2012. *31BC: Antony, Cleopatra and the Fall of Egypt* (London: British Museum Press), p. 132.

57. David Stuttard, private correspondence, 2017.

Chapter 2: Hidden in plain sight: pp. 82–141

1. Flood, Catherine and Grindon, Gavin (eds), 2014. *Disobedient Objects* (London: V&A Publishing), p. 14.

2. Lockwood, Joseph E., 1954. 'Arson and Sabotage', *Journal of Criminal Law, Criminology, and Police Science*, 45:3, p. 340; Flood, Catherine and Grindon, Gavin (eds), 2014. *Disobedient Objects* (London: V&A Publishing), p. 14.

3. Williams, Sheila, 1983. 'The History of Ladies' Machine-Made Hosiery', *Antique Collector*, 54:12, p. 84.

4. Kléber Monod, Paul, 1989. *Jacobitism and the English People, 1688–1788* (Cambridge: Cambridge University Press), p. 52.

5. Fee, Sarah, 'Cloth in Motion: Madagascar's Textiles Through History', in Kreamer, Christine Mullen and Fee, Sarah (eds), 2002. *Objects as Envoys: Cloth, Imagery, and Diplomacy in Madagascar* (Washington: University of Washington Press), p. 61.

6. Oliver, Samuel Pasfield, 1886. *Madagascar: An Historical and Descriptive Account of the Island and its Former Dependencies, Volume I* (London: Macmillan and Co), p. 105.

7. Ellis, William, 1867. *Madagascar Revisited* (London: John Murray), p. 319.

8. Cook Andersen, Margaret, 2015. *Regeneration Through Empire: French Pronatalists and Colonial Settlement in the Third Republic* (University of Nebraska Press, Lincoln), p. 121; Boahen, A. Adu, 1990, *General History of Africa, VII: Africa Under Colonial Domination 1880–1935* (Paris and London, UNESCO and James Currey Ltd), p. 115; Fee, Sarah, 'Cloth in Motion: Madagascar's Textiles Through History', in Kreamer, Christine Mullen and Fee, Sarah, 2002. *Objects as Envoys: Cloth, Imagery, and Diplomacy in Madagascar* (Washington: University of Washington Press), p. 90, n.29.

9. Spring, Christopher and Hudson, Julie, 1995. *North African Textiles* (London: British Museum Press), p. 100.

10. Christopher Spring, Nigel Barley and Julie Hudson, 2001. 'The Sainsbury African Galleries at the British Museum', *African Arts*, 34:3, pp. 27–31.

11. Boddy, Janice Patricia, 2007. *Civilizing Women: British Crusades in Colonial Sudan* (Princeton: Princeton University Press), p. 19.

12. Ibid.

13. Maclean, Kama, 2011. 'The Portrait's Journey: The Image, Social Communication and Martyr-Making in Colonial India', *Journal of Asian Studies*, 70:4, p. 1051.

14. Lal, Chaman, 2007. 'Revolutionary Legacy of Bhagat Singh', *Economic and Political Weekly*, 42:37, p. 3712.

15. Ibid., p. 3714.

16. Ibid., p. 3715.

17. Maclean, Kama, 2011. 'The Portrait's Journey: The Image, Social Communication and Martyr-Making in Colonial India', *Journal of Asian Studies*, 70:4, pp. 1065–73.

18. Bhagat Singh, 'Letter to the Second Lahore Conspiracy Case Convicts', 22 March 1931, in ibid., p. 1065.

19. Quoted in Cosgrove, Ben, 2014. 'Gandhi and His Spinning Wheel: The Story Behind an Iconic Photo', *Life Magazine* (10 September): http://time.com/3639043/gandhi-and-his-spinning-wheel-the-story-behind-an-iconic-photo/ [retrieved 6 April 2017].

20. Ginsberg, Mary, 2013. *The Art of Influence: Asian Propaganda* (London: British Museum Press), p. 70.

21. Nettleton, Anitra, 2015. 'Of Severed Heads and Snuff Boxes: "Survivance" and Beaded Bodies in the Eastern Cape, 1897–1934', *African Arts*, 48:4, p. 28.

22. Ginsberg, Mary, 2013. *The Art of Influence: Asian Propaganda* (London: British Museum Press), p. 22. Colonial officials viewed popular print in India with deep suspicion.

23. Ramos, Imma, 2017. *Pilgrimage and Politics in Colonial Bengal: The Myth of the Goddess Sati* (London: Routledge), pp. 78–79.

24. Aburish, Said K., 1998. *Arafat: From Defender to Dictator* (New York: Bloomsbury), p. 82.

25. Gabiam, Nell Milagny, 2008. *In Order Not to Forget: Dignity and Development in Syria's Palestinian Refugee Camps* (Berkeley: University of California), p. 96; Suleman, Fahmida, 2017. *Textiles of the Middle East and Central Asia: The Fabric of Life* (London: British Museum and Thames & Hudson), pp. 180, 204–5.

26. Daftari, Fereshteh, 2014. *Iran Modern* (New York: Asia Society in association with Yale University Press), p. 40.

27. Zahedi, Ashraf, 2007. 'Contested Meaning of the Veil and Political Ideologies of Iranian Regimes', *Journal of Middle East Women's Studies*, 3:3, p. 75.

28. Tripp, Charles, 2013. *The Power and the People: Paths of Resistance in the Middle East* (Cambridge: Cambridge University Press), pp. 300–1.

29. Dehghan, Saeed Kamali, 2018. 'Second woman "arrested" in Tehran for hijab protest', *Guardian* [https://www.theguardian.com/world/2018/jan/29/second-woman-arrested-tehran-hijab-protest-iran, accessed 29 January 2018].

30. Also 'Umbrella Revolution'.

31. Retrieved from https://www.pussyhatproject.com/our-story/, 29 January 2018.

32. The Book of Kings (II Kings 22:3).

33. Tubb, Jonathan N., 1980. 'An Iron Age II Tomb Group from the Bethlehem Region', *British Museum Occasional Paper*, 14, p. 14.

34. Strabo, *Geography*, 17.1.54.

35. Opper, Thorsten, 2014. *The Meroë Head of Augustus* (London: British Museum Press), p. 27.

36. Cox, John Edmund (ed.), 1846. *Miscellaneous Writings and Letters of Thomas Cranmer, Archbishop of Canterbury* (Cambridge: Cambridge University Press), p. 155. See also Bate, Jonathan and Thornton, Dora, 2012. *Shakespeare: Staging the World* (London: British Museum Press), p. 26.

37. Zarnecki, George; Holland, Tristram and Holt, Janet, 1984. *English Romanesque Art 1066–1200* (London: Hayward Gallery, Arts Council of Great Britain), p. 115. Their cores have rotted away. They survive as shells held together by gesso and paint, subsequently filled with sawdust and glue.

38. Santino, Jack, 1999. 'Public Protest and Popular Style: Resistance from the Right in Northern Ireland and South Boston', *American Anthropologist*, 101:3, pp. 518–19.

39. Paul McCartney, speaking in 1967. See Beatles, The, 2000. *The Beatles Anthology* (London: Cassell & Co.), pp. 196, 237.

40. The copy is owned by the British Library, which was formerly the library department of the British Museum. Prior to this it was owned by George III and formed part of the collection donated to the British Museum by his son, George IV.

41. Walpole was elected to the Order of the Garter in 1726, but production of the medal has been assigned to 1741. See Hawkins, Edward; Franks, Augustus W. (ed.); Grueber, Herbert A (ed.), 1885. *Medallic Illustrations of the History of Great Britain and Ireland to the Death of George II, vol. II* (London: British Museum), 195, p. 563, variant in bronze.

42. The title of Prime Minister did not exist when Walpole assumed office. It became commonly used only from the 1730s. His tenure is therefore widely regarded as having begun with his appointment as First Lord of the Treasury in 1721. He also held the position of Chancellor of the Exchequer and Leader of the House of Commons.

43. For comparison, these words do not appear at all in the biography of Henry Pelham, Prime Minister from 1743 until his death in 1754.

44. Thompson, E. P., 1975. *Whigs and Hunters: The Origin of the Black Act* (London: Allen Lane), p. 197.

45. Goldsmith, M. M., 1979. 'Faction Detected: Ideological Consequences of Robert Walpole's Decline and Fall', *History*, 64:210, p. 1.

46. No. 45 of the *North Briton*, quoted in Jensen, Merrill, 1968. *The Founding of a Nation: A History of the American Revolution, 1763–1776* (New York: Oxford University Press), p. 156.

47. Schrader, Arthur, 1989. '"Wilks," "No. 45," and Mr. Billings', *American Music*, 7:4, p. 418.

48. Cash, Arthur, 2006. *John Wilkes: The Scandalous Father of Civil Liberty* (New Haven: Yale University Press), p. 201.

49. Ibid., p. 212.

50. Schrader, Arthur, 1989. '"Wilks," "No. 45," and Mr. Billings', *American Music*, 7:4, p. 419.

51. Ginsberg, Mary, 2013. *The Art of Influence: Asian Propaganda* (London: British Museum Press), p. 22.

52. Singh, S. P., 1998. 'Indian Nationalism and Burma', *Proceedings of the Indian History Congress*, 59, p. 892.

53. Gandhi, M. K., 1922. *Young India*, 26 January.

54. Gee, Tim, 2011. *Counter Power: Making Change Happen* (Oxford: New Internationalist Publications Ltd), pp. 89–90; Robbins, Mary Susannah (ed.), 1999. *Against the Vietnam War: Writings by Activists* (Plymouth: Rowman & Littlefield Publishers Ltd), p. 31.

55. Central Bank of Seychelles, 2006. *History of Paper Currency in the Seychelles* (Seychelles: Central Bank of Seychelles), p. 24.

56. The final plates were approved by Brian Fox of Bradbury, Wilkinson & Co., but there is no evidence that he was responsible for introducing the subversive designs. See Narbeth, Colin, 1995. 'Letters to the Editor', *IBNS Journal*, 34:1, p. 9; Sanz, Jaime, 2017. '"Sex" and "Hate" in Seychelles 1968 QEII series', *IBNS Journal*, 56:4, pp. 38–39.

57. Hua Junwu, trans. Jenner, W. J. F., 1982. *Chinese Satire and Humour: Selected Cartoons of Hua Junwu, 1955–1982* (Beijing: New World Press), p. 8.

58. Barmé, Geremie R., 1999. *In the Red: On Contemporary Chinese Culture* (Columbia University Press, 1999), p. 171.

59. Alfreda Murck, private correspondence, 19 April 2017.

60. Spring, Christopher, 2012. *African Textiles Today* (London: British Museum Press), p. 194.

Chapter 3: The art of dissent: pp. 142–199

1. Price, Carolyn (ed.), 2008. *The Arts Past and Present, Book 2: Tradition and Dissent* (Milton Keynes: Open University), p. 205.

2. Fairclough, Pauline, 2007. 'The "Old Shostakovich": Reception in the British Press', *Music & Letters*, 88:2, p. 288. Although musicologists and historians are broadly in agreement that Shostakovich loathed the Soviet regime, they continue to debate the extent to which it informed his music. This is in part owing to the unreliability of the documentary evidence, not least *Testimony*, supposedly Shostakovich's posthumously published autobiography, but now widely discredited. Fairclough's article provides a useful summary.

3. Department of Ancient Egypt and Sudan, 1992, 2007. *The British Museum Book of Ancient Egypt* (London: British Museum Press), p. 29.

4. Houlihan, Patrick F., 2001. *Wit & Humour in Ancient Egypt* (London: Rubicon Press), 129–30. The British Museum also has a block statue in its collection of Senenmut, in a formal pose holding Hatshepsut's young daughter.

5. Percy Smythe, 6th Viscount Strangford (1780–1855).

6. Harrison, Evelyn B., 1996. 'Pheidias', in Palagia, Olga and Pollitt, J. J. (eds), *Personal Styles in Greek Sculpture*, Yale Classical Studies, vol. 30 (Cambridge: Cambridge University Press), p. 48.

7. Wang, Eugene, 2009. 'The Elegiac Cicada: Problems of Historical Interpretation of Yuan Painting', *Ars Orientalis*, vol. 37, *Current Direction in Yuan Painting*, p. 187.

8. Whitfield, Roderick, 1993. *Fascination of Nature: Plants and Insects in Chinese Painting and Ceramics of the Yuan Dynasty (1279–1368)*, (Seoul: Yekyong Publications), p. 15.

9. Trans. ibid., p. 30.

10. Michaelson, Carol and Portal, Jane, 2006. *Chinese Art in Detail* (London: British Museum Press), p. 100; see also Sturman, Peter Charles, 1999. 'Confronting Dynastic Change: Painting after Mongol Reunification of North and South China', *RES: Anthropology and Aesthetics*, 35, Intercultural China, p. 148.

11. Goldstein, Robert Justin, 1989. 'The Debate over Censorship of Caricature in Nineteenth-Century France', *Art Journal*, 48:1, p. 10.

12. Kerr, David S., 2000. *Caricature and French Political Culture 1830–1848: Charles Philipon and the Illustrated Press* (Oxford: Clarendon Press), p. 83.

13. Sheon, Aaron, 1976, 'The Discovery of Graffiti', *Art Journal*, 36:1, p. 16.

14. Wechsler, Judith, 2012. 'Daumier and Censorship, 1866–1872, *Yale French Studies*, 122, p. 53.

15. Goldstein, Robert Justin, 1998. 'Fighting French Censorship, 1815–1881', *French Review*, 71:5, p. 791.

16. The authors are grateful to Fiona Savage for sharing a copy of her unpublished article about these doors.

17. Fiona Savage, private correspondence, 20 October 2016.

18. Murck, Alfreda, 2009. 'Décor on Republican Era Tea Wares', in Link, Perry (ed.), *The Scholar's Mind: Essays in Honor of F. W. Mote* (Hong Kong: Chinese University Press), p. 229.

19. Ibid., pp. 239–40.

20. Ibid., p. 233.

21. Ibid., pp. 246–47.

22. Gump, James O., 2001. 'Review', *American Historical Review*, 106:3, p. 1109.

23. Kabwit, Ghislain C., 1979. 'Zaire: The Roots of the Continuing Crisis', *Journal of Modern African Studies*, 17:3, p. 387.

24. Gump, James O., 2001. 'Review', *American Historical Review*, 106:3, p. 1108.

25. Ibid.

26. Lazarova, Daniela, 2015. 'The incredible story of the girl on the one crown coin', (Blog Post, Radio Praha). [http://www.radio.cz/en/section/panorama/the-incredible-story-of-the-girl-on-the-one-crown-coin, retrieved 23 June 2017].

27. Ibid.

28. Ibid.

29. Deacon, Deborah A. and Calvin, Paula E., 2014. *War Imagery in Women's Textiles: An International Study of Weaving, Knitting, Sewing, Quilting, Rug Making and Other Fabric Arts* (Jefferson, NC: McFarland & Co.), p. 181.

30. Tuck, Anthony, 2006. 'Singing the Rug: Patterned Textiles and the Origins of Indo-European Metrical Poetry', *American Journal of Archaeology*, 110:4, p. 540; Bonyhady, Tim, Lendon, Nigel and Dhamija, Jasleen, 2003. *The Rugs of War*. Exhibition Catalogue (Canberra: Australian National University), pp. 6, 20–22; Suleman, Fahmida, 2017. *Textiles of the Middle East and Central Asia: The Fabric of Life* (London: British Museum and Thames & Hudson), pp. 194–97.

31. Tuck, Anthony, 2006. 'Singing the Rug: Patterned Textiles and the Origins of Indo-European Metrical Poetry', *American Journal of Archaeology*, 110:4, p. 540; Bonyhady, Tim, Lendon, Nigel and Dhamija, Jasleen, 2003. *The Rugs of War*. Exhibition Catalogue (Canberra: Australian National University), pp. 6, 16–18.

32. Ekserdjian, David, 1986. 'Review: *I Modi* by Lynne Lawner', *Burlington Magazine*, 128:995, p. 149.

33. Talvacchia, Bette, 1999. *Taking Positions: On the Erotic in Renaissance Culture* (Princeton: Princeton University Press), p. 4.

34. Vasari, Giorgio, 1880. *Le vite de' piu eccellenti pittori, scultori ed architettori*, 9 volumes, ed. Gaetano Milanesi, (Florence: Sansoni), vol. V, p. 418. Quoted from Talvacchia (1999), p. 5.

35. Talvacchia, Bette, 1994. 'Professional Advancement and the Use of the Erotic in the Art of Francesco Xanto', *The Sixteenth Century Journal*, 25:1, p. 153.

36. Dora Thornton, private correspondence, 7 April 2016.

37. Talvacchia, Bette, 1994. 'Professional Advancement and the Use of the Erotic in the Art of Francesco Xanto', *Sixteenth Century Journal*, 25:1, pp. 134–38.

38. Syson, Luke and Thornton, Dora, 2001. *Objects of Virtue: Art in Renaissance Italy* (London: British Museum Press), p. 260.

39. Lahikainen, Amanda, 2017. 'Currency from Opinion: Imitation Banknotes and the Materiality of Paper Currency in Britain, 1782–1847', *Art History*, 40:1, p. 115. See also Hewitt, Virginia, 1998. 'Beware of Imitations: The Campaign for a New Bank of England Note, 1797–1821', *Numismatic Chronicle*, 158, p. 211.

40. Scotland operated on a different system where low denomination banknotes already circulated.

41. Mary Poovey, 2005. 'Discriminating Reading', *Victorian Review*, 31:2, p. 15.

42. Palk, Deirdre, 2007. *Prisoners' Letters to the Bank of England 1781–1827* (Loughborough: Q3 Print Project Management Ltd), p. xx.

43. Ibid., p. xi.

44. Buxton, T. F., 1818. *An Inquiry whether Crime and Misery are produced or prevented by our present System of Prison Discipline*, p. 113; Palk, Deirdre, 2007. *Prisoners' Letters to the Bank of England 1781–1827* (Loughborough: Q3 Print Project Management Ltd), p. xix.

45. Elizabeth Denham in Palk, Deirdre, 2007. *Prisoners' Letters to the Bank of England 1781–1827* (Loughborough: Q3 Print Project Management Ltd), 538, p. 161.

46. Elizabeth Denham in ibid., 551, p. 165.

47. Palk, Deirdre, 2007. *Prisoners' Letters to the Bank of England 1781–1827* (Loughborough: Q3 Print Project Management Ltd), p. viii.

48. Quoted in Tomii, Reiko, 2002. 'State v. (Anti-)Art: Model 1,000-Yen Note Incident by Akasegawa Genpei and Company', *Positions*, 10:1, p. 149.

49. Ibid., p. 152.

50. Akasegawa had previously used dripping acid on an earlier sculpture, *Vagina Sheets* (1961).

51. Tomii, Reiko, 2002. 'State v. (Anti-)Art: Model 1,000-Yen Note Incident by Akasegawa Genpei and Company', *Positions*, 10:1, p. 160.

52. Wang, Eugene Y., 2000. 'The Winking Owl: Visual Effect and Its Art Historical Thick Description', *Critical Inquiry*, 26:3, p. 435.

53. Fang Dan, 1979. 'Pi heihua yuanshi cailiao' (The original document of the Castigation of the Black Paintings), *Nanbeiji*, 105, p. 27 in Wang, Eugene Y., 2000. 'The Winking Owl: Visual Effect and Its Art Historical Thick Description', *Critical Inquiry*, 26:3, p. 436.

54. Laing, Ellen Johnston, *The Winking Owl: Art in the People's Republic of China* (Berkeley: University of California Press, 1988), p. 86.

55. Wang, Eugene Y., 2000. 'The Winking Owl: Visual Effect and Its Art Historical Thick Description', *Critical Inquiry*, 26:3, p. 436.

56. Trans. Chiang, Nicole in Spee, Clarissa von, 2012. *Modern Chinese Ink Paintings* (London: British Museum Press), p. 82.

57. Yang Yongliang, 2007. *Phantom Landscape* (Sales catalogue, OFoto Gallery, Shanghai).

58. Harrison-Hall, Jessica, 2017. *China: A History in Objects* (London: Thames & Hudson), p. 334.

59. At time of writing at least one fake remains on display. It is a spectacular skull carved from rock crystal, acquired in 1897 and purporting to be ancient Mexican, but now known to have been made with modern machine tools. See BM Am1898,-.1.

60. Morris, Steven, 2003. 'Graffiti artist cuts out middle man to get his work hanging in the Tate', *Guardian*, Saturday 18 October [https://www.theguardian.com/uk/2003/oct/18/arts.artsnews1, retrieved 26 September 2017].

61. Simon Wilson, private correspondence, 26 September 2017.

62. 'Cave art hoax hits British Museum', BBC, Thursday 19 May 2005 [http://news.bbc.co.uk/1/hi/entertainment/4563751.stm, retrieved 20 April 2018].

Conclusion: pp. 200–04

1. This has been noted in other studies of protest material culture. See, for example, Flood, Catherine and Grindon, Gavin (eds), 2014. *Disobedient Objects* (London: V&A Publishing), p. 12.

2. Gandhi, M. K., 1905. 'Russia and India', *Indian Opinion*, in Gandhi, M. K., ed. Swaminathan, K., 1958–84. *The Collected Works of Mahatma Gandhi* (New Delhi: Ministry of Information and Broadcasting, Government of India), vol. 5, p. 8.

3. Brownlee, Kimberley, 2008. 'Penalizing Public Disobedience', *Ethics*, 118:4, p. 712, n.4; Kushner, Tony in Glaser, Milton and

Further reading

Ilić, Mirko, 2005. *The Design of Dissent* (Gloucester, MA: Rockport Publishers, Inc.), p. 222.

4. Cheesman, Clive and Williams, Jonathan, 2000. *Rebels, Pretenders & Imposters* (London: British Museum Press), p. 8; Falk, Barbara J., 2008. 'Learning from History: Why We Need Dissent and Dissidents', *International Journal*, 64:1, p. 248. In England the notion that kings and queens were appointed by God and that even a bad monarch should be obeyed, was shattered during the Civil War.

5. Tilly, Charles, 1976. 'Major Forms of Collective Action in Western Europe 1500–1975', *Theory and Society*, 3:3, p. 365; Sunder, Madhavi, 2001. 'Cultural Dissent', *Stanford Law Review*, 54:3, p. 495.

6. Falk, Barbara J., 2008. 'Learning from History: Why We Need Dissent and Dissidents', *International Journal*, 64:1, p. 246.

Algar, Christian, 2016. 'Il Decamerone – "Corrected" by Rome', European Studies Blog, 26 September. [http://blogs.bl.uk/european/2016/09/il-decamerone-corrected-by-rome.html, accessed 21 September 2017]

And, Metin, 1975. *Karagöz: Turkish Shadow Theatre* (Istanbul: Dost Publications)

—, 1991. *Drama at the Crossroads: Turkish Performing Arts Link Past and Present, East and West* (Istanbul: Isis Press)

Andrews, Geoff, 2005. 'Dissent and the Reinvention of Politics', in Andrews and Saward (2005)

—, and Saward, Michael (eds), 2005. *Living Political Ideas* (Edinburgh: Edinburgh University Press)

Arendt, Hannah, 1958. *The Human Condition* (Chicago: University of Chicago Press)

Attwood, Philip, 2004. *Badges* (London: British Museum Press)

Bindman, David, 1989. *The Shadow of the Guillotine: Britain and the French Revolution* (London: British Museum Press)

Boddy, Janice Patricia, 2007. *Civilizing Women: British Crusades in Colonial Sudan* (Princeton: Princeton University Press)

Boldrick, Stacy and Barber, Tabitha, 2013. *Art Under Attack: Histories of British Iconoclasm* (London: Tate)

Briant, Pierre, trans. Daniels, Peter T., 2002. *From Cyrus to Alexander: A History of the Persian Empire* (Winona Lake, Indiana: Eisenbrauns), pp. 44–45

Brownlee, Kimberley, 2008. 'Penalizing Public Disobedience', *Ethics*, 118:4, pp. 711–16

Buchanan, Sherry, 2007. *Vietnam Zippos* (Chicago: University of Chicago Press)

Cash, Arthur, 2006. *John Wilkes: The Scandalous Father of Civil Liberty* (New Haven: Yale University Press)

Cheesman, Clive and Williams, Jonathan, 2000. *Rebels, Pretenders & Imposters* (London: British Museum Press)

Clayton, Tim and O'Connell, Sheila, 2015. *Bonaparte and the British: Prints and Propaganda in the Age of Napoleon* (London: British Museum Press)

Day, John, 2000. *Yahweh and the Gods and Goddesses of Canaan* (Sheffield: Sheffield Academic Press)

Department of Ancient Egypt and Sudan, 1992, 2007. *The British Museum Book of Ancient Egypt* (London: British Museum Press)

Donald, Diana, 1996. *The Age of Caricature: Satirical Prints in the Reign of George III* (New Haven and London: Yale University Press)

Ekserdjian, David, 1986. 'Review: *I Modi* by Lynne Lawner', *Burlington Magazine*, 128:995, p. 149

Elliston, Frederick A., 1982. 'Civil Disobedience and Whistleblowing: A Comparative Appraisal of Two Forms of Dissent', *Journal of Business Ethics*, 1:1, pp. 23–28

Falk, Barbara J., 2008. 'Learning from History: Why We Need Dissent and Dissidents', *International Journal*, 64:1, pp. 243–53

Flood, Catherine and Grindon, Gavin (eds), 2014. *Disobedient Objects* (London: V&A Publishing)

Fong So, 2014. *Umbrella Sketches: A First Hand Impression of the HK Umbrella Movement 2014* (Hong Kong: Fong & Yeung Studio)

Gattrell, Vic, 2006. *City of Laughter: Sex and Satire in Eighteenth-Century London* (London: Atlantic Books)

George, M. Dorothy, 1935–54. *Catalogue of Political and Personal Satires in the British Museum, vols V–IX* (London: Trustees of the British Museum)

Ginsberg, Mary, 2013. *The Art of Influence: Asian Propaganda* (London: British Museum Press)

Glaser, Milton and Ilić, Mirko, 2005. *The Design of Dissent* (Gloucester, MA: Rockport Publishers)

van den Haag, Ernest, 1955. 'Controlling Subversive Groups', *The Annals of the American Academy of Political and Social Science*, 300, Internal Security and Civil Rights, pp. 62–71

Harcourt, Bernard E., 2012. 'Political Disobedience', *Critical Inquiry*, 39:1, pp. 33–55

Harrison, Evelyn B., 1996. 'Pheidias', in Palagia, Olga and Pollitt, J. J. (eds), *Personal Styles in Greek Sculpture*, Yale Classical Studies, vol. 30 (Cambridge: Cambridge University Press), pp. 16–65

Harrison-Hall, Jessica, 2017. *China: A History in Objects* (London: Thames & Hudson)

Heard, Kate, 2013. *High Spirits: the The Comic art Art of Thomas Rowlandson* (London: Royal Collection Trust)

Helm, Charles and Morelli, Mario, 1979. 'Stanley Milgram and the Obedience Experiment: Authority, Legitimacy, and Human Action', *Political Theory*, 7:3, pp. 321–45

Hockenhull, Thomas, 2016. 'Stamped all over the King's Head: Defaced Coins and Women's Suffrage', *British Numismatic Journal*, 86, pp. 238–45

Houlihan, Patrick F., 2001. *Wit & Humour in Ancient Egypt* (London: Rubicon Press)

Hua Junwu, trans. Jenner, W. J. F., 1982. *Chinese Satire and Humour: Selected Cartoons of Hua Junwu, 1955–1982* (Beijing: New World Press)

Jenkins, J. Craig, Wallace, Michael and Fullerton, Andrew S., 2008. 'A Social Movement Society? A Cross-National Analysis of Protest Potential', *International Journal of Sociology*, 38:3, 'Across Nations': Protest and Repression: Cross-National Sociological Analyses, pp. 12–35

Joyner, Russell, 1989. 'Flags, Symbols and Controversy', *ETC: A Review of General Semantics*, 46:3, pp. 217–20

Kirby, John D., 1955. 'Are Morals Subversive?', *American Journal of Economics and Sociology*, 14:4, pp. 335–46

Kreamer, Christine Mullen and Fee, Sarah (eds), 2002. *Objects as Envoys: Cloth, Imagery, and Diplomacy in Madagascar* (Washington: University of Washington Press)

Lazarová, Daniela, 2015. 'The incredible story of the girl on the one crown coin', (Blog Post, Radio Praha). [http://www.radio.cz/en/section/panorama/the-incredible-story-of-the-girl-on-the-one-crown-coin, accessed 23 June 2017]

McCalman, Iain, 1993. *Radical Underworld: Prophets, Revolutionaries, and Pornographers in London, 1795–1840* (Oxford: Clarendon Press)

Marantz, Haim, 1978. 'Civil Disobedience and Social Order', *Il Politico*, 43:3, pp. 410–21

Markovits, Daniel, 2005. 'Democratic Disobedience', *Yale Law Journal*, 114:8, pp. 1897–1952

Martin, Rex, 1970. 'Civil Disobedience', *Ethics*, 80:2, pp. 123–39

Mecartney, John M., 1967. 'Civil Disobedience and Anarchy', *Social Science*, 42:4, pp. 205–12

Michaelson, Carol and Portal, Jane, 2006. *Chinese Art in Detail* (London: British Museum Press)

Millman, Brock, 2005. 'HMG and the War against Dissent, 1914–18', *Journal of Contemporary History*, 40:3 (July), pp. 413–40

Murck, Alfreda, 2009. 'Décor on Republican Era Tea Wares', in Link, Perry (ed.), *The Scholar's Mind: Essays in Honor of F. W. Mote* (Hong Kong: Chinese University Press), pp. 229–51

Nettleton, Anitra, 2015. 'Of Severed Heads and Snuff Boxes: "Survivance" and Beaded Bodies in the Eastern Cape, 1897–1934', *African Arts*, 48:4, pp. 22–33

Nicholson, Eirwen, 1996. 'Consumers and Spectators: The Public of the Political Print in Eighteenth-Century England', *History*, 81, pp. 5–21

Ogborn, Jane and Buckroyd, Peter, 2001. *Satire* (Cambridge: Cambridge University Press)

Packer, Dominic J., 2008. 'Identifying Systematic Disobedience in Milgram's Obedience Experiments: A Meta-Analytic Review', *Perspectives on Psychological Science*, 3:4, pp. 301–4

Parker, Kelly A., 2010. 'Takin' It to the Streets: Hare and Madden on Civil Disobedience', *Transactions of the Charles S. Peirce Society*, 46:1, A Symposium in Memory of Peter H. Hare, pp. 35–40

Price, Carolyn (ed.), 2008. *The Arts Past and Present, Book 2: Tradition and Dissent* (Milton Keynes: Open University)

Pritchard, James B. (ed.), 1969. *Ancient Near Eastern Texts Relating to the Old Testament* (Princeton: Princeton University Press)

Ramos, Imma, 2017. *Pilgrimage and Politics in Colonial Bengal: The Myth of the Goddess Sati* (London: Routledge)

Rawls, John, 1971. *A Theory of Justice* (Cambridge, MA: Harvard University Press)

Roberts, Lucienne, 2018. *Hope to Nope: Graphics and Politics 2008–18* (London: Design Museum)

Rogger, Basil, Vögeli, Jonas and Widmer, Ruedi (eds), 2018. *Protest. The Aesthetics of Resistance* (Zurich: Lars Müller Publishers)

Rosenau, William, 2007. *Subversion and Insurgency*, Rand Counterinsurgency Study, Paper 2 (Santa Monica: RAND National Defense Research Institute)

Ruiz, Pollyanna, 2014. *Articulating Dissent: Protest and the Public Sphere* (London: Pluto Press)

Thomas, Ross, 2013. 'Egyptian Late Period figures in terracotta and limestone', in Alexandra Villing et al., *Naukratis: Greeks in Egypt* (British Museum Online Research Catalogue)

Smith, James, 2004. 'Karagöz and Hacivat: Projections of Subversion and Conformance', *Asian Theatre Journal*, 21:2, pp. 187–93

Spjut, R. J., 1979. 'Defining Subversion', *British Journal of Law and Society*, 6:2, pp. 254–61

Spring, Christopher and Hudson, Julie, 1995. *North African Textiles* (London: British Museum Press)

Sunder, Madhavi, 2001. 'Cultural Dissent', *Stanford Law Review*, 54:3, pp. 495–567

Syson, Luke and Thornton, Dora, 2001. *Objects of Virtue: Art in Renaissance Italy* (London: British Museum Press)

Talvacchia, Bette, 1999. *Taking Positions: On the Erotic in Renaissance Culture* (Princeton: Princeton University Press)

Tarschys, Daniel, 1993. 'The Success of a Failure: Gorbachev's Alcohol Policy, 1985–88', *Europe-Asia Studies*, 45:1, pp. 7–25

Taylor, Bob Pepperman (ed.), 2016. *Civil Disobedience: Henry David Thoreau* (Peterborough, Ontario: Broadview Press)

Tomii, Reiko, 2002. 'State v. (Anti-)Art: Model 1,000-Yen Note Incident by Akasegawa Genpei and Company', *Positions*, 10:1, pp. 141–72

Tubb, Jonathan N., 1980. 'An Iron Age II Tomb Group from the Bethlehem Region', *British Museum Occasional Paper*, 14, pp. 5–14

Turner, James Grantham, 2004. 'Marcantonio's Lost *Modi* and their Copies', *Print Quarterly*, 21:4, pp. 363–84

Vasari, Giorgio, ed. Milanesi, Gaetano, this edition published 1880. *Le vite de' più eccellenti pittori, scultori ed architettori*, 9 vols (Florence: Sansoni).

Wescott, Joan, 1962. 'The Sculpture and Myths of Eshu-Elegba, the Yoruba Trickster. Definition and Interpretation in Yoruba Iconography', *Africa: Journal of the International African Institute*, 32:4, pp. 336–54

White, Benjamin, 1921. *The Currency of the Great War* (London: Waterlow & Sons Limited), pp. 26–28

Whitfield, Roderick, 1993. *Fascination of Nature: Plants and Insects in Chinese Painting and Ceramics of the Yuan Dynasty (1279–1368)*, (Seoul: Yekyong Publications)

List of illustrations

The publisher would like to thank the copyright holders for granting permission to reproduce the images illustrated. Every attempt has been made to trace the accurate ownership of copyrighted images in this book. Any errors or omissions will be corrected in subsequent editions provided notification is sent to the publisher.

Further information about the Museum and its collection can be found at britishmuseum.org

All images © The Trustees of the British Museum unless stated otherwise below.

Frontispiece and p. 21
Altered portrait of Louis XVI, King of France
c. 1785 (original), altered 1792 or later
Etching and stipple, with hand-coloured addition
After Joseph Boze, French
H: 30.1 cm, W: 18.5 cm
2013,7028.3
Funded by Friends of Prints and Drawings

p. 9
Ian Hislop at the British Museum in February 2018
J. Fernandes © Trustees of the British Museum

pp. 10 and 122
Fired brick of Nebuchadnezzar II
Reign of Nebuchadnezzar II, 605–562 BC
Clay, with cuneiform and Aramaic inscriptions
Babylon, southern Iraq
H: 33.7 cm, W: 36.8 cm, D: 8 cm
1979,1220.64

p. 13
'Dump Trump' badge
2017
Plastic, paper and alloy
USA
Diam.: 2.5 cm
2017,4079.3

pp. 14 (detail) and 67
Treason!!!
19 March 1798
Etching

Richard Newton, British
H: 32.2 cm, W: 24.7 cm
1868,0808.6712

p. 16
Openwork badge
14th century
Lead alloy
England
L: 7.7 cm, W: 5 cm
1856,0701.2096

pp. 17 (detail) and 163
Three rectangular door panels carved in low relief
Early 20th century
Wood
Ar'owogun of Osí, Yoruba people, Nigeria
(a) H: 258 cm, W: 50 cm, D: 7.5 cm; (b) H: 218 cm, W: 70 cm, D: 5 cm; (c) H: 221 cm, W: 62 cm, D: 5 cm
Af1954,23.208.a-c
Donated by Wellcome Institute for the History of Medicine

p. 22
Health and safety cover for the anti-Nazi pamphlet 'Freiheit'
January 1938
Published by the Communist Party of Germany
Courtesy of The Wiener Library

p. 23 (left)
Defaced penny
1967
Copper, painted
Issued by Royal Mint, London, England
Diam.: 3.1 cm
2014,4152.3
Donated by Simmons and Simmons

p. 23 (right)
Re-engraved penny
1797
Metal alloy
London, England
Diam.: 3.6 cm
1989,1025.1

p. 24 (left)
Politically defaced penny
1797
Metal alloy
Made by C. James, issued by Thomas Spence, London, England

Diam.: 3.6 cm
T.6224
Donated by Dr Laurie A. Lawrence

p. 24 (below left and right)
Spence Token
1796
Copper alloy
Made by C. James, issued by Thomas Spence, London, England
Diam.: 2.1 cm
T.6819

p. 25
The Contrast
1795
Print
Thomas Spence, published in Pigs' Meat
H: 22 cm, W: 18 cm
British Museum Coins & Medals Library: B NUM 4 SPE

p. 27
Suffragette penny
1903, defaced 1913–14
Bronze
Issued by Royal Mint, London, England
Diam.: 3.1 cm
1991,0733.1
Donated by R. Johnson

p. 28
Photograph of a protest meeting by the WSPU outside the Queen's Hall in central London
1910
PA/PA Archive/PA Images

p. 30
Badge for the National League for Opposing Woman Suffrage
c. 1910–18
Metal, enamel, textile
UK
Diam.: 2 cm
1984,0558.1

p. 31
A Suffragette's Home
1912
Poster
John Hassall, published by the National League for Opposing Woman Suffrage
Image courtesy the People's History Museum

p. 32
Defaced florin
1937
Silver
Issued by Royal Mint, London, England
Diam.: 2.9 cm
2014,4152.2
Donated by Simmons and Simmons

p. 33
Four re-engraved pesos
1933, re-engraved 1977
Cupronickel
Chile
Diam.: 2.9 cm
2015,4168.1; 2015,4168.3; 2015,4168.6; 2015,4168.7

p. 34
Over-stamped 1 yuan banknote
1999
Paper
Issued by People's Bank of China
H: 6.2 cm, W: 13 cm
2009,4142.1

p. 35
Detail of a defaced £20 banknote
2014
Paper
Issued by Bank of England, overstamped by David Blackmore
L: 14.9 cm, H: 8 cm
2017,4059.1
Reproduced by permission of the artist

p. 36
Two defaced €5 banknotes
2013
Paper
Issued by European Central Bank, defaced by Stefanos
L: 12 cm, H: 6.2 cm
2015,4051.1; 2015,4051.2
Donated by Stefanos
Reproduced by permission of the artist

p. 37
Defaced US $1 banknote
1963, removed from circulation 1979–83
Paper
Issued by Federal Reserve Bank, USA
L: 15.5 cm, H: 6.6 cm
2016,4060.1
Donated by Sam Moorhead

Defaced US $10 banknote
2009
Paper
Issued by Federal Reserve
Bank, USA
L: 15.5 cm, H: 6.6 cm
2015,4031.1
Donated by Francis Allard
through Sascha Priewe

p. 37
Defaced Libyan 1 dinar
banknote
2004
Paper
Issued by Central Bank
of Libya
L: 14 cm, H: 7 cm
2013,4125.1
Donated by Salem Abdulla
Ai-Jadi Masoud

p. 38
Poster made of Zimbabwean
banknotes
2009
Paper
Designed by TBWA/Hunt/
Lascaris, South Africa
H: 110.9 cm, W: 73.2 cm
2009,4134.3
Donated by TBWA/Hunt/
Lascaris

p. 39
Cover of Private Eye
27 June 2008
Reproduced by kind
permission of PRIVATE EYE
magazine - private-eye.co.uk

p. 40
'Tuck Frump' badge
2017
Plastic, paper and
alloy
USA
Diam.: 2.5 cm
2017,4079.2

'Make America Gay Again'
badge
2016
Plastic, paper and
alloy
USA
Diam.: 5.6 cm
2016,4156.1
Donated by Henry Flynn

p. 41
'Black Lives Matter' badge
2017
Plastic, paper and alloy

USA
Diam.: 5.5 cm
2017,4015.23

'Migrant Lives Matter' badge
2015
Plastic and alloy
UK
Diam.: 2.4 cm
2015,4172.5
Donated by Philip Attwood

'I stayed up to see Farage
lose' badge
2015
Plastic, paper and alloy
UK
Diam.: 2.6 cm
2016,4092.1

'Crooked Hillary' badge
2017
Plastic, paper and alloy
USA
Diam.: 7.6 cm
2017,4015.15

'Conservatives putting
the n in cuts' badge
2011 or earlier
Plastic, paper and alloy
UK
Diam.: 2.9 cm
2013,4141.2

'Bollocks to Austerity' badge
2013
Plastic, paper and alloy
UK
Diam.: 3.8 cm
2013.4094.3
Donated by Philip Attwood

'Say Yes' badge
2014
Plastic, paper and alloy
UK
Diam.: 2.6 cm
2014,4090.7
Donated by John Stenhouse

'NHS not for sale' badge
2014
Plastic, paper and alloy
UK
Diam.: 4.5 cm
2014,4083.3
Donated by Philip Attwood

'Say No' badge
2014
Plastic, paper and alloy
UK
Diam.: 2.6 cm

2014,4090.9
Donated by John Stenhouse

'Free Palestine' badge
2014
Plastic, paper and alloy
UK
Diam.: 5.5 cm
2014,4092.1
Donated by Patricia Wheatley

p. 42
Poster showing a shouting face
2012
Digitally generated image
on paper
The Syrian People Know
Their Way
H: 59.3 cm, W: 43.1 cm
2016,6034.35
Funded by CaMMEA
Acquisition Group
Reproduced by permission
of the artist

p. 43
Poster showing the silhouette
of a person holding a catapult
2011
Digitally generated image
on paper
The Syrian People Know
Their Way
H: 59.5 cm, W: 43.2 cm
2016,6034.36
Funded by CaMMEA
Acquisition Group
Reproduced by permission
of the artist

pp. 44–45
Illustrated papyrus
Ramesside period,
1307–1070 BC
Painted papyrus
Deir el-Medina, Egypt
H: 8.6 cm, L: 53.5 cm
EA10016,2

p. 45
Painted ostracon
Ramesside period,
1307–1070 BC
Limestone
Deir el-Medina, Egypt
H: 10 cm, W: 17.5 cm, D: 2 cm
1843,0507.120

p. 47
The cats castle besieged
and stormed by the rats
c. 1660, this impression
after 1665 etching
Print

Published by John Overton,
British
H: 21.7 cm, W: 29.5 cm
1953,0411.70
Bequeathed by Edward
Howard William Meyerstein

p. 48
Hudibras encounters
the Skimmington
1726
Etching and engraving
William Hogarth, published
by John Overton and John
Cooper, British
H: 27 cm, W: 51.1 cm
1847,0508.19

p. 51
Glass goblet
c. 1600
Gilded, enamelled glass
Venice, Italy
H: 19.5 cm, Diam.: 12.5 cm
S.852
Bequeathed by Felix Slade

p. 53
Shadow puppet scenery
probably 19th or early
20th century
Animal hide
Turkey
H: 27.2 cm, W: 18.4 cm,
D: 1.4 cm
As 1969,03.280

Male shadow puppet
probably 19th or early
20th century
Animal hide
Turkey
H: 26.3 cm, W: 9 cm, D: 1 cm
As 1969,03.186

Male shadow puppet
probably 19th or early
20th century
Animal hide
Turkey
H: 26.5 cm, W: 13.4 cm,
D: 1.4 cm
As 1969,03.123

p. 55
Factory worker Day of the
Dead figurine
1980s
Papier mâché, cane, wood
Pablo Morales, workshop of
Linares family, Mexico City,
Mexico
H: 69 cm, W: 25 cm, D: 22 cm
Am 1989,13.92

Reproduced by permission
of the artist

Uncle Sam Day of the Dead
figurine
1980s
Papier mâché, cane
Workshop of Linares family,
Mexico City, Mexico
H: 72 cm, W: 21 cm, D: 25 cm
Am1989,13.22
Reproduced by permission
of the artist

p. 56
La Calavera Catrina
Day of the Dead figurine
1980s
Papier mâché
Agustin Galicia, Mexico City,
Mexico
H: 114 cm, W: 50 cm, D: 32 cm
Am1986,06.414
Reproduced by permission
of the artist

p. 59
*Fashionable Contrasts;-or-The
Duchess's little Shoe yielding to
the Magnitude of the Duke's Foot*
1792
Hand-coloured etching
James Gillray, published by
Hannah Humphrey, British
H: 25.5 cm, W: 35.5 cm
1868,0808.6150

p. 61
*A Voluptuary under the Horrors
of Digestion*
1792
Hand-coloured etching and
stipple
James Gillray, published by
Hannah Humphrey, British
H: 36.6 cm, W: 29.5 cm
1851,0901.618

p. 62
*The Presentation-or-The Wise
Men's Offering*
1796
Hand-coloured etching
James Gillray, published by
Hannah Humphrey, British
H: 24.3 cm, W: 34.4 cm
1868,0808.6495

p. 63
*Farmer Looby Manuring
the Land*
1794–96
Hand-coloured woodcut
Anonymous, British
H: 28 cm, W: 20 cm
1868,0808.6380

p. 65
Head–and Brains
1797
Drawing
Richard Newton, British
H: 32.3 cm, W: 29.7 cm
1868,0808.6381

p. 69
*The Prince of Whales or the
Fisherman at Anchor*
1812
Hand-coloured etching
George Cruikshank, published
by M. Jones, British
H: 19.6 cm, W: 49.9 cm
1859,0316.36

p. 72
Verse Account of Nabonidus
c. 539 BC
Clay, with cuneiform
inscription
Babylon, southern Iraq
H: 12 cm, W: 12.5 cm,
D: 3.3cm
1880,1112.181

p. 73
Stela of Nabonidus
Neo-Babylonian dynasty,
c. 539 BC
Basalt
Possibly Babylon, southern Iraq
H: 58.5 cm, W: 47 cm,
D: 24.5 cm
1825,0503.99

p. 75
Statue of a woman,
11th century BC
Limestone
Nineveh, northern Iraq
H: 101.5 cm, W: 49 cm,
D: 26 cm
1856,0909.60

p. 76
Figure of a comic actor
3rd century BC
Terracotta
Alexandria, Egypt
H: 7 cm
1926,0930.49

p. 78
Relief carved with an erotic
scene
1st century BC – 1st century AD
Marble
Roman, possibly made in Italy
H: 36 cm, W: 40 cm, D: 5.5 cm
1865,1118.252
Donated by Dr George Witt

p. 79
Oil lamp
AD 40–80
Terracotta
Roman, made in Italy
L: 9.2 cm, W: 7.6 cm
1865,1118.249
Donated by Dr George Witt

p. 81
Silver denarius
28 BC
Silver
Roman Imperial, minted in Italy
Diam.: 2 cm
1860,0328.114

p. 84
Photograph of Czechoslovak
students offering their keys
symbolically to Václav Havel
4 December 1989
Pascal George/AFP/Getty
Images

p. 86
Clog, sabot
19th century
Wood, leather and iron
Europe
L: 29.5 cm, W: 11.5 cm
Eu.4221

p. 87
Portrait of Charles I
c. 1660
Etching
Possibly by Richard Gaywood,
British
H: 19.4 cm, W: 12.9 cm
1869,0710.19

Finger ring with enamelled
portrait of Charles I
1640–60
Gold, diamond, enamel
Europe
H: 2.8 cm, W: 0.5 cm, D: 2 cm
AF.1439
Bequeathed by Sir Augustus
Wollaston Franks

pp. 88–89
Jacobite garter
c. 1745
Woven silk
British
L: 122.3 cm
1893,0205.58
Donated by Sir Augustus
Wollaston Franks

p. 90
*Queen Adelaide receiving the
Malagasy ambassadors at
Windsor Castle in March 1837*

Painting
Henry Room
© Image; Crown Copyright:
UK Government Art Collection

p. 91
Striped Merina *lamba*
early 19th century
Woven silk
Madagascar
L: 244 cm, W: 118 cm
Af1993,04.1
Donated by Alfred and
Mary Bewley

p. 92
Tunic, *muraqqa'a*
probably before 1885
Cotton and wool
Sudan
L: 91 cm, W: 159 cm
Af1886,0628.1
Donated by Surg-Maj. H.J.
Waller-Barrow

Tunic, *jibba*
late 19th century
Cotton and wool
Sudan
L: 90 cm, W: 125 cm
Af1972,11.14
Donated by Miss M. Collins

p. 93
General Gordon's Last Stand
1893
Oil on canvas
George William Joy
Leeds Museums and Galleries
(Leeds Art Gallery) UK/
Bridgeman Images

p. 94
Photograph of Emir Mahmoud
captured during the Battle of
Atbara
Possibly by Gregson Francis
© Imperial War Museum
(HU 93852)

p. 95
Photograph of Bhagat Singh
1929
Dinodia Photos/Alamy Stock
Photo

p. 97
Bhagat Singh figurine
late 20th century
Hand-modelled, painted
ceramic
Delhi, India
H: 7.5 cm, W: 3 cm
As1991,07.9

p. 98
Photograph of Gandhi
at his spinning wheel
1946
Margaret Bourke-White
for *Time* magazine
The LIFE Picture Collection/
Getty Images

p. 99
Lacquered dish featuring
depiction of Gandhi
1930s
Bamboo, lacquer, gold foil
Burma
H: 1.5 cm, Diam.: 15.2 cm
2001,0612.2

p. 100
Beaded necklace with a
snuffbox showing the head
of King George V
early 20th century
Tin, fibre, glass
Mpondomise people, South
Africa
H: 45.2 cm, W: 21 cm,
D: 1.9 cm
Af1933,0609.31
Presented by Dr Frank Corner
with Art Fund support
(as NACF)

p. 101
Popular print of the goddess
Kali on the battlefield
c. 1895
Coloured lithograph
Chore Baghan Art Studio,
Calcutta, India
H: 40.6 cm, W: 30.5 cm
1950,1014,0.24

p. 102
Photograph of the Palestinian
leader Yasser Arafat
1980
Mondadori Portfolio/Alberto
Roveri/Bridgeman Images

p. 103
Bedouin Man's *keffiyeh*
1920–48
Dyed and woven cotton
Palestine
L: 114 cm, W: 121 cm
As1966,01.290

*Woman's belt made from
a man's keffiyeh*
1980s
Cotton, synthetic fibre
Palestine or Jordan
L: 156 cm, W: 13 cm
As1988,06.22

p. 104
Bad Hejab
2008
Photo collage
Ramin Haerizadeh, Iran
H: 30 cm, W: 42 cm
2008,6036.4
Reproduced by permission
of the artist

p. 105
Escape
1975
Aquatint on paper
Nahid Hagigat, Iran
H: 37.5 cm, W: 30.5 cm
2014,6047.2
Purchased with funding from
CaMMEA Acquisition Group
Reproduced by permission
of the artist

p. 106
Photograph of Vida Mohaved
protesting on a Tehran street
30 December 2017
SalamPix/Abaca/Sipa USA

p. 107 and p. 108 (below)
Sketches from an album
documenting the Hong Kong
Umbrella Movement
2014
Pencil, felt marker, coloured
pencil and crayon on paper
Fong So, Hong Kong
H: 30 cm, W: 42 cm
2016,3016.2.1;
2016,3016.2.58;
2016,3016.2.19
Donated by Fong So
Reproduced by permission
of the artist

p. 108 (above)
Sketch from a sketchbook
documenting the Hong Kong
Umbrella Movement
2014
Pencil, felt marker, coloured
pencil and crayon on paper
Fong So, Hong Kong
H: 21 cm, W: 29 cm
2016,3016.1.1–78
Donated by Fong So
Reproduced by permission
of the artist

p. 109
Yellow umbrella used during
the Hong Kong Umbrella
Movement
2014
Loaned by Ian Hislop

p. 110
Women and men wearing
'pussyhats' at the Women's
March on Washington
21 January 2017
© Ruth Fremson/The New
York Times/Redux/eyevine

p. 111
Knitted 'pussyhat'
2017
Acrylic wool
Washington, DC, USA
H: 18 cm, W: 24.5 cm
2018,8002.1

p. 113
'Pillar' figurine
7th century BC
Fired clay, painted
Bethlehem, modern
Palestinian authority
H: 17.5 cm, W: 9 cm, D: 9 cm
1865,0805.1
Donated by Rev. Joseph
Barclay

p. 114
A Sudanese workman posing
with the Meroë head
1910
Image courtesy of The Garstang
Museum of Archaeology,
University of Liverpool

p. 115
Meroë head
27–25 BC
Bronze, calcite, glass
Roman
H: 46.2 cm, W: 26.5 cm,
D: 29.4 cm
1911,0901.1
Donated by Sudan Excavation
Committee with Art Fund
support (as NACF)

p. 116
Photograph of the chancel
in the church of St Mary at
Kettlebaston, Suffolk
Reproduced by permission
of N. A. Stollery

p. 117
Fragmentary alabaster panel
depicting God seated on the
throne with crucified figure
of Christ
14th century
Painted alabaster
England
H: 31.7 cm, W: 27 cm,
D: 4.7 cm
1883,0806.1
Donated by Rev. James Beck

p. 118
Fragment of an alabaster
panel showing the Coronation
of the Virgin
14th century
Painted alabaster, gold
England
H: 24.8 cm, W: 29 cm,
D: 4.6 cm
1883,0806.3
Donated by Rev. James Beck

Fragment of an alabaster panel
showing the seated Virgin
14th century
Painted alabaster, gold
England
H: 25.2 cm, W: 25 cm,
D: 4.6 cm
1883,0806.2
Donated by Rev. James Beck

p. 119
Foot of Christ
12th century
Painted wood, gesso
England
H: 6.5 cm, W: 4 cm, L: 12 cm
1994,1008.2
Purchased with Art Fund
support (as NACF)

Head of Christ
12th century
Painted wood, gesso
England
L: 15.5 cm, W: 7.2 cm,
D: 7.7 cm
1994,1008.1
Purchased with Art Fund
support (as NACF)

p. 120
The Stonyhurst Salt
1577–78
Silver gilt, ruby, rock-crystal,
garnet and enamel
Possibly made by John
Robinson, London, England
H: 26.3 cm, Diam.: 9.4 cm
1958,1004.1
Purchased with Art Fund
support (as NACF)

p. 121
Letter seal matrix, with
wax impression
14th century
Bronze
England
Diam.: 2.2 cm
1889,0507.30
Donated by Sir Augustus
Wollaston Franks

H: 7.2 cm, W: 3.2 cm,
D: 2.3 cm
1973,0501.34
Donated by Egypt Exploration
Fund

Ithyphallic figure holding
an amphora
500–250 BC
Painted terracotta
Egypt
H: 7.3 cm, W: 5 cm, D: 3.3 cm
1973,0501.64
Donated by Egypt Exploration
Fund

Seated ithyphallic figure
with a harp
500–250 BC
Painted terracotta
Egypt
H: 9.7 cm, W: 6.2 cm,
D: 3.1 cm
1973,0501.40
Donated by Egypt Exploration
Fund

Seated ithyphallic figure
playing the tambourine
500–250 BC
Painted terracotta
Egypt
H: 9.7 cm, W: 5.5 cm, D: 3.5 cm
1909,1201.20
Donated by Egypt Exploration
Fund

p. 153
The Strangford Shield
AD 200–300
Marble
Roman
H: 43.2 cm, W: 45.7 cm
1864,0220.18

p. 154
Photograph of a full-scale
replica of the original Athena
statue
Fotan/Alamy Stock Photo

p. 156
Fascination of Nature
1321
Painted silk
Xie Chufang, China
H: 27.8 cm, L: 352.9 cm
1998,1112,0.1.CH
Purchased with support from
the Brooke Sewell Permanent
Fund and the Art Fund (as
NACF)

p. 159
*Croquades faites à l'audience
du 14 nov.*

1831
Lithograph
Charles Philipon, published
by Aubert, French
H: 33.3 cm, W: 25.6 cm
1886,1012.343

Ah! his!... ah! his!... ah! his!...
1832
Hand-coloured lithograph
Honoré Daumier, printed by
Becquet, published by Aubert,
French
H: 32.5 cm, W: 19.5 cm
1918,0511.27
Donated by Charles Lambert
Rutherston

p. 160
*Voulez vous aller faire vos
ordures plus loin, polissons!*
1833
Lithograph
Auguste Bouquet, French
H: 19 cm, W: 25 cm
Source: gallica.bnf.fr/
Bibliothèque nationale de
France

p. 161
Illustration from Victor Hugo's
play *Le roi s'amuse*
c. 1895
Etching
Adolphe Laluze after
François Flameng, French
H: 24.9 cm, W: 18 cm
1914,0228.1692
Bequeathed by Henry
Spencer Ashbee

p. 164
British Empire Exhibition poster
1924
R. T. Cooper
Mary Evans Picture Library

Photographic postcard of the
Nigeria pavilion at the British
Empire Exhibition
1924
© Brent Museum and Archives

p. 166
Teapot painted in black enamel
1913
Porcelain and metal
Painted by Luo Fatai,
Jingdezhen, China
H: 18 cm, W: 14 cm, D: 12 cm
2013,3007.26
Donated by Alfreda Murck

p. 167
Baluster teapot
1931

Porcelain
Jingdezhen, China
H: 19 cm, W: 12 cm, D: 17 cm
2013,3007.118
Donated by Alfreda Murck

p. 169
Fringed square of woven
raffia cloth
1970s–90s
Raffia palm fibre
Democratic Republic
of Congo
L: 72.5 cm, W: 74 cm
2011,2029.1

p. 170
Five zaire banknote
1985
Paper
Banque du Zaïre, Zaire
L: 13.2 cm, W: 6.3 cm
2005,0824.207

p. 171
Czechoslovak 1 koruna coin
1957
Bronze plated aluminium
Designed by Marie
Uchytilová-Kučová, issued
by Government of
Czechoslovakia
Diam.: 2.3 cm
1993,0111.58
Donated by D. L. F. Sealy

p. 172
Photograph of Marie
Uchytilová-Kučová
1980
Courtesy Sylvia Klánová

Slovak State Savings
Bank book
1970
Paper
Slovak State Savings Bank,
Czechoslovakia
L: 13 cm, W: 9 cm
2017,4074.1
Donated by Popeliš family

p. 174
Afghan war rug with a border
featuring a convoy of tanks
1980s
Wool
Afghanistan
W: 101.5 cm, L: 162 cm, D: 1 cm
2010,6013.12
Donated by Graham Gower

p. 175
Afghan war rug featuring
repeated rows of helicopters
and tanks

1980s
Wool
Afghanistan
W: 96 cm, L: 206 cm, D 1.7 cm
2010,6013.9
Donated by Graham Gower

p. 177
Nine fragments of engravings
depicting *I Modi*
c. 1524 or later
Engraving, mounted on paper
Probably engraved by
Agostino Veneziano, after
Marcantonio Raimondi and
Giulio Romano, Italian
H: 24 cm, W: 27 cm
1972,U.1306-1314

p. 178
Earthenware plate
1534
Tin-glazed and lustred
earthenware, maiolica
Painted by Francesco Xanto
Avelli (possibly with an assistant),
probably lustred by the
workshop of Maestro Giorgio
Andreoli, after Marcantonio
Raimondi, Urbino, Italy
H: 3.3 cm, Diam.: 28.2 cm
1855,0313.11
Donated by Sir Augustus
Wollaston Franks

p. 179
Reproduction of one of
the *I Modi* engravings
16th century or later
Drawing
Unknown copyist, after
Marcantonio Raimondi, Italian
H: 16.5 cm, W: 21.8 cm
1857,0711.20

p. 180
Bank Restriction note
1819
Paper
George Cruikshank, published
by William Horne
H: 13 cm, 20.5 cm
1984,0605.11958

p. 183
*An interior view of Cold Bath
Fields Prison, in which Thos
Ranson was unlawfully
confined...*
1818
Etching and engraving
Thomas Ranson, printed by
William Bishop, British
H: 20.2 cm, W: 17 cm
1868,0808.1928

Acknowledgments

We are grateful to the staff of all curatorial departments for responding gamely as we searched the collection, occasionally in vain, for potentially subversive material. The list of British Museum colleagues who provided support is extensive, but we would particularly like to thank the following current and former staff for their contributions to this book: Richard Abdy, Ben Alsop, Philip Attwood, Lloyd de Beer, Lissant Bolton, Richard Blurton, Esther Chadwick, Hugo Chapman, Timothy Clark, Barrie Cook, Jill Cook, Sheila O'Connell, Stephen Coppel, Irving Finkel, Lesley Fitton, Alexandra Fletcher, John Giblin, Mary Ginsberg, Alexandra Green, Alfred Haft, James Hamill, Jessica Harrison-Hall, Eleanor Hyun, Ian Jenkins, Zeina Klink-Hoppe, Yu-Ping Luk, Marcel Maree, Sam Moorhead, Jane Portal, Venetia Porter, Imma Ramos, Ilona Regulski, Judy Rudoe, St John Simpson, Clarissa von Spee, Christopher Spring, Fahmida Suleman, Ross Thomas, Dora Thornton, Jonathan Tubb, Sarah Vowles, Helen Wang, Richard Wakeman and Simon Wilson.

Within the Publishing Department we are grateful to our publishing managers, Claudia Bloch, Kathleen Bloomfield and Alice Nightingale, for their help, advice and patience. At Thames & Hudson we would like to thank Julia MacKenzie and Rachel Heley, and at Grade Design our thanks go to Peter Dawson and Alice Kennedy-Owen. Images of British Museum objects have been provided by a team of in-house photographers, led by John Williams. They are Stephen Dodd, Joanna Fernandes, Dudley Hubbard, Kevin Lovelock and Saul Peckham.

From design to marketing, object conservation to installation, the process of mounting an exhibition is a collaborative effort involving many people. A number of those individuals are named above, and we would also like to extend our thanks to the following colleagues for making it happen: Maxwell Blowfield, Hannah Boulton, Mark Finch, Hartwig Fischer, Stuart Frost, Joanna Hammond, Joseph Kelly, Deklan Kilfeather, Ann Lumley, Joanna Mackle, Harriet McColm, Megumi Mizumura, Tomasina Munden, Clara Potter, Angela Pountney, Lee Roberts, David Souden, Christopher Stewart, Jennifer Suggitt, Sian Toogood, Sophie Tregent, Victoria Ward, Josephine Weisflog, Jonathan Williams, Sam Wyles and Suzie Yarroll.

Our exhibition project team comprises Julie Carr, who edited the exhibition text, Janet Larkin, who provided curatorial and project support, project manager Mary Linkins, ably assisted by Heather Blair and Katherine Young, with 2D, 3D and lighting design by Helen Eger of Studio Eger, Peter MacDermid and David Roberston of DHA Designs respectively. Their suggestions, questions, provocations and unwavering commitment have been invaluable in refining the exhibition concept, from which this book is ultimately derived.

Finally, beyond the British Museum we would like to thank Sarah Fee, Sylvia Klánová, Freda Murck, Fiona Savage and David Stuttard for agreeing to check text and for sharing their wealth of knowledge, expertise and enthusiasm. We must also thank Citi, the sponsors of this exhibition, for their generous support. Last but not least, we are grateful to our external lenders – Banksy; and Christian Algar and Karen Limper-Herz, our colleagues at the British Library who pointed us in the direction of subversive objects in their printed collections.

p. 184
Forged Bank of England note
1816
Paper
Issued by Bank of England
H: 11.9 cm, W: 12.4 cm
CIB.8021
Donated by ifs School
of Finance

p. 186
Great Japan Zero-Yen Banknote
1967
Paper
Akasegawa Genpei, Japan
H: 14 cm, W: 30 cm
2014,3063.2
The JTI Japanese Acquisition Fund
© 1967 Akasegawa Genpei

p. 188
Two Owls
1977
Ink on paper
Huang Yongyu, China
H: 48 cm, W: 45.5 cm
1996,0614,0.12
Gift of Yang Xianyi through Gordon S. Barrass
Reproduced by permission of the artist

p. 189
Winking Owl
1978, based on a work of c. 1972
Huang Yongyu, China
Reproduced by permission of the artist

p. 190
Field Work
1983
Woodblock print, ink on paper
O Yun, Korea
H: 35 cm, W: 25.5 cm
1997,1107,0.4

p. 191
Grandmother II
1983
Woodblock print, ink on paper
O Yun, Korea
H: 51 cm, W: 35.6 cm
1997,1107,0.2

p. 192
HET! ['Nyet!']
1954
Viktor Govorkov
Image: Russian State Library

p. 193
Plate featuring reproduction of *HET!* ['Nyet!'] poster and portrait of Gorbachev
Possibly after 1991
Printed and glazed porcelain
USSR (Russia)
H: 2.8 cm, Diam.: 20.2 cm
2015,8028.1
Donated by Judy Rudoe

p. 194
Mountain Market, Clearing Mist
Early 13th century
Album leaf; ink on silk
Xia Gui, China
H: 24.8 cm, W: 21.3 cm
Metropolitan Museum of Art, New York (13.100.102)
John Stewart Kennedy Fund, 1913

p. 195
Phantom Landscape III
2007
Digital image; inkjet print on Epson textured fine art paper
Yang Yongliang, Shanghai, China
H: 45 cm, W: 45 cm
2008,3012.1
Brooke Sewell Permanent Fund

p. 196
Learn from Comrade Lei Feng
2012
Ink on Xuan rice paper
Qu Leilei, London
H: 171 cm, W: 91 cm
2014,3031.2
Donated by Qu Leilei
Reproduced by permission of the artist

p. 197
Statuette carved in the form of a squatting human figure
Early 20th century
Stone
Yemen
H: 18.6 cm, W: 6 cm, D: 8 cm
1935,0309.13
Donated by Maj. J. R. C. Crosslé

p. 198
Peckham Rock
2005
Marker pen on found rock
Banksy, UK
© Banksy courtesy of Pest Control Office

Index